The authors would like to thank Laura Owen and Brian Morris at AVA, Clare Masefield for her tireless picture research, Alan McFaden for his product photography, and all those who contributed images to this book

For my wife, Sharron, and my
wonderful sons, Miles and Lucas
Nigel

For Alan, my Dad, and Barbara, my Mum,
for all your support and belief, I love you
Steve

AN ILLUSTRATED

A TO Z
OF
DIGITAL PHOTOGRAPHY

AVA Publishing SA
Switzerland

D1415976

An AVA Book

Published by AVA Publishing SA

Chemin de la Joliette 2

Case Postale 96, 1000 Lausanne 6

Switzerland

Tel: +41 786 005 109

Email: enquiries@avabooks.ch

Distributed by Thames and Hudson (ex-North America)

181a High Holborn

London WC1V 7QX

United Kingdom

Tel: +44 20 7845 5000

Fax: +44 20 7845 5050

Email: sales@thameshudson.co.uk

www.thamesandhudson.com

Distributed by Sterling Publishing Co., Inc.

in USA

387 Park Avenue South

New York, NY 10016-8810

Tel: +1 212 532 7160

Fax: +1 212 213 2495

www.sterlingpub.com

in Canada

Sterling Publishing

c/o Canadian Manda Group

One Atlantic Avenue, Suite 105

Toronto, Ontario M6K 3E7

English Language Support Office

AVA Publishing (UK) Ltd.

Tel: +44 1903 204 455

Email: enquiries@avabooks.co.uk

ISBN 2-88479-077-2

10 9 8 7 6 5 4 3 2 1

Design by Steve Crabb

Production and separations by

AVA Book Production Pte. Ltd., Singapore

Tel: +65 6334 8173

Fax: +65 6334 0752

Email: production@avabooks.com.sg

AN ILLUSTRATED

ATOZ
OF
DIGITAL PHOTOGRAPHY

Nigel Atherton & Steve Crabb

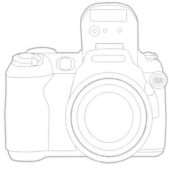

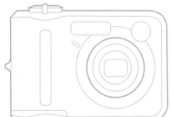
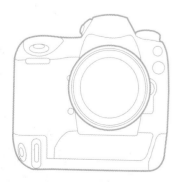

AN ILLUSTRATED
A TO Z
OF
DIGITAL PHOTOGRAPHY

GETTING STARTED

DIGITAL CAPTURE

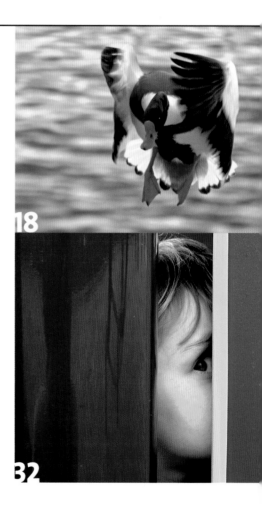

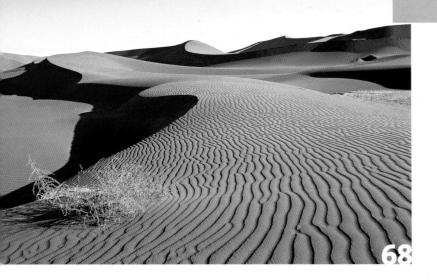

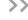

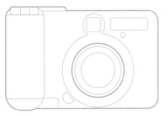
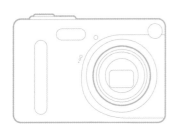

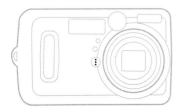

PHOTOSHOP

REFERENCE

WHAT IS DIGITAL?

We're currently in the middle of the biggest revolution in photography since its invention in 1839. For nearly 170 years photographers have been reliant upon a cocktail of light-sensitive chemicals smeared onto a sheet of glass or acetate in order to record the world around them. But no more. Photography has gone digital. Film has been replaced by an electronic sensor made up of millions of tiny light-sensitive dots. Together, these dots provide an electric 'map' of the world which is then, in turn, translated into binary digital data by the processor. And it all happens in milliseconds.

A digital image on a memory card is invisible to the eye and is in fact no more than a collection of millions of numbers, but view it on a computer (even the one built in to the camera) and that code is magically and instantly transformed into a photographic image.

It's a miracle of science – but this is only the beginning of the journey, because that data can now be sent down a telephone line to the other side of the world, beamed wirelessly to a printer in the study or copied onto the PC, where it can be distorted, erased and rearranged to transform it into an entirely different image.

So welcome to the world of digital photography. A world where the picture is just the starting point, and where images have more possibilities than ever before.

Welcome to the revolution!

Nigel Atherton Steve Crabb

the checklist

Found on all the subject-based pages, the checklist provides a brief summary of the main points covered in the text.

the tips

Many pages contain a useful tip or nugget of advice on an aspect of the particular topic covered on that page.

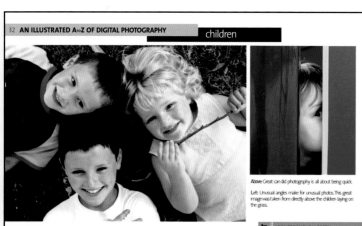

Above: Great candid photography is all about being quick.

Left: Unusual angles make for unusual photos. This great image was taken from directly above the children laying on the grass.

Left: Try shooting a sequence of images of with the sequence mode on your camera. It will catch all the action in one go. It can work as a complete sequence, or pick out the best of the bunch.

Below Left: Stooping down to your children's level, rather than looking down on them from above, usually produces the best results.

Children

Forget cheesy mugshots, the best shots of kids are those that catch them acting naturally and showing their true personalities.

CHECKLIST

- LOOK FOR NATURAL POSES
- USE FILL-IN-FLASH
- TRY USING PROPS
- MOVE RIGHT IN CLOSE
- SHOOT A SEQUENCE
- REMEMBER TO BE QUICK
- DON'T FORGET... MAKE IT FUN

use props around you

Children either love to pose or hate it. If this gives you trouble, try using props to give them something to interact with. This can make for a much more relaxed shot. (For more on shooting people, see page 98)

MAKE A RECORD

When the kids are all grown up we'll look back at their younger years and remember key events like holidays, day trips, family get togethers, or simply moments relaxing in the home or garden. We'll remember that time they caught a fish, that tree they used to climb, that pedal car we just couldn't get them out of. We'll smile at the memory of them with chocolate at over their face, or that peculiar grimace they made when they were sad. And then we'll turn to the photo album. Will those magic moments be there? Or will them just be a procession of posed mugshots and fake smiles at formal get togethers? With digital cameras there's no excuse to not always keep your camera with you and use it constantly. Set yourself the task of making a detailed visual record of the kid's lives that you (and they) will treasure when they're older. Remember, it costs nothing to take a picture, and you can always delete the bad ones later.

KEEP THEM ACTIVE

The best pictures of children usually show them engaged in some sort of activity, whether it be building a sand castle on the beach, riding their bikes in the park or painting and drawing.

Try to contrive situations that lend themselves to good photo opportunities. On rainy days art and crafts indoors can provide some great shots. Try to shoot in natural light if you can, as flash can be unflattering and lead to washed out skin tones and dark backgrounds. Digital cameras can shoot in quite low ambient light but check your LCD monitor to make sure, and if necessary try to raise the light level or increase the ISO rating slightly. Ironically flash often works best as a fill-in, when there is already lost of ambient light. If your camera offers fill-in flash, use it.

When the weather is fine take children outside, but stay close so they don't look like specks in the distance. Diffused light is best, but in high-contrast light (such as bright sun) use fill-in flash.

DOWN TO THEIR LEVEL

When photographing children try to avoid looking down at them from a standing position. Except in occasional circumstances, when it can add humour or pathos to a situation, it's generally much better to crouch or kneel so you're at their level. This gives the resulting images a sense of entering the child's world, rather than looking down on it from the outside. They'll probably crowd round the back of your camera afterwards, to see the shots on the LCD but that's part of the fun!

FILL THE FRAME

A common fault of inexperienced photographers is to think that when you're photographing someone you must get their entire body in shot, feet and all. This has the inevitible result of making the subjects faces (the most interesting part of the shot) smaller and their expressions more difficult to see

there are lots of occasions where you want to see the kids full length, especially if they're doing something (like climbing or cycling). For portrait shot however, try moving in closer, or zooming in, until your subject is cropped at the waist or ever the chest. With children, being small, this ofter means getting very close, but this will serve to increase the sense of being there. Another brefit to getting close is that you can exclude distracting background. If your camera has aperture control, set a wide f stop to further throw as much of the scene out of focus as possible. (You can also do this on the PC later but it takes longer and looks less natural).

DECISIVE MOMENTS

With children more than most subjects, capturing their expressions at precisely the right moment can make the difference between success and failure. Kids rarely stay still for long, and their expressions are constantly changing! Keep the camera ready and your eye on the subject.

Unfortunately one of the drawbacks of many digital cameras is their lack of urgency when you press the shutter. Some are faster than others, but with most models, even something simple like a running child can pose problems, as the subject may well have left the frame altogether before the picture actually takes.

The solution is to frame your subject, then press the shutter button halfway and hold it there. This locks the exposure and focus, so as long as light and distance remain much the same, you can keep your finger in this position till you're ready to shoot. At this point, the camera will fire almost instantaneously

THE POSED APPROACH

It's sometimes easier to pose your subjects than to catch great but fleeting candid moments, but there are way to make them more interesting than the cheesy mottled background shots they get at school. For the most relaxed results, photograph children in a familiar setting (such as at home) or while they're engaged in a favourite activity. Alternatively, get them to pose with a new toy or something they have made. This will give them something to interact with.

Get The Most
From This Book

This book is divided into two distinct sections. The first is an alphabetical journey through all of the major topics, genres and techniques of digital photography. Technical issues such as resolution and sensor types sit alongside subjects such as nature and sport photography.

The second part of the book is concerned with the key image-editing skills, using Adobe Photoshop. It shows how to tackle the most common problems, such as poor colour and contrast, cropping, red-eye and blemishes, before moving onto more ambitious projects, such as creating black-and-white images and fun montages.

the images

The photographs, diagrams and other illustrations have been carefully chosen to both illustrate the points made in the text and provide inspiration to try the techniques for yourself.

the text

Each topic is divided into columns, each of which explores one aspect of the subject under discussion.

before image

The starting point for our tutorial, this shows the image as it came out of the camera.

skill level

Some projects are more ambitious than others, and this provides an indication of the level of difficulty.

after image

What we ended up with at the end of the tutorial. Hopefully this will look better than the 'before' image!

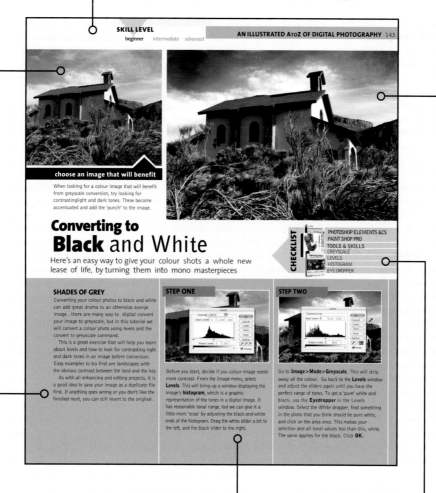

SKILL LEVEL

beginner intermediate advanced

AN ILLUSTRATED ATOZ OF DIGITAL PHOTOGRAPHY 143

choose an image that will benefit

When looking for a colour image that will benefit from greyscale conversion, try looking for contrasting light and dark tones. These become accentuated and add the 'punch' to the image.

Converting to **Black** and White

Here's an easy way to give your colour shots a whole new lease of life, by turning them into mono masterpieces

CHECKLIST

PHOTOSHOP ELEMENTS &CS
PAINT SHOP PRO
TOOLS & SKILLS
GREYSCALE
LEVELS
HISTOGRAM
EYE DROPPER

SHADES OF GREY

Converting your colour photos to black and white can add great drama to an otherwise average image . there are many way to digital convert your image to greyscale, but in this tutorial we will convert a colour photo using levels and the convert to greyscale command.

This is a great exercise that will help you learn about levels and how to look for contrasting light and dark tones in an image before conversion. Easy examples to try first are landscapes with the obvious contrast between the land and the key

As with all enhancing and editing projects, it is a good idea to save your image as a duplicate file first. If anything goes wrong or you don't like the finished reult, you can still revert to the original.

STEP ONE

Before you start, decide if you colour image needs more contrast. From the Image menu, select **Levels**. This will bring up a window displaying the image's **histogram**, which is a graphic representation of the tones in a digital image. It has reasonable tonal range, but we can give it a little more 'snap' by adjusting the black-and-white ends of the histogram. Drag the white slider a bit to the left, and the black slider to the right.

STEP TWO

Go to **Image>Mode>Greyscale**. This will strip away all the colour. Go back to the **Levels** window and adjust the sliders again until you have the perfect range of tones. To get a 'pure' white and black, use the **Eyedropper** in the Levels window. Select the White dropper, find something in the photo that you think should be pure white, and click on the area once. This makes your selection and all tonal values less than this, white. The same applies for the black. Click **OK**.

the text

Provides an introduction to the tutorial, explains the aims and objectives, and why you would wish to learn this skill.

the steps

How to perform the task set, in simple steps. Each step is illustrated, where relevant, by a screen shot showing what you will be seeing on screen at that point in the tutorial.

the checklist

A quick reference list of all the key skills, tools and techniques that you'll be learning in this particular tutorial.

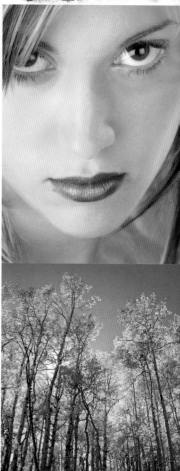

mode dial

Some cameras place their mode selector on a rotating dial. This may be on a ring around the shutter release, or on its own, as shown here. On simple cameras this may only be a choice of camera, movie and playback mode, while on more advanced cameras you may also have a choice of manual and automatic exposure modes, plus a selection of subject-based programs such as sport and landscape.

flash

Provides extra illumination when light levels drop too low for good results. Most cameras provide a choice of flash modes, in addition to the auto setting. These include red-eye reduction (which usually involves firing a pre-flash to close the pupils), flash on (fires the flash every time you take a picture – ideal for 'fill-in' flash shots in bright light), and flash off (for use in museums and places where flash isn't allowed). Most cameras also have a 'slow sync' mode, which combines flash with a slow shutter speed for action photography or to record some of the ambient atmosphere in a low-lit interior.

The power of a flash is expressed as a guide number in metres, usually at ISO 100. The higher the number, the more powerful the flash. Some more advanced cameras also feature a hotshoe for the addition of a more powerful external flashgun.

shutter release

Press this button to take a picture. The shutter release usually has a two-stage action. Pressing the button halfway activates the auto-focusing and metering, pressing all the way takes a picture. Holding the button at the halfway stage locks the focus and exposure so that when the decisive moment arrives a final push will take the shot almost instantaneously.

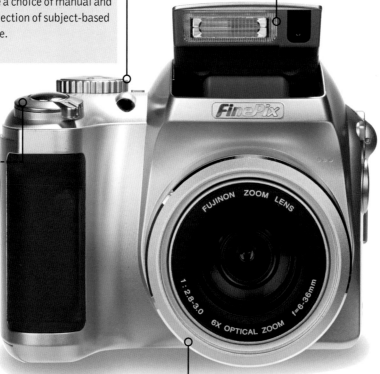

lenses and zoom

Lens focal lengths are usually described by their zoom magnification range (eg 2x, 3x) and by their 35mm equivalent focal length (eg 35–70mm). The actual focal lengths are different and relate to the physical dimensions of the sensor, which vary in size between the different cameras.

Most digital cameras offer an optical zoom range of at least 3x (ie the most telephoto position is three times the magnification of its most wide-angle position). These lenses will typically be in the 35–105mm (equivalent) range. Longer zoom ranges of up to 10x are, however, widely available and may be more suitable if you like to photograph wildlife or take candid shots of the kids from a distance. In addition, most cameras offer a digital zoom which magnifies the central portion of the shot. These lower the image quality so aren't recommended for regular use.

Tour of a
Digital Camera

Digital cameras can be intimidating to those unfamiliar with them, but they're simple really. Here's a quick guide to what's what.

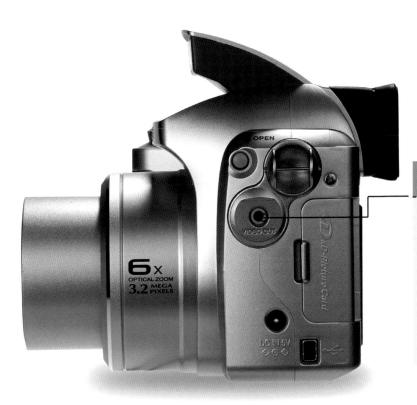

slots and ports

Most digital cameras provide a variety of terminals. The USB port enables the camera to be connected to a PC for downloading of images, using the supplied USB lead. The Video Out lets you connect the camera to a TV, where you can view a slide show. There is often a DC port for mains power connection and invariably a slot for whatever media cards the camera uses (in this case xD PictureCard).

viewfinder

The viewfinder provides direct viewing of the subject and an alternative to using the LCD monitor. Not all cameras have a viewfinder, but they do offer advantages; although you can also compose using the LCD, this is sometimes difficult to see in bright sunlight. The LCD monitor also consumes more battery power. As the viewfinder is to one side of the lens its view isn't quite the same as what the camera will record, and you usually get quite a bit more in your picture than you saw through the viewfinder to compensate. Some cameras have an electronic viewfinder, or EVF (like a camcorder) which overcomes this problem. EVFs do show the actual image you're recording and offer more visual shooting data, but being made up of pixels (like a tiny TV) they're not usually as clear and detailed as a traditional optical viewfinder. Like LCD screens, they also consume a lot more power.

LCD monitor

Invariably found on the back of the camera, LCD monitors come in various sizes, from about 25–63mm (1–2.5in) across (diagonally) and are sometimes hinged, allowing them to be tilted and/or turned for easier viewing.

The LCD monitor has three major functions: to display the menu options, to allow the user to view the subject as it will be recorded by the camera, and to play back images already taken. Many users compose their pictures using the monitor in preference to the viewfinder, as you do see (more or less) exactly what you're going to get. Better-quality monitors feature non-reflective glass and brightness controls so they can be viewed in bright sunlight (not the case with cheaper LCDs). They also boast more pixels (for finer detail) and a faster refresh rate, so the screen doesn't go blurred when you pan quickly with the camera.

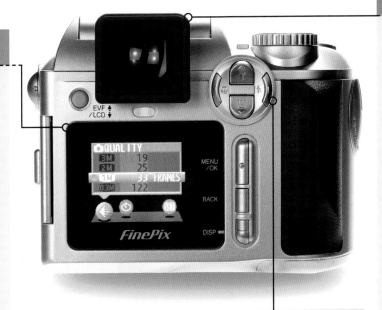

controls and buttons

Virtually all digital cameras feature a four-way rocker/controller, or toggle. This is the heart of the camera's interface, allowing the user to navigate through the menu options displayed on the LCD screen and, in camera mode, often doubling as flash, zoom, macro and other functions. On some cameras this controller is actually four separate buttons in a circle, placed north, south, east and west.

lens quality

The quality of the lens is vitally important – not just the range of the zoom but the quality of the glass used and the coating on their surfaces. How wide is the maximum aperture, and how well does it control image killers such as flare, distortion and chromatic aberrations? (See page 72 for more on lenses.)

sensors and megapixels

The first thing that people tend to ask about a digital camera is 'How many megapixels does it have?'

This question refers to the number of pixels present on the sensor that records the image (see sensors, page 114). A million pixels is equal to one megapixel (MP), and the more megapixels there are, the more detail that the sensor will record and the bigger the prints that can be made from the images.

Cameras of 2MPs or less are suitable only for casual snaps up to enprint size, and we'd recommend 3MP as a minimum for anyone who is even slightly discerning about image quality. A 3MP will produce great quality up to 6 x 4in and will still give reasonable A4 prints when occasion demands. For serious enthusiasts, 5MP is really the starting point.

However, it isn't just about the megapixels, there are other factors to take into account.

other factors

A bad car with a Ferrari engine is still a bad car, albeit a faster one. If the rest of the car is not up to scratch, the result will be a failure. With digital cameras, the success of the whole is dependent on all the various parts doing their job properly. What of the build quality of the camera itself? Is it sturdy and robust, can it take a knock or two (it's bound to happen)? Is it fast enough in operation? Does it have all the features you need? Can you add accessories such as flashguns?

processor

You wouldn't buy a car based purely on the size of the engine, or assume that a car with a 1.8 engine is necessarily better than one with a 1.6. The same is true of cameras.

While the number of pixels on the sensor is important, it's what the camera does with those pixels that determines the quality of a camera. That's where the processor comes in. The processor turns the raw electrical data produced by the sensor into a proper photograph, so its role is central to the image-making process. The colour, contrast, sharpness, detail, tonal range and other pictorial qualities are dependent on the processor doing a good job – and doing it quickly, because long delays before taking a picture or between shots are very frustrating.

Most of the major manufacturers have developed high-quality processing engines to extract the very best from their sensors.

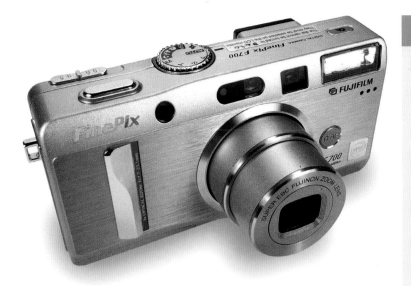

compact cameras

There are three main types of digital camera. Each has its own benefits and advantages, as well as drawbacks.

The most popular type of camera is the compact. The main audience for compacts is mass-market consumers who see cameras as straightforward memory-recording devices – for holidays, birthdays, family occasions etc.

Some compacts also appeal to style-conscious trendsetters, especially the slimline silver metal bodied models pioneered by the Canon Ixus. For this group, size and looks are the most important qualities.

The design ethos of compact cameras is to be as small and simple to use as possible, and not overburdened with features, so infrequent users won't have to revisit the instruction manual every time they get the camera out.

Some enthusiasts and even professionals also buy compacts to use alongside their SLRs.

prosumer cameras

It's a horrible word, prosumer – an unholy marriage of the words 'professional' and 'consumer' – but it does actually describe these cameras much better than the other term, 'bridge' cameras. Prosumer cameras are a halfway house between compacts and SLRs. Some are like souped-up compacts, featuring all the bells and whistles (exposure, metering, focusing modes etc) of an SLR in a much more slimline package.

Others look more like slightly miniaturised versions of SLRs, but with fixed lenses. One common feature these cameras often share is a big zoom, anywhere from 7x to 10x or even bigger. They also offer high-end features such as RAW format shooting, 2 or 3 frame per second shooting, even a choice of colour spaces. At the top end they're not actually much cheaper than an SLR, but they do offer a more convenient package.

SLR cameras

Single lens reflex cameras have long been the choice of serious amateur and many professional photographers for decades. They offer the best combination of quality, features, handling and versatility.

SLRs provide a big, bright, through-the-lens view of the subject, enabling full control of focus, depth of field and composition. You can fit any of hundreds of fixed focal length, zoom and specialised lenses tailored to whatever you're photographing.

Accessories such as flashguns, battery packs, drives and remote triggers can enhance your picture-taking opportunities still further. Internally, SLRs offer an unequalled level of control – a huge range of shutter speeds, ISO settings, exposure, metering and other modes – in fact, every aspect of the process.

They may be much bigger than compacts, but there's nothing you can't do with SLRs.

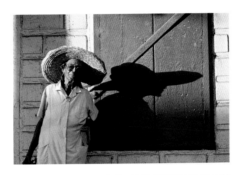

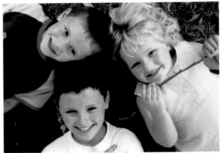

AN ILLUSTRATED

A to Z
OF
DIGITAL PHOTOGRAPHY

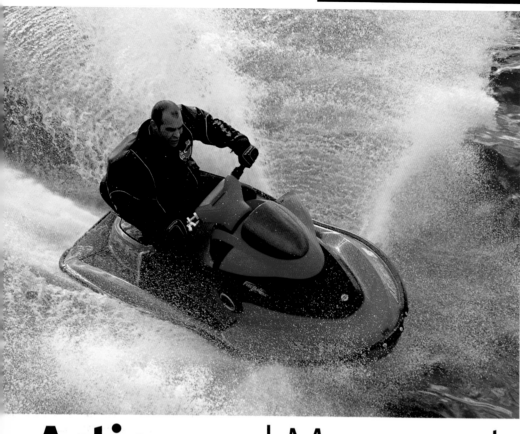

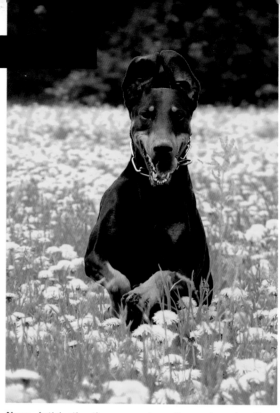

Above: Anticipating the movement can allow you to capture the unusual. This dog is positioned best at the height of the jump.

Left: Long telephoto lenses enable you to crop tightly on the action.

Action and Movement

Running, jumping, laughing, crying – if you want to capture fleeting moments in time, you'll need to be prepared.

CHECKLIST

- LONG LENS FOR TIGHT FRAMING
- WIDE APERTURE FOR DRAMA
- SMALLER ONE FOR UNPREDICTABLE SUBJECTS
- SET PROGRAM OR AUTO FOR GRAB SHOTS
- PAN THE CAMERA WITH MOVING SUBJECTS
- ANTICIPATE THE MOMENT
- TAKE LOTS OF SHOTS TO ENSURE SUCCESS

ANTICIPATING THE MOMENT

Moving subjects are difficult to photograph at the best of times, but some cameras make it easier than others. The ideal camera is an SLR, but with a little practice even budget compacts can produce great action shots.

The biggest factor determining the success of an action shot is the ability of the photographer to anticipate the moment and to be able to predict what will happen in the next couple of minutes. Armed with this knowledge, the next task is to be totally prepared, with camera settings chosen and finger on the shutter button.

Some cameras experience a delay of up to a second before firing. With these cameras it's a good idea to lock onto your subject by pressing the shutter halfway down and then keeping it there. This will preset the focus and exposure on whatever you're pointing the camera at, so that when you're ready to shoot the camera will fire almost instantly.

APERTURE

An understanding of the exposure settings can make a big difference to how your action shots look . The aperture determines how much of the scene is in focus. A small aperture provides sharp focus from foreground to background. This can be distracting, but can also be useful when shooting unpredictable subjects such as children playing in a park . A wider aperture isolates your subject, but you need to be much more precise with focusing to get a sharp subject – not always easy with a moving subject.

SHUTTER SPEED

There are two kinds of action shot: those where a fast-moving subject is 'frozen' in time (such as a child in mid-leap) and those where the subject (or background) is blurred due to its movement across the frame. Both kinds have their merits, depending on the subject. Freezing movement is achieved by setting a high shutter speed (at least 1/250sec). It's best to set your camera to shutter priority or manual exposure mode for this, or use the action mode. This technique is ideal for people or animals, where the subject can be captured in mid-air, or with legs outstretched, indicating its movement.

The other method is to select a slow speed (less than 1/60sec, depending on the speed of the subject) and, holding the camera still (a tripod is useful), press the shutter as the subject crosses the frame, allowing it to create a blur of movement as it does so. This is ideal for subjects such as cars and other forms of transport.

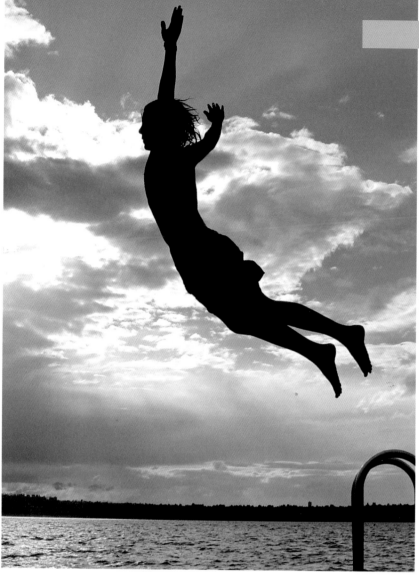

Left: Flash can be used to freeze fast action, especially in low light or contre-jour.

Below: Wherever possible, being close to your action subject lends a greater sense of drama.

long telephoto lens

A long telephoto or zoom lens makes action photography easier, as subjects appear to move more slowly when they are further away. You can, however, shoot action without one – you'll just have to get closer and react more quickly, as this image shows. For more on telephoto lenses, turn to page 124.

PANNING

So what's the point in deliberately blurring a subject? Surely sharp pictures are better? Well with some subjects, such as a travelling bus, a degree of blur is the only way to indicate that the subject was moving, rather than simply parked. But if you don't want the subject to look blurred there is an alternative, which works well with subjects travelling across the frame – panning.

With panning you select the same slow shutter speed but you follow the subject's movement with the camera, keeping it in roughly the same part of the monitor or viewfinder. When you're ready to shoot, press the shutter but keep turning the camera. The result will be a sharply recorded subject and a horizontally streaked background. This has the advantage of not only conveying the movement but also reducing any distracting elements in the background. A tripod or monopod is useful for this technique, making it easier to move the camera in just the plane of motion.

USING FLASH

A highly effective way to enhance a panned photograph is to add a burst of fill-in flash to the mix. Using flash at slow shutter speeds is called 'slow-sync flash' , and it's done in the same way as straight panning but with a flash attached, or with the camera set to its slow-sync flash mode. When you press the shutter the long speed records the background as a blur and the flash 'freezes' the subject, making it stand out more. If you choose not to pan, your subject can be recorded as both blurred (the ambient exposure) and sharp (the flash), which can also look great.

Some cameras and flashguns offer a second (or 'rear') curtain sync option, which fires the flash at the end of the exposure, rather than the beginning. This is better for action shots since the sharp image precedes, rather than follows, the blur, creating a more natural look.

Obviously these techniques only work when your subject is within the flash range.

ZOOM BURST

Panning works well with subjects moving across the frame, but not subjects travelling towards the camera. There is a technique for this too, although it can only be done with cameras that have a manually operated zoom, not a motorised one. As with panning, a slow shutter speed should be set. Release the shutter while the subject is still some distance away, and simultaneously zoom in while the shutter is open. As with panning, a tripod is recommended. Zoom bursts can also be simulated on a PC using the Radial Blur filter.

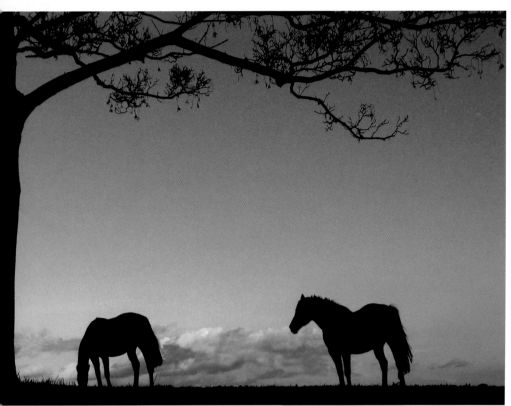

Left: These horses were photographed as a silhouette, using a telephoto lens. (For more on silhouettes, see page 117.)

Above: Dogs are often a willing and photogenic subject for the camera, and relatively easy for coaxing good expressions.

Animals and Pets

The best way to guarantee 'ooohs and aaahs' over your photos is to photograph animals, but great shots don't come easily.

CHECKLIST

OPERATE ON THEIR TERMS
KNOW THE SUBJECT'S PERSONALITY
AVOID DIRECT FLASH
BE PATIENT
KEEP SESSIONS SHORT
USE A GOOD TELEPHOTO LENS
TAKE AS MANY SHOTS AS YOU CAN

PET SUBJECTS

Animals are among the most popular subjects for photography, but among the most difficult to do well – they just won't pose on demand! But if you're prepared to operate on their terms, and to be ready for the right moment, your patience will be rewarded.

Domestic animals are probably the easiest, as they are all around us, but great shots are still the exception rather than the rule. Some animals are easier than others. Dogs are more responsive to direction than cats; rabbits don't tend to move much; caged birds, rodents and other small creatures may be more cooperative on someone's hand. It helps to know the subject's personality.

Wild animals require a little more effort. Local farms are a great source of subjects, or for more exotic fare the zoo is the place to go. Alternatively, you may find your own garden or local park a rich source of material, with birds, squirrels, foxes and perhaps even badgers.

POSED PETS

Anyone who has ever tried to shoot a posed portrait of their dog or cat knows it can be a frustrating experience, but very rewarding. If you're shooting indoors, you need plenty of light, especially if the subject has dark fur, as this absorbs a lot of light and could underexpose. Choose a brightly lit spot or use bounced flash. Cats and dogs have highly reflective eyes, so avoid direct flash.

With very dark or light fur there's also a risk of under- or overexposure, if your camera's meter is unduly influenced by the fur. Do a test shot and check the LCD, then use exposure compensation as necessary.

Be patient and be prepared to shoot a lot of pictures to get the right one. Use a toy or treat to attract the animal's attention and direct the gaze to where you want it. Keep the session short (20 minutes maximum), as they'll only indulge your odd behaviour for a limited period of time!

CANDID PETS

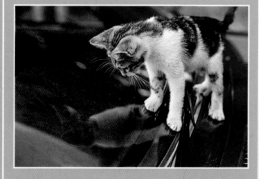

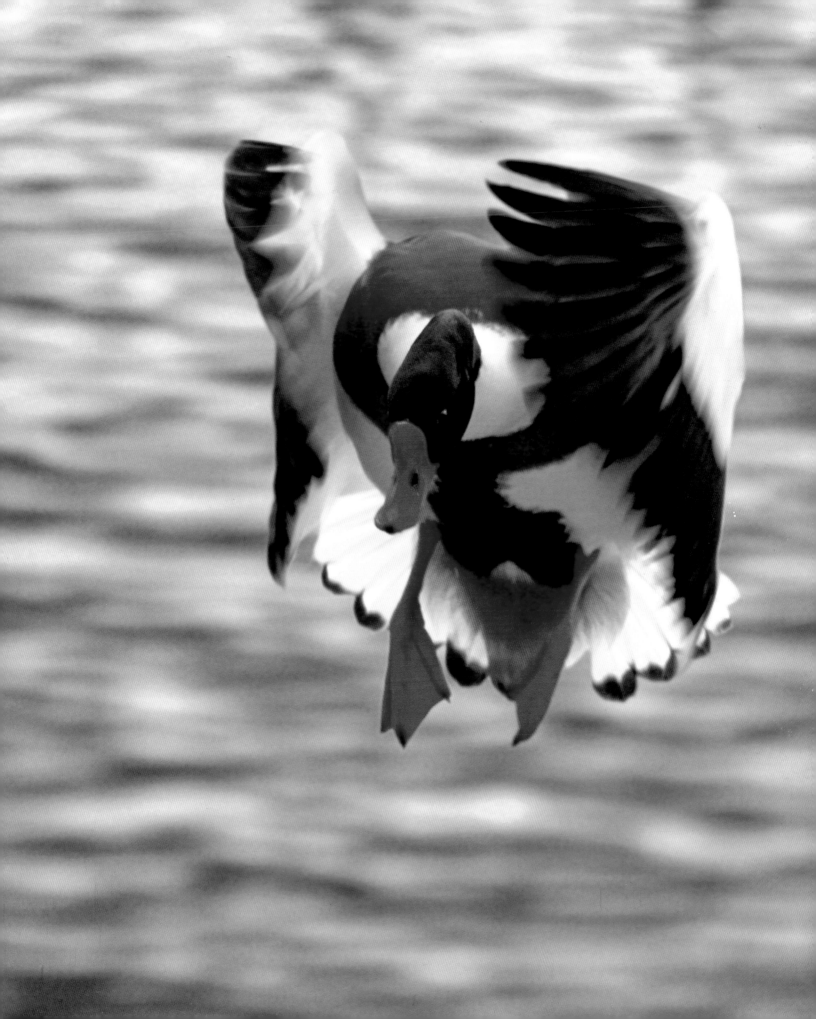

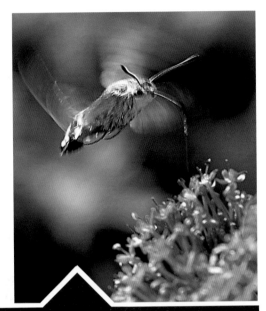

insects and bugs too!

Don't forget the smallest members of the animal kingdom. Insects and other bugs can make great subjects if you have the right equipment. (For more on macro, see page 76.)

Above:
With a macro lens you can shoot amazing close-ups such as this.

Right:
This fox was photographed at a local wildlife park.

IN THE WILD

There's a surprising amount of photogenic wildlife on your doorstep. Domestic gardens can be a hive of activity and you can photograph your visitors from the comfort of your house if you have a decent zoom and a clean window. If not, you can set the camera up in the garden on a tripod and trigger it remotely at the right moment. You need to coax your subjects to where you can shoot them by leaving food for them or planting shrubs that will attract them.

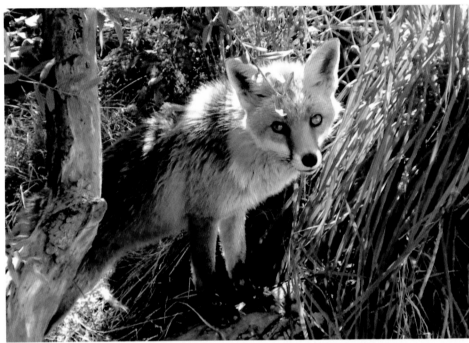

ON THE FARM

As a cursory look at the children's section of any bookshop will confirm, farm animals have always been close to our hearts. Fortunately, few of us live far from a farm – even the biggest cities have city farms, and there are lots of farm parks open to the public.

One of the most effective ways to photograph farm animals is to go in close for individual portraits. Look for the cutest characters, the ones with that extra 'aahh' factor. Zoom in tightly and try to make eye contact with the subject. Some subjects, such as pigs, have a naturally amusing appearance that can be exaggerated by going in as close as is safely possible using a wide-angle lens.

Another approach is to capture the animals within their landscape – cows grazing etc. This often works best early in the morning or at dusk, when the light is at its best.

AT THE ZOO

'Lions and tigers and bears' – if, like Dorothy and the Tin Man, you have the more exotic wild animals in mind but don't have the time or budget to go to Africa or Asia to see them, the nearest safari park or zoo will have to suffice.

The trick with photographing in these places is not to make it look as though the animals are in captivity. This isn't always easy with the small enclosures, unnatural environment and crowds that zoos often provide, but it can be done.

You'll need a good telephoto lens set to a wide aperture. The aim is to go for tightly framed headshots with shallow depth of field, to throw any incongruous background detail out of focus. If shooting through bars or mesh, get as close as is safely possible. With luck the obstruction will be so blurred that it won't register. Patience is the name of the game, once you've found the best angle from which to shoot.

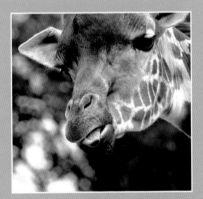

depth of field

The choice of aperture also has a huge effect on how the picture looks. Wide apertures produce a shallow zone of focus (left picture) in front of and behind the point focused upon, while small apertures ensure everything is sharp from the foreground to the background (right picture). This zone of focus is called depth of field. Some subjects lend themselves to a shallow depth of field, and others to a deep one, and the aperture control is the means to control this. (For more on depth of field, see page 43.)

Aperture

Along with the shutter speed, the aperture is one of the two most important factors in determining exposure.

THE 'F' IN EXPOSURE

The aperture is the adjustable hole in the lens which controls the amount of light that is allowed to fall on the sensor. Its diameter is described in f-stops, a series of numbers that is based on scientific measurements.

The precise range of apertures varies between cameras, but a typical digital camera's f-stop range may be f/2; f/2.8; f/4; f/5.6; f/8; f/11; f/16. Smaller numbers indicate a wide aperture, while high numbers describe a narrow opening. Each number step represents a halving (going up the scale) or doubling (going down) of the amount of light passing through. The wider the maximum aperture, the better able the camera is to shoot in low light without the need for flash.

Apertures used to be adjusted using a ring around the lens throat marked with the f-stops, but now they are controlled electronically, either automatically or using an input dial on the camera itself.

APERTURE CONTROL

Digital sensors, as with film, require just the right amount of light in order to produce a correctly exposed image. The camera automatically adjusts the light level reaching the sensor by choosing the right combination of aperture (intensity of light) and shutter speed (duration of exposure), but on many cameras it is possible to override the automatic settings. For example, if you decide you'd like to use a wider aperture, that's OK as long as you also reduce the shutter speed, to compensate for the fact that you're now letting more light in through the hole, and vice versa.

So why would you want to override the f-stop chosen by the camera? The main reason is that the camera does not always get the exposure right. Sometimes it can be fooled into producing a shot that's too dark or light. The aperture control can be used to adjust it. (For more on exposure, see page 48.)

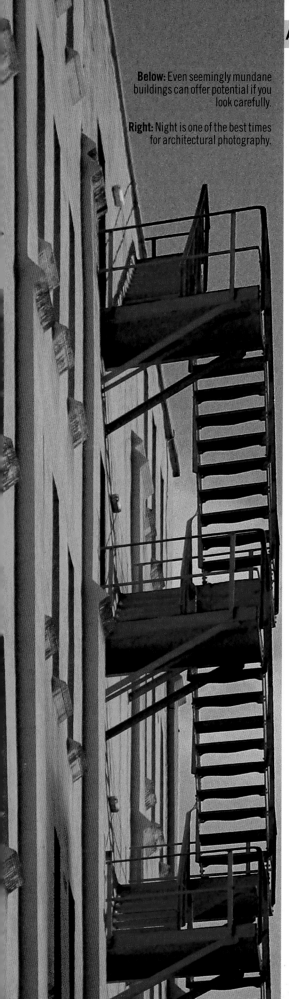

Below: Even seemingly mundane buildings can offer potential if you look carefully.

Right: Night is one of the best times for architectural photography.

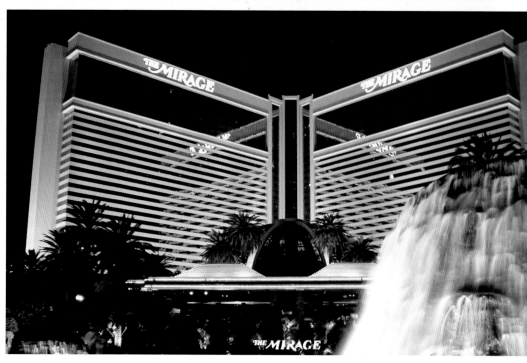

Architecture

The built environment provides plenty of opportunities for great photographs, as long as you follow a few simple rules.

CHECKLIST

- CHOOSE THE BEST VIEWPOINT
- TAKE A WIDE-ANGLE LENS (YOU'LL NEED IT)
- TRY USING A TRIPOD
- LOOK FOR DETAILS
- WAIT FOR THE BEST LIGHT
- DON'T FORGET THE INTERIORS
- TRY TO KEEP THE VERTICALS STRAIGHT

SUBJECTS ARE EVERYWHERE

Architecture represents man's greatest form of self expression. Buildings are the biggest and most permanent memorials to human endeavour and creativity – they can arouse passion, joy, sadness and anger, they can stir the senses and move the soul. No wonder they make such great subjects. Architecture encompasses everything from the pyramids to the Guggenheim Museum – old cathedrals, modern office blocks, ruined castles, skyscrapers under construction.

Many people photograph buildings in their entirety, but in many cases some of the most interesting images are abstract or detail shots of selected parts. Don't forget that pictures of a building shown in the context of its environment can be more powerful than just the building on its own: think of St Paul's Cathedral on the London skyline, or New York's Chrysler Building set amid Manhattan's skyscrapers.

VIEWPOINT

One of the most difficult tasks for architectural photographers is selecting a viewpoint. This is easier with rural buildings, but unobscured views of urban subjects can be hard to find.

Once you have isolated your chosen subject the next problem is that of converging verticals, especially with tall buildings. This is where the sides of a building lean inwards, making it look as though it is falling over backwards. This is caused by having to tilt the camera upwards to get the top of it in the shot. Levelling the camera would chop the top off the building, and stepping back further isn't always possible.

The solution is to find a higher viewpoint from where to shoot, such as an adjacent building or bridge. Ideally this should be at half the height of the building you're shooting, otherwise you'll get the opposite effect – the building will appear narrower at the bottom.

>>

Above: Shooting tall buildings from far away can help to keep the verticals straight.

Left: Don't just focus on one building - look how they work together as a group, with shapes and colours.

TIME OF DAY

Unlike people, buildings rarely look at their best with the light behind them (Stonehenge and other iconic silhouettes excepted). So with architectural photography it's useful to either have a compass or at least be aware of the direction in which buildings are facing. A west-facing façade, for example, will look a lot better at the end of the day, bathed in warm sunlight, than at the beginning. Conversely, buildings exposing their best bits to the east beg for a morning visit.

If you're setting out to photograph specific landmarks, it may be useful to consult a map first (you can usually find maps on the Web).

Although it's good to plan there is great pleasure too in wandering the streets with a camera and an open mind. Accept, however, that you'll be restricted to certain viewpoints, and if you want to photograph the unlit side of a building, you'll have to either live with flat illumination or return another time.

inside and out

Don't forget that great architectural design can be found inside as well as outside. Lobbies are usually the best place to capture interesting shots. They have been designed to give maximum interior impact for visitors, and can well be the best area inside the building. Just be prepared to get past any doormen first! (For more on interiors, see page 66.)

EXPLORE THE ANGLES

With many buildings, one viewpoint will be more interesting than the others. This will often be the front – especially with subjects like ornate Gothic cathedrals. But it pays to walk all the way around the building to photograph it from different angles. Often there may be interesting detail shots to be had, or the light quality may be better from another angle, or perhaps there's an interesting juxtaposition with another nearby building, person or other element.

CITY LIGHTS

Often, buildings look at their best not in the morning or afternoon but at dusk, when the sun goes down and the lights come on. This tends to apply more to urban buildings than rural ones, but not necessarily.

With modern office buildings the illumination often comes from the internal lighting. This may well be fluorescent strip lighting, so it's worth experimenting with your camera's white balance settings to find the best one for the subject.

Don't wait for it to get completely dark before shooting. The best time to shoot is when there is still some colour in the sky, when there's enough ambient light to fill in the gaps between the lit parts of the building.

After shooting, check your LCD monitor to ensure that the exposure is correct and that the meter was not unduly influenced by the lights. (For more on night photography, see page 88.)

EXPLORE THE OPTIONS

Don't forget those small details that reveal so much of a building's character. That interesting gargoyle on the side of a church, that ornate window, can make a better picture than the whole building. Experiment with different focal length lenses (wide-angle and long telephoto), and try tilting the camera at unusual angles to add a sense of drama and dynamism.

Just to contradict the advice on keeping the sides level, some buildings look good when shot with exaggerated, distorted perspective.

AUTO

PORTRAIT

LANDSCAPE

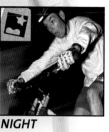
NIGHT

FAST SPEED

SLOW SPEED

STITCH ASSIST

MOVIE

MANUAL

SCENE/SUBJECT MODES

Most digital cameras also offer a selection of scene or subject modes – preset programs designed for specific subjects, indicated by icons or pictograms. Portrait mode, for example, may select a shallow depth of field, perhaps a softer sharpening algorithm. Sport mode would set a faster shutter speed and continuous drive and AF. Other popular subject modes include landscape, night shots and macro, while some cameras provide such specialised modes as beach/snow, sunset, candlelight and fireworks.

manual mode

For complete control over every aspect of the process, use the manual mode. This lets the user set everything by hand. One benefit of manual is consistent exposure – ideal when identically exposed shots are needed (such as batch shooting or making panoramas), or for unusual subjects or techniques.

Auto Modes

Digital cameras offer a bewildering variety of exposure modes to ensure that you get perfect results every time.

FULL AUTO AND PROGRAM

Most consumer digital cameras offer both Auto and Program modes, and there is some confusion between them. Auto mode is usually picked out in green on the dial (where there is a dial). In this mode the camera takes care of everything: the shutter speed, aperture, ISO rating, whether or not flash is needed, and so forth. The user has no control and is forbidden by the camera from interfering with its intentions. It's an ideal mode for users new to photography.

In Program mode the camera still takes care of both the aperture and shutter speed, so no human input is needed, but users can override the camera if they think they know better. They can switch the flash on or off, apply exposure compensation, change the ISO etc. Program Shift, found on some models, lets users shift the chosen exposure combination up and down the scale if they fancy, say, a smaller aperture or faster speed than those chosen by the camera. The value stays the same.

PRIORITY MODES

APERTURE (A/AV) SHUTTER (S/TV) PROGRAM (P)

The priority modes are the camera's attempt to do everything itself and the user's desire to have some creative input. It's effectively saying, 'OK, you control the aperture and I'll set the shutter speed' or vice versa. This is an amicable arrangement which allows users to determine how they want the shot to look without having to take light readings and do the whole exposure thing manually.

In Aperture priority the user gets to chose the desired f-stop, and is an ideal mode when depth of field considerations are important and the user wants to control them. Once an aperture is chosen, the camera sets the corresponding speed that will produce the optimum exposure.

Shutter priority is best for action or other times when the choice of shutter speed is of primary concern. Again, the camera sets the aperture. In both modes the photographer has full access to the various overrides and shooting preferences.

Left: Sometimes the background is just as important as your foreground. Careful positioning will ensure the best results.
Below: Throwing the background out of focus with a wide aperture and long focal length lens is often the best approach.
Bottom: You can make your own background from almost anything.

Background Choice

Getting a good pose and expression from your subject is very important, but don't forget about what's behind.

CHECKLIST

- BACKGROUNDS ARE IMPORTANT TO THE PICTURE
- CHOICE OF VIEWPOINT INFLUENCES THE BACKGROUND
- USE A WIDE APERTURE TO BLUR THE BACKGROUND
- USE A SMALL APERTURE FOR BACKGROUND SCENERY
- MAKE YOUR OWN BACKGROUNDS
- BUY READY-MADE BACKGROUNDS
- IMPROVE BACKGROUNDS IN PHOTOSHOP

BACKGROUND INFORMATION

A common mistake of casual photographers is to be so focused upon the subject that no attention is paid to what is behind them. That's when you get the classic 'telegraph pole growing out of the head' scenario.

With people especially (but with other subjects, too), the choice of background plays an important role in the success, or otherwise, of the image, so don't forget to pay some attention to it.

CHOOSING BACKGROUNDS

For most subjects, especially portraits, a plain, uncluttered background will almost always be preferable to a busy, messy one, because with the latter, viewers' attention will be distracted. Move either the subject or your shooting position (take a few steps to the left or right, or try a higher or lower viewpoint) until you're satisfied with the inoffensiveness of the background.

EMPHASISING BACKGROUNDS

The exception is when you're shooting someone in front of a landmark, and want to show it off as much as possible. Don't stand them right in front of, say, a cathedral, because to get the whole building in shot your subject will be tiny. Move away from the building so it shrinks in the frame, get close to the person so they're a decent size, place them to one side of the shot and pick a small f-stop to get everything in focus.

IMPROVING BACKGROUNDS

Sometimes you're stuck with a less than ideal background. Perhaps you're unable to move your subject, or your own position. What can you do? One solution is to use as long a focal length lens as you can and select a wide aperture to throw your background out of focus . Another is to crop in tightly on the main subject later, either in the camera or on your PC.

BUYING BACKGROUNDS

For some subjects, such as portraits, still lifes and other genres which are often tackled in a home studio, it may be desirable to buy a custom background. There are hundreds to choose from: long rolls of thick paper in every colour, plain or textured fabrics, mottled canvas backdrops so beloved of commercial studios, even painted rustic scenes. However, many of these are quite expensive for casual or amateur use.

MAKING BACKGROUNDS

A cheaper alternative is to make backgrounds out of things that weren't intended for this purpose. For large subjects such as portraits, bed sheets work well, as do large rugs or pieces of carpet. For tabletop subjects try weathered wood, ceramic tiles, piles of pebbles or sand, sheets of metal or plastic from DIY shops, or craft paper from art shops. Almost anything can be used.

Album software can be useful in helping you archive your work, saving and organising indexed thumbnails of all your images and telling you where to find the hi-res version. Some even tell you when you have enough new images to burn a new CD, so you don't forget. (For more on organisation, see page 92.)

Backup Devices

Archiving your precious images should be an essential part of your photographic routine.

WHY BACK UP?

If your house caught fire and you could only save one of your possessions, what would it be? Well, if you're like most people in the surveys, it would be your photo album. It's a cliché, but it's probably true. Our photos are an irreplaceable record of our lives, and those of our family. Even hobbyists pursuing pictorial photography may have spent years, and hours of labour, producing beautiful portfolio images. To lose any of our photos in this way would be devastating. In digital photography most of our images are now no longer in albums but stored on the PC. Not only is this much heavier to carry out of the house in a fire or flood (which DO happen), but computers present the risk of a far more likely catastrophe: hard disk failure.

There's an entire industry of people whose job is repairing computers, which go wrong all the time; yours probably will too, one day. The question is, what will you do when it happens to you, and everything on your hard disk is lost forever?

AT HOME

The obvious answer is to make a permanent copy of all your digital image files, so that if anything does happen to your PC or your home, your precious memories can be saved.

There are several ways to do this. Separate external hand drives, which attach to your PC, are small, portable and can store over 80GB of images (depending on the model).

But these can fail too, so by far the best method of archiving is to burn your images onto a CD. Once copied in this way, the images are fairly safe. Most modern PCs come with a built-in CD writer, or even a DVD writer, which offers much higher storage capacities. If you don't have one, they're a relatively small investment for the insurance they provide.

Of course, CDs can be damaged, too. They're easily scratched or corrupted, so make two copies of your files, ideally keeping one in a different place in case of fire or flood.

OUT AND ABOUT

Going on holiday or an extended trip away from home can pose its own set of problems. Unless you have a whole handful of memory cards (which would cost you a fortune), you run the very real risk of running out of space to store all the images you'll be taking.

Memory cards aren't ideal as a form of filing anyway. A good solution is to buy a portable hard drive. Once you've filled your card simply take it out of the camera, slip it into the card slot in the hard drive and copy the contents, clearing the card for reuse.

Some of the better hard drives feature a built-in colour LCD screen so you can review what you've taken later, and perhaps edit as you go along.

An alternative solution that's growing in popularity is the portable CD writer, which you can take with you and burn CDs as you go. This is instant archiving at source, but as yet no models feature any kind of playback option.

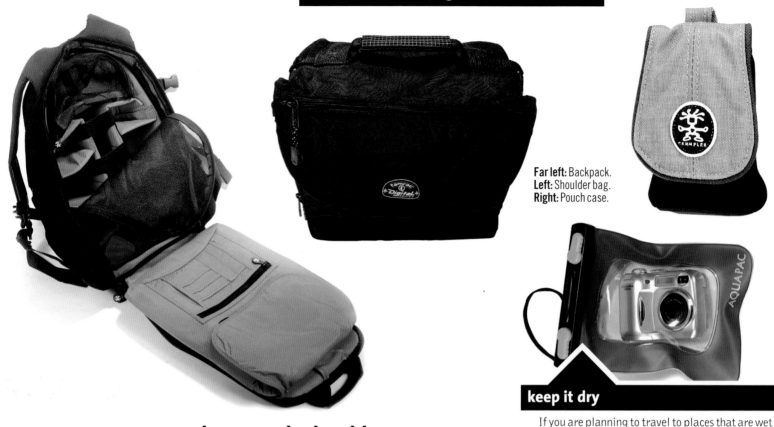

Far left: Backpack.
Left: Shoulder bag.
Right: Pouch case.

keep it dry

If you are planning to travel to places that are wet or sandy, it is advisable to carry your equipment in a sealed waterproof bag. (For more on travel photography, see page 125.)

Bags and Holdalls

If you want to keep your camera in pristine condition, you'll need something protective to keep it in.

WHY YOU NEED ONE

Years ago, when you bought a camera it came with its own custom case. Sadly, it's rare to get any kind of case nowadays, so if you want one you'll have to buy one.

It's tempting to perhaps save your money and just stick the camera in your pocket, but this would be a false economy. Digital cameras are expensive, and cases offer protection not only against knocks and scratches, but dust, moisture, rain and even extreme cold.

At their most basic, cases only have enough room for the camera, but it's worth spending a bit more for one with an extra pocket for spare cards and batteries. Resist the urge to buy one that holds all your paraphernalia too – charger, power lead, USB cable, video cable etc – as it will be a burden to carry around (although such cases are fine if used for storage and transportation purposes).

If you're an SLR user, however, you'll need one big enough for all your lenses and accessories.

OPTIONS FOR SMALL KITS

Pouch/case: This is ideal for those who like to travel light. It can either hang around your neck or off a shoulder, on a strap, or be attached to your belt. (The latter option is more secure from a theft point of view.) Get one with at least one spare pocket for batteries and cards.

Zoomster: This is basically a pouch with a longer snout for a big zoom lens. The camera must usually be removed for shooting, though one or two let you shoot with the case still on.

Small bag: Ideal for two lens SLR kits and larger prosumer models. Compact owners can keep all their bits (chargers, leads etc) together in one at home, and use a smaller case when out shooting.

Bumbag: Also called a waistpack, this small bag clips around the waist on a belt and, although designed for travellers to carry a wallet and passport, is a secure, theft-resistant, hands-free method of carrying a small camera, although it won't win you any awards in the style stakes.

FOR BIGGER SYSTEMS

Shoulder bag: The most popular choice of pros and enthusiasts, this comes in hundreds of sizes, shapes, designs, colours and materials. Some offer features such as foldaway rain covers, grab handles, detachable side pockets, customisable interiors and so on. They can be quite big and heavy but can hold even the biggest SLR system and loads of extras in all those hidden pockets.

Backpack: Your chiropractor would recommend one of these. They offer the space and variety of a shoulder bag, but distribute the weight more evenly. Ideal for walkers, though the gear isn't as accessible when needed in a hurry.

Hard case: Offers maximum protection and you can even stand on one to shoot over crowds etc, but is uncomfortable to carry and must be put down to open. Silver ones also attract thieves.

Photojournalist's vest: This spreads the weight and lets you get to a lot of gear quickly – if you don't mind looking like a war correspondent.

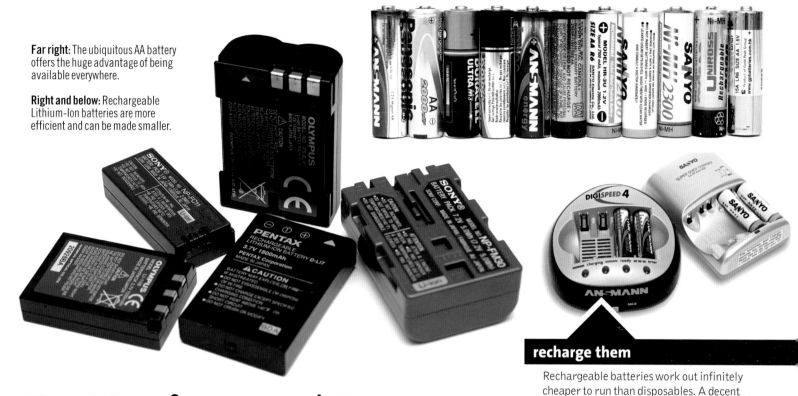

Far right: The ubiquitous AA battery offers the huge advantage of being available everywhere.

Right and below: Rechargeable Lithium-Ion batteries are more efficient and can be made smaller.

recharge them

Rechargeable batteries work out infinitely cheaper to run than disposables. A decent smart charger will ensure they're kept in the best condition to maximise their lifespan.

Batteries and Power

There's one thing no digital camera can live without, and it causes more headaches than almost anything else.

BATTERY FACTS

Many 35mm cameras don't need batteries to work – disposable cameras, for example (the non-flash varieties). But digital cameras are totally dependent on them. Most use either AAs or Lithium-Ion cells. Whichever kind your camera uses, there are some tips that you should follow to keep your photography as stress-free as possible.

Firstly, digital cameras are high drain devices so keep a spare set with you at all times so you can always keep shooting. Ideally you should have three sets: one in the camera, a spare set in the bag and a third set on charge at home.

To minimise the battery consumption, especially when in remote areas, keep the LCD screen off as much as possible and don't zoom back and forth needlessly. In the set-up menu, set the camera to power-saver mode, which switches the camera off after a predetermined period of inactivity. Finally, if you use AAs, don't leave them in the camera when not being used, in case they should leak.

AA BATTERIES

If there's such a thing as a universal battery, the AA is it. You can buy AAs in any corner shop, which is one huge advantage for cameras that use them. The drawback is that, at the rate your camera goes through them, alkalines can work out expensive in the long run.

But there is a solution. Invest in a decent set of rechargeable AAs and a high-quality trickle charger. Nickel metal hydride (NiMH) cells are the best because they offer higher performance and are less pernickety about charging than the cheaper NiCads (which must be fully discharged before recharging). In the long run you'll get many more charges out of them. On the minus side they don't retain their charge as well as NiCads, so you'll have to recharge them more frequently between uses.

Some cameras take single-use lithium batteries, which offer better performance than alkalines but are expensive and are best used in emergencies when there's nothing else.

LITHIUM-ION BATTERIES

Many manufacturers are now making cameras that only accept their own unique rechargeable Lithium-Ion (Li-Ion) batteries. These can be made to virtually any shape and size (and indeed are) so they're appealing to camera designers trying to come up with ever smaller models.

Li-Ion batteries do offer some advantages over AAs. For their size and weight they offer higher capacities, better performance and longer life. But there's a major drawback: if you're out shooting and run out of power you can't just pop into the nearest shop and buy another one, because it's unique to your make (and probably model) of camera. So it's essential to buy at least one spare if you don't want to get caught out, but they're very expensive – at least ten times the cost of a pack of AA alkalines. The total reliance on these cells and the need to charge them before a shoot does take some of the spontaneity out of your photography.

Left: Black and white adds a timeless quality to an image.
Above: Landscapes can look more dramatic in mono.
Right: It can also be flattering for skin tones in portraiture.

Black and White

Despite the advances and improvements in colour photography, good old black and white will never go away.

CHECKLIST

- LEARN TO SEE IN 'TONES'
- PICK GRAPHIC SUBJECTS
- SHOOT PATTERN AND TEXTURE
- EMPHASISE LIGHT WITH BLACK AND WHITE
- USE THE MONO MODE TO PREVIEW
- SHOOT IN COLOUR, CONVERT LATER
- THE IMAGE IS JUST A STARTING POINT

WHY BLACK AND WHITE?

Some of the greatest photographs of all time were shot in black and white. Many were taken in the early days of the medium, when that's all there was. How those early pioneers would have loved the amazingly saturated colour films that we have today, so they'd be very perplexed to know that people still choose to shoot in black and white.

The reason is that black-and-white (or 'mono') photographs have a power and impact that colour often struggles to match, and they have a timeless quality that, unlike colour, does not date. Think of the most famous images of the last 50 years. How many of them were in colour? Exactly. Black-and-white photography works because it reduces a scene to its bare bones: shape, pattern, tone, texture, light. Colours in a scene can often be a distraction. The impact of a great portrait, for example, can be greater in mono, because the lack of colour focuses attention on the ekpression, rather than the clothing.

SEEING IN MONOCHROME

In order to create successful black-and-white photographs it is first necessary to learn to see in black and white, to see past the colours and look at them as tones. A red flower in a green field may look great in colour but would be lost in black and white. The reason is that, when reduced to black and white, red and green record as very similar tones. There would simply be no contrast. Think in terms of light and dark colours, and how they will appear when the scene is reduced to black and white.

In days of old some photographers would peer through deep red viewers to remove the colour from a scene, now, peering through a heavy squint helps. Of course, most digital cameras have a mono mode, which takes the guesswork out of how a scene would look, because you can shoot in black and white and review the image afterwards. With practice, though, this should not be necessary.

DIGITAL MONO

As already stated, most digital cameras have a mono mode, but is this the best way to shoot black and white? Not necessarily. When you choose the mono mode you have the benefit of being able to see your scene in black and white straight away. You can get a good idea of whether or not it works as a composition.

But in this mode the camera uses only one channel, which means that file sizes are smaller and you can get more shots on a card, but the camera will only record 256 steps from deep black to pure white – nowhere near enough to obtain a smoothly toned image.

As any traditional mono photographer will tell you, at least half the magic takes place in the darkroom. Great mono images are usually beautifully printed. Digital is no different. For best quality, shoot in colour, keep the maximum tonal information and save the conversion for later. (See page 143 for more on this.)

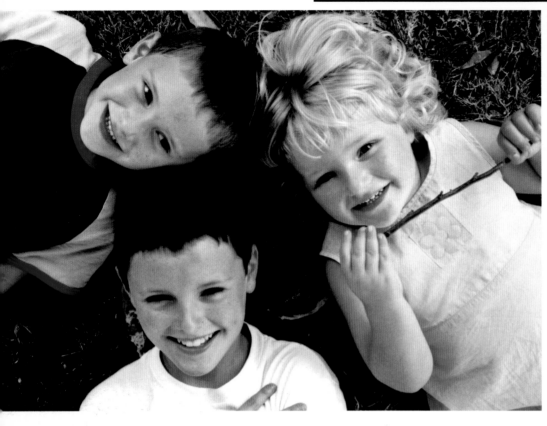

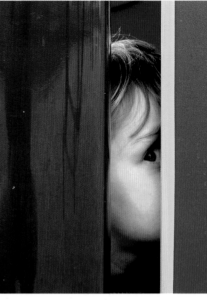

Above: Great candid photography is all about being quick.

Left: Unusual angles make for unusual photos. This great image was taken from directly above the children lying on the grass.

Children

Forget cheesy mugshots: the best shots of kids are those that catch them acting naturally and showing their true personalities.

CHECKLIST

LOOK FOR NATURAL POSES
USE FILL-IN FLASH
TRY USING PROPS
MOVE IN CLOSE
SHOOT A SEQUENCE
REMEMBER TO BE QUICK
DON'T FORGET – MAKE IT FUN

MAKE A RECORD

When the kids are grown up we'll look back at their younger years and remember key events, such as holidays, day trips, family get-togethers or simply moments relaxing in the home or garden. We'll remember that time they caught a fish, that tree they used to climb, that pedal car we just couldn't get them out of. We'll smile at the memory of them with chocolate all over their faces, or that peculiar grimace they made when they were sad. And then we'll turn to the photo album. Will those magic moments be there? Or will there just be a procession of posed mugshots and fake smiles at formal get-togethers? With digital cameras there's no excuse to not always keep your camera with you and use it constantly. Set yourself the task of making a detailed visual record of the kids' lives that you (and they) will treasure when they're older. Remember, it costs nothing to take a picture, and you can always delete the bad ones later.

KEEP THEM ACTIVE

The best pictures of children usually show them engaged in some sort of activity, whether it be building a sandcastle on the beach, riding their bikes in the park or painting and drawing.

Try to contrive situations that lend themselves to good photo opportunities. On rainy days, art and crafts indoors can provide some great shots. Try to shoot in natural light if you can, as flash can be unflattering and lead to washed-out skin tones and dark backgrounds. Digital cameras can shoot in quite low ambient light, but check your LCD monitor to make sure, and if necessary try to raise the light level or increase the ISO rating slightly. Ironically, flash often works best as a fill-in, when there is already lots of ambient light. If your camera offers fill-in flash, use it.

When the weather is fine take children outside, but stay close so they don't look like specks in the distance. Diffused light is best, but in high-contrast light (such as bright sun) use fill-in flash.

DOWN TO THEIR LEVEL

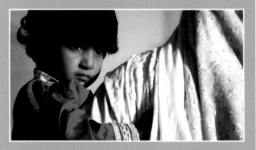

When photographing children try to avoid looking down at them from a standing position. Except in occasional circumstances, when it can add humour or pathos to a situation, it's generally much better to crouch or kneel so you're at their level. This gives the resulting images a sense of entering the child's world, rather than looking down on it from the outside. They'll probably crowd round the back of your camera afterwards to see the shots on the LCD, but that's part of the fun!

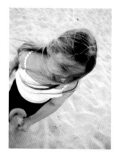 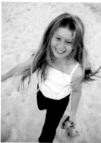 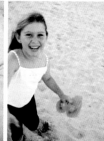

Left: Try shooting a sequence of images with the sequence mode on your camera. It will catch all the action in one go. It can work as a complete sequence, or you can pick the best of the bunch.

Below left: Stooping down to your children's level, rather than looking down on them from above, usually produces the best results.

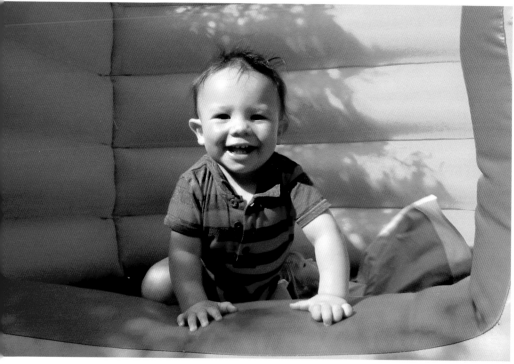

use props around you

Children either love to pose or hate it. If this gives you trouble, try using props to give them something to interact with. This can make for a much more relaxed shot. (For more on shooting people, see page 98.)

FILL THE FRAME

A common fault of inexperienced photographers is to think that when you're photographing someone you must get their entire body in shot, feet and all. This has the inevitable result of making the subjects' faces (the most interesting part of the shot) smaller and their expressions more difficult to see.

There are lots of occasions where you want to see the kids full-length, especially if they're doing something like climbing or cycling. For portrait shots, however, try moving in closer, or zooming in, until your subject is cropped at the waist or even the chest. With children being small, this often means getting very close, but this will serve to increase the sense of being there. Another benefit to getting close is that you can exclude distracting backgrounds. If your camera has aperture control, set a wide f-stop to further throw as much of the scene out of focus as possible. (You can also do this on the PC later, but it takes longer and looks less natural.)

DECISIVE MOMENTS

With children more than most subjects, capturing their expressions at precisely the right moment can make the difference between success and failure. Kids rarely stay still for long, and their expressions are constantly changing! Keep the camera ready and your eye on the subject.

Unfortunately, one of the drawbacks of many digital cameras is their lack of urgency when you press the shutter. Some are faster than others, but with most models, even something as simple as a running child can pose problems, as the subject may well have left the frame altogether before the picture is actually taken.

The solution is to frame your subject, then press the shutter button halfway and hold it there. This locks the exposure and focus, so as long as light and distance remain much the same, you can keep your finger in this position till you're ready to shoot. At this point, the camera will fire almost instantly.

THE POSED APPROACH

It's sometimes easier to pose your subjects than to catch great but fleeting candid moments, but there are ways to make them more interesting than the cheesy mottled background shots they get at school. For the most relaxed results, photograph children in a familiar setting (such as at home) or while they're engaged in a favourite activity. Alternatively, get them to pose with a new toy or something they have made. This will give them something to interact with.

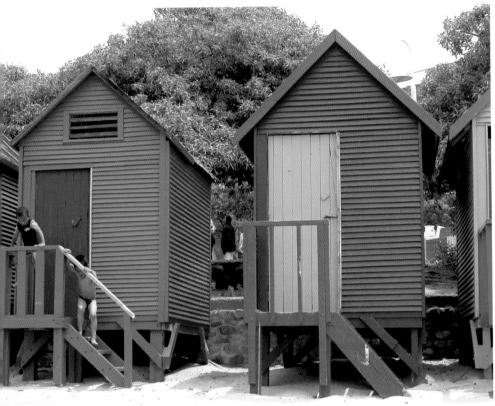

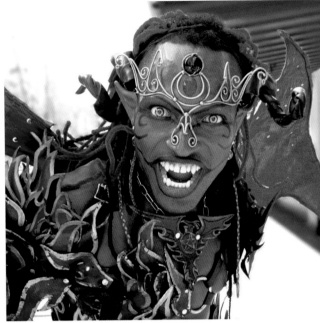

Left: The bright colours of the huts make this image. In black and white, these would all equate to similar shades of grey.

Above: The vivid reds and unusual eye colour contribute to the impact of this shot.

Capturing Colour

Daylight is made up of a spectrum of colours, and knowing how colour works can enhance your photography.

CHECKLIST

'WHITE' LIGHT IS COMPOSED OF THE FULL SPECTRUM
THE COLOUR OF LIGHT IS MEASURED IN KELVINS
DAYLIGHT AVERAGES AROUND 5500K
DIGITAL CAMERAS USE RGB FILTERS TO MAKE COLOUR
MOST PRINTING PROCESSES USE CMYK
CHOOSE THE CORRECT COLOUR SPACE
USE COLOUR IN COMPOSITION

COLOUR IN LIGHT

Although our eyes perceive light to be white, it is in fact made up of all the colours in the rainbow. The precise mix of these colours varies, depending on the brightness of the light, the time of day, the seasons, even the local geography.

The colour of light is called its temperature, and it can be measured using the Kelvin scale. The higher the temperature the more blue the light is, the lower the temperature the more orange it becomes. Normal average daylight has a temperature of between 5500K and 6000K, but at high altitudes or in shade on a sunny cloudless day it can be higher.

Artificial light has a much lower temperature. A domestic light bulb is around 3000K, while a candle is about 2000K.

The colour of the objects we see around us changes depending on the colour of the light falling upon it, though our eyes do not notice these subtle changes of colour.

DIGITAL COLOUR

For photographic purposes light can be divided into three primary colours: red, green and blue (RGB). From a mixture of these, all other colours can be made. Each primary colour has an opposite, or complementary colour, made by mixing the other two. The complementary of blue is yellow (made by mixing red and green light), for red it is cyan, and for green it is magenta.

Colour filters work by allowing their own colour to pass through, and blocking the others.

Pixels cannot actually see colour, they can only measure the intensity of light, but colour is simulated by placing a grid of red, green and blue filters over each pixel, which block out all other colours. By measuring the relative levels of three consecutive R,G and B pixels, the processor can calculate what the colour was at that part of the scene. So effectively, it takes three pixels to describe a single colour. This individual primary colour information is stored within the file.

RGB VERSUS CMYK

Although digital cameras use primary coloured filters to reproduce colour (known as the additive process), this isn't true of the print. Traditional colour photography uses the subtractive process, based upon the secondary colours – cyan, magenta and yellow – in both the film and printing paper, and this is true also of digital printing.

Because of the difficulty in producing pure rich black from these colours, black dye is also added. The subtractive process is called CMYK (for cyan, magenta, yellow and key, meaning black) and is not only used by home inkjet and dye-sublimation printers, but virtually all printed material – books (including this one), magazines, even packaging.

If preparing images for reproduction the file must be converted to CMYK in Photoshop (either by yourself or the publisher/repro house) before printing, but this isn't necessary for home printing as consumer printers make this conversion automatically in the software.

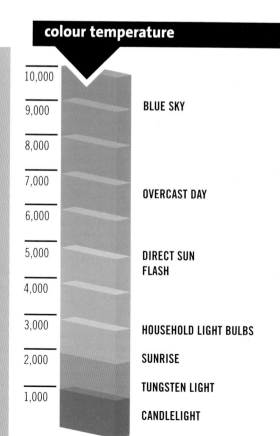

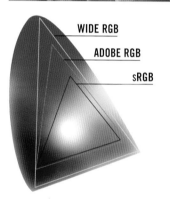

WIDE RGB
ADOBE RGB
sRGB

Above: This illustrates the different colour ranges that can be reproduced by sRGB and Adobe RGB colour spaces

RGB MODE

CMYK MODE

Above: The additive process uses red, green and blue to reproduce colour.
Above right: The subtractive process uses a combination of cyan, magenta and yellow.

colour wheel

To fully understand the way colour works in composition terms, it's important to know how each individual colour relates to others in the spectrum. This relationship is well demonstrated by the colour wheel. Colours that are vaguely opposite to each other on the wheel complement each other much better than colours that are near or adjacent to each other.

COLOUR GAMUT

It's well known that people see colours differently. One man's pink is another man's purple. Perhaps surprisingly, machines are no different. The colours in an image will vary from one monitor or TV to another. To further confuse things, a print will always show colour differently to a screen.

For digital photographers this poses problems when trying to produce consistent colour, but there are things that can be done to minimise them.

First, familiarise yourself with the colour space that your camera is using. This refers to the range of colours, or 'gamut', that can be reproduced and applies to all media – oil paints have a different gamut to watercolours, for example. The default colour space for most digital cameras is RGB, though some cameras offer an Adobe 98 option, which has a wider gamut but isn't supported by all devices. Make sure that you select the correct colour space when editing the image in Photoshop.

SHOOTING COLOUR

Colour plays an important part in composition – the precise mixture and spread of colours in a scene can make or break an image. Some of the most successful images are in fact an essay in colour. They may be monochromic, made up almost entirely of hues of a single colour band, perhaps with a small detail picked out in a complementary colour, or may use patterns or bands of colour for compositional effect.

It may be the vibrancy of a subject that draws you to it. If this is the case think about how you can convey this in your picture – perhaps by moving your position to select a contrasting backdrop, for example.

A great way to capture maximum saturation at the shooting stage is to use a polariser over the lens, which increases colour saturation by reducing the reflections on objects' surfaces. This is more effective than using the Saturation control in Photoshop.

colour temperature

10,000	
9,000	BLUE SKY
8,000	
7,000	OVERCAST DAY
6,000	
5,000	DIRECT SUN
4,000	FLASH
3,000	HOUSEHOLD LIGHT BULBS
2,000	SUNRISE
1,000	TUNGSTEN LIGHT
	CANDLELIGHT

Left: Clever framing of one horse by another creates a superb composition.

Above: An exercise in curved lines and colour.

Above right: A low viewpoint has created a more dramatic composition.

Right: A palm tree provides a natural frame.

Composition

What makes a photograph pleasing to the eye? Probably the composition. There are a few basic rules to follow and to break.

CHECKLIST

USE THE RULE OF THIRDS FOR HARMONY
LOOK FOR SYMMETRY IN COMPOSITION
USE LINES TO LEAD THE EYE
CREATE SHAPES WITH KEY ELEMENTS
FIND NATURAL FRAMES FOR YOUR SHOTS
TRY A HIGH OR LOW VIEWPOINT
EXPERIMENT WITH LENS PERSPECTIVE

THE RULE OF THIRDS

Artists throughout history have followed certain compositional 'rules' to make their work pleasing to the eye. One of them is the 'rule of thirds'. The principle is simple: divide the frame into nine equal sections by placing invisible lines one third of the way in from either side of the frame, and one third of the way in from the top and bottom – just like a Rubik's cube.

When composing your photograph, place the important elements on or around these lines. For example, the horizon usually looks better when placed on the upper or lower third. Portraits are generally more pleasing when the eyes, face or body straddle the vertical thirds, and elements of a landscape please the eye when placed in these positions.

Obviously this is just a guideline and is not to be followed religiously, but it does work a surprising amount of the time.

SYMMETRY

Having said that, there are many great pictures that do the complete opposite. Sometimes the best place to put the main subject is bang in the centre of the frame. This works best when there is an element of symmetry to the picture, where the right half of the picture is virtually a mirror image of the left half. Symmetrical portraits, for example, can have great visual impact, and the technique can work well with architectural and landscape subjects too.

LINES AND SHAPES

Another compositional device is to use natural lines in the scene to lead the viewer's eye across the frame, especially when it takes them to a focal point in the image. These lines can be formed from the top of a wall or fence, the edge of a road, a person's arm – whatever is to hand. Diagonal lines tend to add a sense of drama, while horizontal and vertical lines create a harmonious mood.

Shapes play an important role too. If you look carefully you'll see that a picture can often be broken down into vague shapes, such as squares or triangles. Pleasing images often use shapes in their composition – they're used especially effectively in group portraiture. As with lines, triangles are considered more dynamic than orderly square shapes. It's worth thinking about the shapes in your own compositions, especially with constructed images such as still lifes.

VIEWPOINT

Most photographs are taken from about 1.8m above the ground, because that's where most of our eyes happen to be. If our eyes were in our knees, imagine how different most of our pictures would look! This may sound ridiculous, but it's amazing the difference an unexpected perspective can make to an image. Try crouching or lying on the ground to give a completely different emphasis. Or how about standing on a park bench for a giant's-eye view of your subject?

focal points

One of the most important ingredients for any photograph is a focal point – just what is the image supposed to be? Without one of those, your picture is likely to be doomed. And don't be afraid to zoom in close and fill the frame. Crop out all that wasted space round the edges.

NATURAL FRAMES

Good composition is all about guiding the viewer's eye around an image in a controlled way, rather than letting it wander around the picture aimlessly looking for something to land on. The natural frame is a useful and oft-employed compositional device. Its main purpose is to serve as a barrier, to keep the viewer's eye inside the picture area and deter it from wandering out of the frame. Think of it as a sheepdog rounding up sheep!

Popular natural frames include doorways, arches and windows, low tree branches (especially when hanging down from the top of a picture), the edges of buildings, even a portrait subject's own arms. How about the classic reflection in someone's sunglasses? If you look carefully, you'll find lots of ways to provide a frame. It doesn't have to go all the way around – indeed, it can just sit happily on one edge of the shot, like a wall or tree.

THINK IN THREE DIMENSIONS

Question: how many dimensions does a normal photograph have? Two? Well, from a physical point of view yes, but from a compositional perspective it has three – as well as a left and right, and an up and down, it also has a foreground and background, and this third dimension is often neglected by photographers, who place everything of interest on the horizon, or 3m away.

Where your main subject is some distance away (be it a person, building or mountain), it's a good idea to try to juxtapose this with something in the foreground which will act as a contrast, frame or leading line. One way to enhance the importance of the foreground is to tilt the camera down slightly and place the main subject higher in the frame, or shoot from a low level. Use a small aperture and focus on a mid-point so that both the foreground and background are sharp.

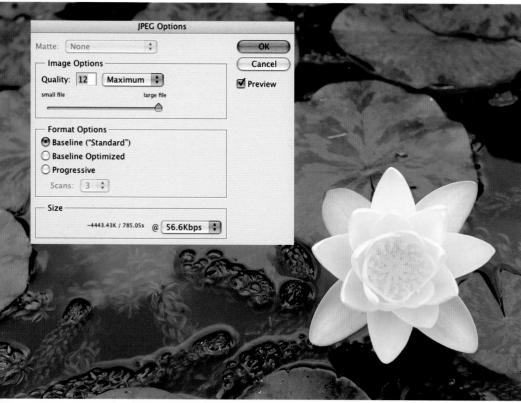

bad blocks

Every time you make a change to a JPEG image and then resave it, it discards yet more data. Do this several times and the image will soon become unusable, with obvious 'blocks' appearing. Save your image in another, uncompressed format to work on it. (For more on image quality, see page 63.)

Compression

Contrary to what the cliché says, you can fit a quart into a pint pot. At least, that's the principle behind image compression!

THE PROBLEM

Not long ago the floppy disk was the universal means of moving and storing computer data. It could hold 1.4MB worth of information, which seemed like plenty at the time. Now, you'd struggle to fit more than one image onto it from the average consumer digicam. It takes a lot of memory to describe the average digital photo in numerical form. A 5MP camera has 5 million pixels, whose density, colour and other values all have to be described individually. That's a big job, and it's getting bigger as camera pixel counts climb ever skywards. The space required to store these pictures is enormous, not just on the computer (where images can soon fill gigabytes of disk space) but in the camera, which must hold all of the pictures you take on a tiny card until you can download them.

If only there was a way to shrink these file sizes down (without making the pictures smaller, so you could fit more of them into the same space).

THE SOLUTION

Actually there is a way. It's called image compression and it works in a very clever way. Instead of recording the value of every individual pixel, it recognises when there are large areas of pixels with identical information (typically a sky, beach, road or other area of uniformity). It then simply says 'pixel 20 to pixel 350 all have the same value'. This takes much less space.

This sounds great. So how do you compress photos? Well, you do it without realising every time you save a photo as a JPEG file, because JPEG files automatically compress images. JPEGs offer various degrees of compression, which you can determine either in the camera (the 'quality') setting or when you resave in your editing software. In effect, you're setting the threshold at which the processor will either describe a slightly different pixel as being the same, or recognise its subtle difference and give it its own value.

THE DRAWBACK

There had to be one, didn't there? Well there are few slabs of uniform colour in reality. The world is made up of an infinite range of subtle shades. Even a sky, which may look uniformly blue, actually has many hues. If you were to create a blue sky from a single, solid colour it would not look real. By describing a pixel as being the same as another, the processor is discarding the actual data for that pixel, resulting in a tiny loss of detail.

The more compression is applied, the less discriminating it becomes about subtle value differences, and the more detail is lost. Heavily compressed images end up looking blocky. The trick is to compress just enough to cut the file size down to less than a quarter of its full size without anyone noticing – which is pretty much what the highest quality setting on the camera does, so use that one and avoid the others! Bear in mind, though, that the degree of compression applied depends on how detailed the shot is.

Computers

Computers and digital cameras go together like strawberries and cream. Here's a rundown of the basic considerations.

THE DIGITAL HUB

You don't actually need a computer to enjoy the benefits of digital photography – you can still review your pictures instantly, delete as you go and reuse your media card. If you have a DirectPrint printer you can even make prints, but to get the full benefit of your camera you'll need to own, or have access to, a computer.

Once you have downloaded (copied) your photos onto a PC there's a world of things you can do with them, from minor adjustments, such as cropping, straightening, improving the colour and sharpness, through to more ambitious projects, such as removing blemishes and unwanted details (facial blemishes, lamp posts, ex-partners etc), right up to complex photo-montage work limited only by your imagination.

Then, when you're done, you can print them, e-mail them to friends or to an online processing lab, post them on a Web site, make a slide show, postcard or calendar, or burn them to CD or DVD.

HARDWARE

These are the main features to consider when buying a computer for digital photography:
Hard disk: Where the computer stores your files. The bigger it is, the more space you'll have for pictures and other documents. Get as big a hard disk as possible – it's amazing how quickly you'll fill it when you shoot digitally.
RAM: Temporary memory used for storing work in progress. Data held in RAM is lost once the PC is shut down unless it's saved first. The more RAM you have, the bigger the image files and software applications you can handle.
Processor: The processor translates your commands into actions. The faster it is, the less you'll have to wait around for things to happen.
CD/DVD writer: You'll need one or other of these, either built-in or external, for archiving all the hundreds of images you'll accumulate.

SOFTWARE

Operating system: There are two main types of computer system: Microsoft Windows and Apple Macintosh. Both have pros and cons. Windows has over 90 per cent of the market, but Macs are more popular with imaging professionals such as designers, because they were designed for this purpose. Early versions of Windows were no match for Macs, but newer versions such as XP perform as well as Macs, so the choice is now down to personal preference.
Applications: A vast number of software programs are available to enable you to do things to your pictures. These include editing software (for improving your photos), album software (for organising/filing and viewing them), CD-burning software and many others, such as project-led software (for making calendars or caricatures). The leading players in imaging software are Adobe, JASC, Ulead, Corel and Roxio.

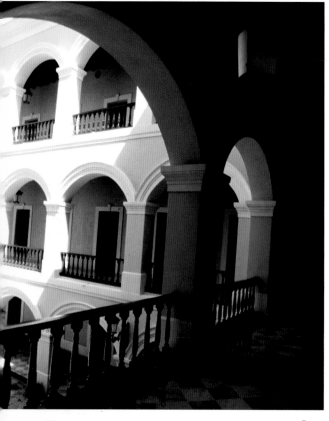

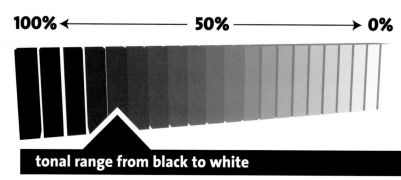

100% ← **50%** → **0%**

tonal range from black to white

Every scene we look at can be broken down into thousands of subtly different shades of brightness – from brilliant white at one end of the scale to jet black at the other. This is known as the tonal range, and the relative difference in brightness between both ends of that scale is the contrast. Some scenes are comprised entirely of mid-range shades – perhaps a field with trees on an overcast day. Other subjects contain very bright and very dark areas and perhaps few grey areas in between – for instance, a black cat in sunlit snow. This would be a very high-contrast scene.

Note the reference to the weather, because contrast is very dependent on the lighting. Sunshine produces inherently higher contrast than the diffused light of a cloudy day. It creates dazzling, squint-inducing highlights on surfaces such as water, and casts deep, dark shadows in areas where it does not fall. Such extremes of brightness can be hard for cameras to cope with. (For more on black and white, see page 30.)

Contrast and Tone

Contrast is the difference in tone between the lightest and darkest parts of a scene or image.

CAPTURING CONTRAST

Different types of film and digital sensor react differently to contrast. Negative film, for example, is inherently more capable of coping with high contrast than transparency film, and can reproduce a greater number of tonal steps. Films with a low tolerance to high contrast are unable to record both the brightest parts and the darkest parts without losing the detail at one end or the other. The photographer then has to decide which end he or she would rather keep.

Digital photographers face a similar problem. Most sensors can cope better with shadows, however, than highlights. The former can often be fleshed out using Photoshop, but once the highlights are lost they can't be recovered. For this reason it's preferable to keep the highlights than the shadows, if faced with the choice. Better digital cameras are set to a deliberately low contrast so that the sensors are more able to record both ends of the spectrum.

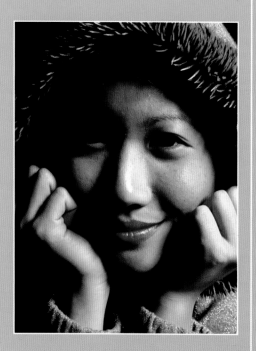

IMAGE CONTRAST

Capturing the different contrast levels is only half the story. The other half is all about reproducing them in your final image.

Take a classic high-contrast scene such as a wedding on a sunny day – the bride in white, the groom in a dark pinstriped suit. Having worked hard to ensure that both the fine lacework of the dress and the pinstripes in the suit have been recorded by the sensor, this doesn't guarantee that they will automatically be visible in your print. Some degree of contrast adjustment will almost certainly be necessary. This is best done using the 'Levels' feature (see page 150).

There's also the aesthetics of the image to consider. Flat, low contrast images do not look very appealing. By adjusting the contrast on the computer we can give our images more 'punch' – deep blacks in the shadows and bright white highlights, with just a hint of detail and a wide range of tones in between.

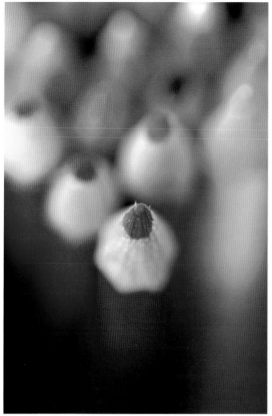

HYPERFOCAL POINT

LENS Focus here INFINITY

Hyperfocal distance Range of sharpness

focusing

A useful technique for obtaining maximum depth of field at a given lens/aperture is to focus on the hyperfocal point. Depth of field usually extends one third in front and two thirds behind the point focused upon. When you focus on infinity, that two thirds is wasted. The closest point that appears sharp when focused at infinity is the hyperfocal point. If you focus on this point instead (shown by the red line) the depth of field will extend from half the hyperfocal distance all the way to infinity. (For more on focusing, see page 58.)

Depth of Field

One of the most important techniques in the photographer's arsenal, depth of field is influenced by many factors.

WHAT IS DEPTH OF FIELD?

Depth of field refers to the zone of sharp focus that extends in front of and beyond the point focused on. An image where everything is in sharp focus, from the closest object right back to the horizon, is said to have a wide (or great) depth of field. Conversely, an image which is almost totally out of focus except for a narrow sliver of space immediately around the subject is said to have a shallow (or narrow) depth of field.

In truth, a lens can only focus on a single distance at a time. Any appearance of sharpness in front of or behind that point is actually an optical illusion. True sharpness occurs when points of light at the subject record as points on the sensor, but away from the plane of focus they record as tiny circles, known as 'circles of confusion'. The further from the focal point you go, the bigger these circles appear, until they are visibly circles rather than dots. This is the point at which the image appears out of focus.

DECIDING FACTORS

The zone of apparent sharpness (depth of field) therefore is that zone where the circles still appear as dots to the eye. The precise depth of field achieved in an image depends on many factors, first the focal length of the lens: the more telephoto the lens, the shallower the depth of field, other things being equal. The physical dimensions of the sensor have an influence, too, because larger formats need longer lenses to produce the same field of view as shorter lenses on smaller formats. Shallow depth of field is more difficult to achieve with digital cameras than with film because the sensor is physically smaller and the focal lengths are thus shorter.

The sensor-to-subject distance is also important. The closer you are to your subject, the shallower the depth of field will be.

Finally, the lens aperture plays a crucial role in deciding depth of field. At wide apertures it will be shallow, at smaller ones it will be greater.

DEPTH OF FIELD CONTROL

With this knowledge at your disposal, you know how to control the depth of field. The creativity is in the 'when'. Some subjects suit a shallow depth of field: a face in a crowd, a single flower – indeed, any occasion where it's desirable to isolate the subject from its surroundings.

Remember that to achieve a shallow depth of field, zoom in rather than out, get close rather than far away, and use a wide aperture rather than a small one.

For other subjects (such as landscapes) you want everything in the image to be sharp. Wide-angle lenses combined with the smallest possible apertures maximise your depth of field.

Working at very small apertures will result in longer shutter speeds, so you'll probably have to use a tripod to avoid camera shake.

Some lenses have depth of field markings engraved on the lens barrel, which tell you how much depth of field you'll get at each aperture.

Left: Popular culture, such as sports, makes a great subject for the documentary photographer.

Above: This candid shot, taken at a river dock in Brazil, has an interesting symmetry but also tells a story.

Documentary

Our perception of life and events over the last hundred years has been formed almost entirely by this genre of photography.

CHECKLIST

DOCUMENTARY IS A RECORD OF LIFE
SUBJECTS CAN BE NEWSWORTHY OR NOT
CHOOSE A SUBJECT FOR A LONG-TERM PROJECT
DON'T JUST SHOOT CANDIDS FROM A DISTANCE
GETTING IN CLOSE CREATES MORE INTIMACY
BE OBSERVANT, LOOK FOR 'DECISIVE MOMENTS'
TELL A STORY WITH A BODY OF WORK

WHAT IS DOCUMENTARY?

You may know it by another name – reportage, photo-journalism, street photography. Whatever you call it, this field of photography has, more than almost anything else, formed our view of the last century. We can imagine what it was like to be in the trenches in the First World War, or at a Nuremburg Rally. We feel as if we were there when the Hindenburg crashed, when Lee Harvey Oswald was shot, and when a young Vietnamese girl ran naked down the road after a napalm attack. Such is the power of photography.

But it isn't all wars, world leaders and headline-grabbing events. We can also picture ourselves in America's dustbowl during the Great Depression, dining with Brandt's black-faced Northumbrian coalminer, or smiling at Cartier-Bresson's cheeky young French boy running down the street, a grin on his face and a bottle of wine under his arm.

Documentary photography is about making a record of the world around us in all its glory.

WHY DOCUMENTARY?

In the current social climate of paranoia and suspicion, it isn't as easy as it once was to walk the streets with a camera, recording small vignettes of contemporary life. You'd have to think twice before photographing kids playing in the street (as Cartier-Bresson, Bert Hardy and so many others once did) for fear of arrest by the police, and everywhere you go jobsworth security guards at offices and shopping centres question the motives of anyone with a camera. But a dedicated band of photographers still persist because our life and culture is worth recording. It changes so fast now that, within our lifetimes, the way we live today will seem anachronistic in even 20 years' time.

We may not be able or willing to head off to the nearest war zone (and such 'death tourism' has a bad name anyway), but there's plenty of colour on our own doorsteps, if only we're prepared to look for it.

SHOOTING DOCUMENTARY

The cliché of a photojournalist is someone with either a chest adorned with beaten-up Nikons on neckstraps, or the discreet observer armed only with a Leica and a talent for blending into the background. Both types are equally valid.

Leica 35mm rangefinder cameras were popular because they were small, quiet and unobtrusive. This describes the average digital camera, too. Most observational photography is done with either a standard or only moderately wide-angle lens – well within the capabilities of the simplest digital compact. Although the old school used manual focus and exposure settings this has more do with the fact that that's all that was on offer. Modern auto functions allow you to forget about the technicalities and concentrate on the observation.

The SLR brigade put up with heavier gear for the benefits of very wide and telephoto lenses, and these are also now available on digital SLRs.

COLOUR OR MONO?

People often associate reportage photography with black and white. This is mainly because much of it was made for newspapers of the time.

But there's a lot of colour reportage being done too by the likes of Martin Parr, and the pages of *National Geographic* are filled with it.

There are pros and cons for both. Mono has a timeless feel and, stripping out the colour, somehow manages to get to the heart of the subject, without distraction. It also has a special ability to convey, and elicit, emotion that colour sometimes fails to do.

The best colour photographers use colour not incidentally but as an intrinsic part of their compositions. They 'paint' with their cameras, using bold, primary palettes or muted pastels. Their photography is often about the colour. Whatever your prefence, with digital cameras it's better to shoot in colour and convert to mono later.

Far left: Documentary isn't just about snatched candid shots, it's also about getting up close and personal with your subjects.

Left: Newsworthy subjects, such as Concorde being towed down London's River Thames past the Houses of Parliament, have a historical as well as a commercial value.

THE DECISIVE MOMENT

It's all too easy to associate reportage with grim and depressing subject matter: war, famine, poverty and other downbeat subjects. This is understandable, as many photographers are driven by a desire to show the world what is happening under their noses in the hope of changing things for the better.

But there's another, gentler, more humorous side. Much documentary photography plays with subtle juxtapositions – such as Elliot Erwitt's hat-wearing chihuahua dwarfed by the legs of a Great Dane and their mutual owner's boots.

Whether the style is upbeat or down, there's one thing that all photo-journalism has in common – an exquisite sense of timing. It captures moments that last a fraction of a second – one second either way and the shot would have been lost. The moral is to be ready for the moment, and learn to recognise it in a split second when it happens. And don't be afraid to take a lot of shots.

TELLING A STORY

One major difference between reportage and other disciplines is that it's not usually about the single image. Documentary photographers seek to tell a story, and do so in a series of images . There is no set number – it could be just half a dozen shots, while some photographers dedicate their whole lives to a single story. Others have a couple of themes on the boil over many years and build up story over time – such as Elliot Erwitt's dog photos.

It therefore isn't necessary to always try to tell the whole story in one frame, although those images are still very desirable for their ability to provide a precis for the rest of the story.

It is the ambition of most photographers to have a book of their work published, and working on a single theme like this offers a greater chance of this becoming a reality. Perhaps a photo essay on your town, your profession, your hobby or your family would be a good place to start.

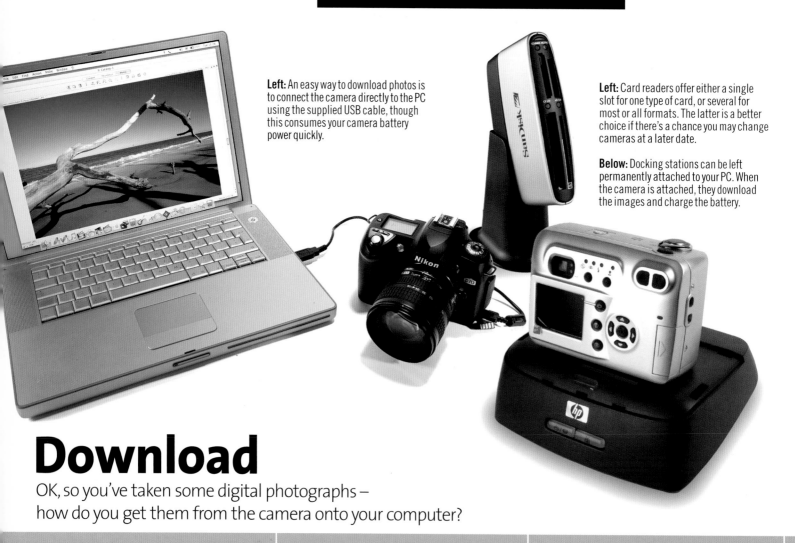

Left: An easy way to download photos is to connect the camera directly to the PC using the supplied USB cable, though this consumes your camera battery power quickly.

Left: Card readers offer either a single slot for one type of card, or several for most or all formats. The latter is a better choice if there's a chance you may change cameras at a later date.

Below: Docking stations can be left permanently attached to your PC. When the camera is attached, they download the images and charge the battery.

Download

OK, so you've taken some digital photographs – how do you get them from the camera onto your computer?

USB

Every digital camera comes with a cable in the box for connecting the camera to your PC. This will almost certainly be a USB cable, since USB has become an almost universal method of connecting external devices to PCs and Macs.

One end of the cable goes into a spare USB port on the PC, while the other (usually smaller) plug goes into the camera. When the camera is switched on, its icon will mount on the desktop, and files can be copied onto the computer.

Depending on the operating system in use, the software that came with the camera (which you have to install first) and the preferences set, you may get a dialogue box asking you if you want to download the images, as well as other options.

Some higher-quality cameras offer USB 2.0 transfer, which is many times faster than USB 1.0, as long as your computer supports it, while pro SLRs may offer Firewire instead of USB, which is faster still.

CARD READERS

The problem with using USB to download your pictures is that it consumes your camera's battery power, and may even drain it in the time it takes to download a cardful of images. You also have a fiddly cable to deal with, which may involve going round the back of your PC.

A card reader is a simple, elegant solution. These inexpensive devices are small and take up little room on the desk . Leave them permanently connected to your PC and, to download your images, simply take the card out of the camera, pop it into the slot on the reader and an icon should mount on the PC desktop. Copy as normal.

For a small premium, multicard readers feature several slots for a variety (if not all) types of card – useful if you use more than one camera or are likely to ever change yours for a new one. As with the other methods, you may have to install software before using one, depending on your computer's operating system.

DOCKING STATIONS

Docking stations (also known as camera docks or cradles) are among the best ideas that have come out of the digital arena.

A dock is essentially a hub that you leave permanently connected to your PC (via USB). Your camera slots snugly onto the dock and over the protruding contacts which slide up inside the camera. On pressing a button, the dock automatically copies all your image files from the camera onto the PC – usually straight into your 'My Pictures' folder in Windows, unless you tell it otherwise. You have the option to delete the card after downloading or not.

But that isn't all. The dock also recharges the camera battery for as long as it's attached. Most dock users leave the camera on the dock when not in use, so it's always charged when needed.

Docks will usually require the installation of some software when you first use them, but this is a once-only job, and is easy to do.

PHOTO IMPACT　　**PAINT SHOP PRO**　　**PHOTOSHOP ELEMENTS**　　**PHOTOSHOP CS**

Editing Software

One of the main advantages of digital photography over film
is what you can do with your photos after you've taken them.

THE SKY'S THE LIMIT

Digital cameras offer numerous benefits over their film-based counterparts. With film cameras, once the photos have been taken, that's the end of the process for most people. The film is handed in to the lab, back comes a set of prints. That is, unless you want to find space in the loft or the cupboard under the stairs to set up a home darkroom, with all the plumbing needs and noxious chemicals that entails.

With digital photography, the image in the camera is just the starting point for the user. With a basic home computer and some editing software, the sky is the limit. From simple enhancements, such as cropping, rotating, colour and contrast adjustment and red-eye removal, through to more ambitious projects, such as removing unwanted elements and even creating imaginative montages, there's almost nothing you can't do. These are the most popular image-editing programs on the market.

THE SOFTWARE

Adobe Photoshop: This was the application that started it all – the original photo-editing program. Photoshop is still the only serious choice for most of the world's photographers, designers and other imaging professionals, and is very popular with keen amateurs too, despite its price. PC/Mac

Adobe Photoshop Elements: Adobe recognised that its pro application was too complex and expensive for a general consumer audience, so it produced a simplified, cut-down version which, despite its modest price, is nevertheless still quite sophisticated. PC/Mac

JASC PaintShop Pro: Started as shareware and has evolved to become probably the world's most popular consumer-level editing program. Does three-quarters of what Photoshop can do for less than a quarter of the price. Elements a relatively new rival. PC only

Ulead PhotoImpact: A consumer-targeted rival to PaintShop Pro and Elements, this program is also very well specified for the price and does most of what any enthusiast is ever likely to want. Takes plug-ins too. PC only

ArcSoft PhotoStudio: One of several well featured editing programs loosely based on the Photoshop interface and sold on the strength of its value for money.Often bundled. PC only

Corel Draw: Combines advanced photo editing tools with graphic design, Web animation and much more. Priced for the pros. PC only

Roxio PhotoSuite: Slightly different to the others in being a wizard-driven program with a bright, button-oriented, non-technical interface. Inexpensive, packed with templates for calendars and so forth, and aimed more at the inexpert family user than photo enthusiasts. PC only

The Gimp: The best-value editing program of all, because it's free! Offers a lot of features despite this. Download only. PC/Mac

Exposure

Your sensor needs just the right amount of light for a good picture. Too much or too little spells trouble.

EXPOSURE WITH DIGITAL

Exposure was always a big problem with film, partly because you couldn't see if you'd got it right until it was too late. With digital we can see our picture on the LCD screen immediately, but there's a sting in the tail: digital cameras are, in fact, much fussier about exposure than most films, especially with overexposure. Once a pixel receives too much light the detail is lost forever, and no amount of Photoshop trickery can bring it back. The problem with LCD screens is that they can lead to a false sense of security. It looks OK on the back of the camera, so it must be fine. But the LCD is too small and inaccurate to be reliably trusted.

Most good cameras offer a histogram feature, which shows the spread of tones in graphic form. Better still are those cameras which highlight areas of the image where detail has been lost.

Cameras are easily fooled when there's, say, a dark subject in a very light background, and vice versa. In these instances use the Exposure Compensation (which overrides the camera), take a spot reading (see page 78) or exposure lock, or switch to Manual mode.

Left: Exposure compensation of two thirds of a stop was applied on this shot to compensate for the brightly lit white wall.

Right: This is technically a little overexposed, but the photographer preferred the high-key effect to the supposedly 'correct' version.

CHECKLIST

'CORRECT' EXPOSURE IS SUBJECTIVE
FOR MOST SHOTS, AIM FOR A FULL RANGE OF TONES
DARK OR LIGHT SUBJECTS CAN FOOL THE CAMERA
CONTROL EXPOSURE USING APERTURE AND SPEED
THE ISO SETTING INFLUENCES EXPOSURE
DON'T PUT TOO MUCH FAITH IN THE LCD
USE THE HISTOGRAM DISPLAY IF YOU HAVE ONE

WHAT IS EXPOSURE?

A picture is taken when the camera's sensor is exposed to a controlled amount of light for a predetermined period. This amount of light is referred to as the exposure.

Just how much light is needed for a photograph depends on several factors: the nature of the subject, the ambient light levels, the sensitivity of the sensor and personal taste. It makes sense, however, that, all else being equal, a bright subject records itself on the sensor faster than a dark one.

In a photo of a bride and groom at a wedding, for example, you'd want to see the intricate lacework in the bride's white dress (which records quickly) as well as the lapels and details of the groom's dark suit, which takes longer to record.

A perfect exposure is one that strikes a balance between recording the brightest and the darkest parts of a scene , so that the dark bits are not too dark (underexposure) and the bright bits not too washed out (overexposure).

ADJUSTING EXPOSURE

The exposure is altered by a combination of the aperture (which controls the intensity of light entering the lens) and shutter speed (which sets the duration of the exposure). The more light that reaches the sensor, the less time it needs to expose for. Reduce the aperture, so less light comes in, and you'll need to expose for longer to accumulate the same amount of light.

Think of a tap filling a glass of water. Turn it on just a little and it will take a long time to fill the glass. Turn the tap so that it's fully open and the glass will fill much more quickly.

Changing the ISO has an indirect effect on exposure. It doesn't change the amount of light reaching the sensor, just the amount required. Using the water analogy, it is like changing the size of the glass. A higher ISO is like a smaller glass, requiring less water to fill it. Stretching the analogy to breaking point, adding a flash is like introducing a second tap.

CANDID CAMERA

The best shots of your family are often unposed moments hurriedly grabbed. Always keep your camera with you when you're out. Don't leave it switched on (it will drain the batteries) but be ready to turn it on and use it at short notice.

Keep it in Program mode to minimise the need to fiddle, but to still allow you to pop the flash up if you think some fill might be necessary. Keep an eye on your memory card and change it in good time, so you don't find your card full when a great shot presents itself.

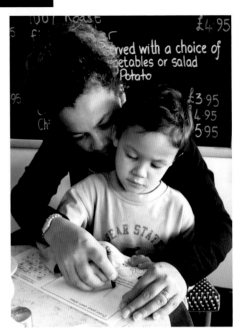

Left: Family outings present great opportunities for photography, so don't leave home without your camera.

Above: Always be ready and prepared for intimate family moments. Candids like this often say much more than a posed shot could.

Family and Friends

Many serious enthusiasts spend hours creating artistic masterpieces but never think to photograph their own families.

CHECKLIST

- ALWAYS KEEP A CAMERA WITH YOU
- RECORD GET-TOGETHERS AND SPECIAL OCCASIONS
- YOU DON'T HAVE TO POSE EVERY SHOT
- ARRANGE GROUP SHOTS TO FORM A SHAPE
- PHOTOGRAPH THE GRANDPARENTS
- SHOOT BABIES IN SOFT LIGHT, NO DIRECT FLASH
- GIVE COPIES OF THE BEST SHOTS AS GIFTS

A FAMILY AFFAIR

For most people, the family is the most important thing in their lives, yet many photographers will happily spend hours shooting a landscape scene but put no effort into recording that which is most dear to them.

You should consider it a major crime to take any family holiday, go on any day trip or attend any extended family get-together without taking your digital camera along with you.

As the in-house photographer, you should make it one of your responsibilities to create and maintain the photo archive that is The Story Of Your Family, which will be passed down to your children and to their children and so on.

Children grow up so fast, families change, age, evolve, that if you keeping putting it off you'll wake up one day in years to come, reach for the photo album for a bit of nostalgia and find it empty. There's no time to start like the present, and here are some ideas to get you started.

WHAT TO SHOOT AND WHERE

Although almost any time is a good time to take photographs, there are certain key events that should never go unrecorded. Christmas is one such occasion. At this time of year we often get to see relatives that we don't see at any other time. The children are excited, the food and drink are flowing, and everyone is, hopefully, relaxed. How about some pictures around the dinner table, and of the kids opening their presents? With indoor shots, raise the ISO and shoot without flash for a warmer atmosphere.

Birthdays are another opportunity. Why not take a posed head-and-shoulders record shot of your children on every birthday, perhaps in the same spot, so you can compare them from year to year as they get older?

Don't forget to take a camera on trips to the zoo, the theme park and on holiday. Shoot freely, as you can delete the bad ones later.

Top left: Don't be afraid to zoom in tightly to capture those expressions

Centre left: Don't forget to photograph the grandparents, too

Left: The triangle indicates a typical composition shape for a pleasing group arrangement

grandparents

Grandparents often have a special relationship with their grandchildren that's well worth recording at every opportunity. The results can make perfect gifts. (For more on photographing people, see page 98.)

GROUP PHOTOS

It's always good to get a few group shots of family and friends, especially when you meet infrequently. These are not easy to do well, but there are some tips that can help. First, find a location that has enough room for everyone to gather, and enough space for you to stand back to take the shot.

Large groups will be easier to shoot outside. Find a spot with a plain background, in a shady spot where people won't be squinting into the sun.

POSING GROUPS

There are some guidelines about posing. First, don't stand all your subjects in a line like a firing squad. This will make for an unattractive composition. The rule of thumb is to make sure that every person's eyes are at a different level. A garden bench makes a good prop. Position some sitting, some standing behind, a couple perched on the arms and, if necessary, the younger ones on the ground in front. Try to create a triangular shape with your subjects' heads.

Get everyone to squeeze nice and close together because any gaps will look bigger in the photo, and ask your subjects to turn their shoulders at an angle to the camera, rather than be square on. Divide the shot in half and have the people in each half turn in towards the centre. This will create a more harmonious composition. And don't forget to include yourself! Put the camera on a tripod or rest it on a table or fence post and use the self-timer.

AND BABY TOO

Few things are as worthy of recording as a new baby. Avoid direct flash – it's unkind and unflattering to a newborn. Use natural light (or diffused flash) and go in close to fill the frame. Try to keep the background neutral and exclude any extraneous distractions. For the first three months or so the baby will be lying down or supported in the photos, but once it can sit up, the photo fun really begins!

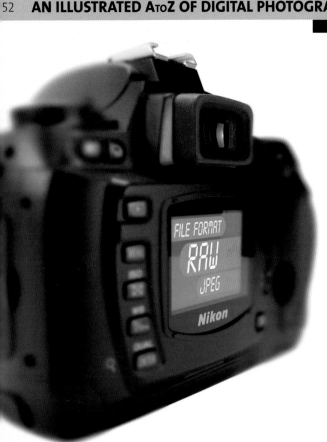

RAW FILES

The Camera RAW format is found on all SLRs and many high-end compacts, and offers the best-quality results. As RAW files are unprocessed by the camera, they can be compared to the negative in film photography, holding the maximum amount of information. Though RAW files are more inconvenient to open and work on later, many cameras now offer the option to simultaneously save both a RAW and JPEG file of each shot – the latter intended for quick viewing and sharing.

File Formats

These may sound rather unexciting, but knowing the options can make a big difference to your photography.

WHAT IS A FILE FORMAT?

When a camera records an image on its sensor, the processor must interpret the data being passed from the CCD and write it as a data file that can be read and understood later.

Computers do the same with image files saved on them. But as in the real world, there is not just one but several different languages that data can be written in. These are called file formats and, like spoken languages, a file saved in one format cannot always be read and understood by a software application using another. There are dozens of file formats in existence, but in reality there are only a handful that you need to know about. These fall broadly into two camps: compressing and non-compressing formats. Compressing formats shrink the file so that it takes up less space on the disk. Some do this by discarding some of the data ('lossy' formats) while others do not (lossless). (For more on compression, see page 40.)

JPEG (.jpg)

The JPEG format is becoming the universal file of choice, as it's used by over 90 per cent of the world's digital cameras. Many offer nothing else. This is because it compresses the data to get more shots onto the card. As it is a lossy format there is some loss of quality, but at low-compression settings few would spot the difference.

TIFF (.tif)

An almost universally readable format for saving photos without compression, TIFFs are the most popular choice for saving high-resolution images on the PC for printing. Few cameras offer TIFFS, as they're slow to write and file sizes can be huge.

GIF (.gif)

Not a format used in digital cameras, GIFs are widely used for putting images on the Web, due to their small file sizes, which they achieve by using a reduced palette of only 256 colours.

CAMERA RAW (.crw)

Preferred by most pros and enthusiasts, RAWs are unprocessed camera-based files that contain more data than other, processed formats, but in a smaller file than TIFFs. The drawback is that each camera brand's RAW file is unique to them so you must use their software to open the file on the PC, unless there's a Photoshop plug-in.

PHOTOSHOP (.psd)

The ubiquitous image-editing program has its own non-compressing file format. The benefit of .psd files is that they're able to save all the layers along with the image, for later editing (which TIFFs cannot do), but file sizes can be huge.

OTHERS

Other file formats include EPS (.eps) files, used in some drawing programs and for export to printers, bitmap (.bmp), a generic Windows-only format and PICT (.pic), a Mac-only format.

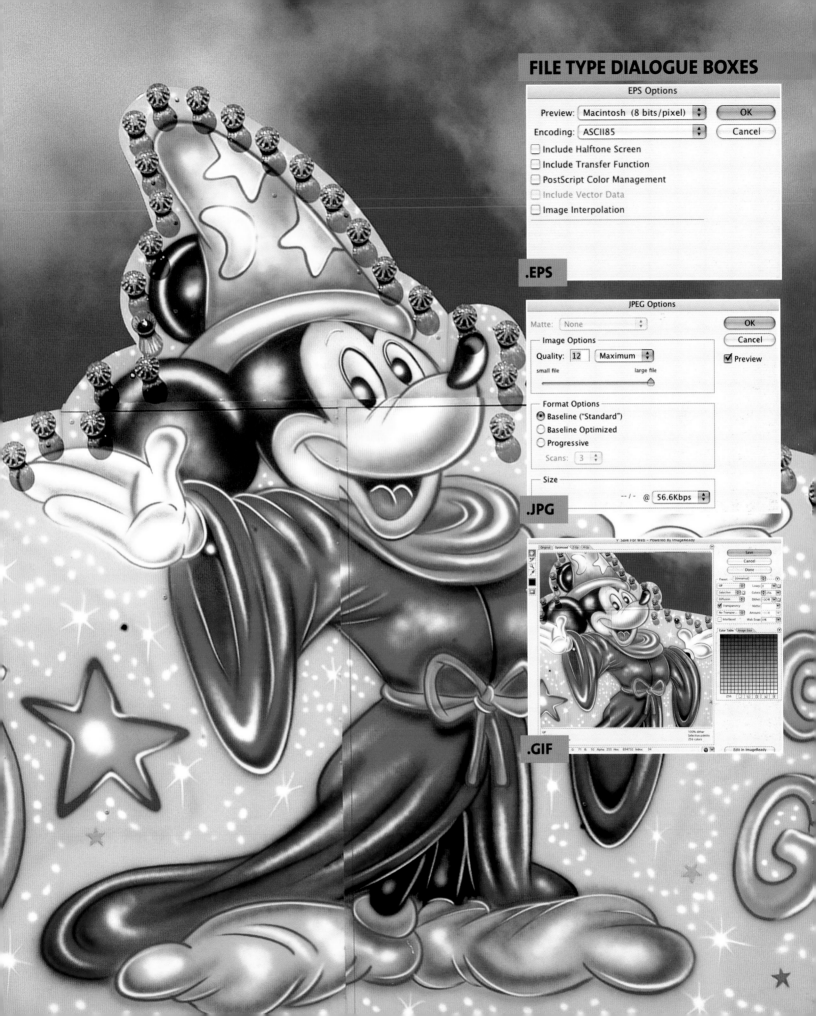

FILE TYPE DIALOGUE BOXES

EPS Options

Preview: Macintosh (8 bits/pixel) OK

Encoding: ASCII85 Cancel

☐ Include Halftone Screen
☐ Include Transfer Function
☐ PostScript Color Management
☐ Include Vector Data
☐ Image Interpolation

.EPS

JPEG Options

Matte: None OK

Cancel

Image Options

Quality: 12 Maximum ☑ Preview

small file large file

Format Options

◉ Baseline ("Standard")
○ Baseline Optimized
○ Progressive

Scans: 3

Size

-- / - @ 56.6Kbps

.JPG

.GIF

Filters and Gradients

If you thought that on-camera filters had no place in digital photography, then think again.

CHECKLIST

PROTECT THE LENS
CUT THROUGH HAZE
REDUCE BRIGHTNESS
ENHANCE COLOUR
ADD DRAMA
SHOOT ONE WITH
SHOOT ONE WITHOUT

FILTERS WITH DIGITAL

In the days before digital cameras came along photographers wanting to alter the reality of the scene in front of them had to resort to using filters over the lens, and most had a handful of different ones for various purposes.

Now that many of these filter effects are replicated in editing software such as Adobe Photoshop, and photographers can alter their images beyond recognition on the PC, is there any longer a need for the real thing?

Of course. Admittedly, there are now fewer filters that need to be hauled around, but there are a few that either can't successfully be simulated using software or are just more quickly and easily done on camera.

Note that not all digital cameras readily accept filters. All SLRs can, of course, as well as some prosumer cameras. For cameras without a thread on the lens, filters can be fitted via an adaptor that screws into the bottom.

UV/SKYLIGHT

The primary reason why a UV or Skylight filter is the first filter on most photographers' lists is that it's used to protect the front element of the camera lens from scratches, fingerprints and other damage. Obviously it's a lot cheaper to replace a damaged filter than a lens.

Because these filters are clear and virtually colourless they do not dramatically affect the image, so they can be left on the lens all the time. But that isn't to say that they don't do anything. Both filters have the ability to cut through haze and, in the case of the UV, ultraviolet radiation which reduces the contrast in outdoor shots (especially telephoto ones) and causes a slight blue colour cast. This degradation affects digital images, and although this can be corrected to some extent in editing, lost detail in distant subjects cannot always be fully recovered. For these reasons, a Skylight filter is advised for digital cameras.

GREY GRADUATED FILTER

Graduated filters, or 'grads', are clear at one end and tinted at the other, gradually merging in the middle. They are used to darken half the image while leaving the other half untouched. They're used to reduce the brightness of the sky so the detail isn't lost to overexposure. Some grads have coloured tints to add a sunset or other colour to the sky. Grads are equally useful in digital photography, where highlight detail is even more fragile and, once lost, cannot be recovered. A grey or 'neutral density' grad is recommended, as colours can always be added, with more precision, later on in the editing.

OTHER FILTERS

There are lots of other filters whose effects can sometimes be simulated at the editing stage, but it's usually a lot quicker to do them at the shooting stage. The main argument against doing this is that, unlike Photoshop effects, the result cannot usually be undone afterwards if you don't like it, so it's best to shoot both with and without the filter.

Among the main effects filters is the double-exposure mask (not really a filter actually but it's used like one), which lets you place someone in a picture twice, in opposite halves of the image; the multi-image prism, which provides a fly's compound-eye view of the world, duplicating the image many times in one frame; and a split field filter which allows you to shoot a macro subject in one half and infinity in the other. Then there's the starburst, which turns point light sources into little stars. None of these filters are especially useful, but they can be a lot of fun.

lcd monitor is better

With compact and other non-SLR cameras it's difficult to gauge the effect of some filters when you attach them to the lens (eg polarisers). When using filters, view using the LCD rather than the viewfinder, as this will give a better indication of the true effect.

POLARISER

The single most dramatic and effective filter you can buy, polarisers reduce or remove reflections from surfaces and, in so doing, have a profound effect on the colour saturation and contrast of everything in your scene. Polarising filters are especially effective with plants and foliage, water and shiny subjects such as cars. To use them they must be rotated in front of the lens until the right angle is reached, but note that their overall effectiveness depends to a large extent on the position of the sun, which should be behind the photographer. They have little or no effect on contre-jour projects.

Some may question the need for a polariser when the saturation can always be increased when editing, but although that can be done it is not the same as doing it at the source. Over-saturation at the editing stage can look unnatural, and of course reflections on the surface of water will still be present.

NEUTRAL DENSITY

A neutral density (ND) filter is like a grey/ND grad except that it's grey all over instead of just one half. Its purpose is to reduce the amount of light passing through the lens across the whole image. It's for when you want to use a long shutter speed (say, to blur a waterfall) during daytime but the light level is such that, even at the smallest aperture, the shutter speed is too high. ND filters are available in different strengths, from one to three stops, and can be combined for even greater light-blocking effects.

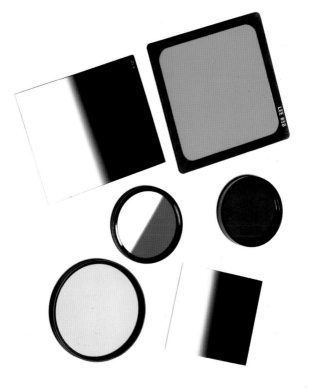

Above: Soft, subtle lighting like this is impossible with built-in flash. External flashguns or studio flash heads allow total control over the quality and direction of light, and can be bounced or diffused to obtain results such as this.

Left: Slow-sync flash is a great way to convey a sense of movement in action shots.

Flash

Not just the saviour of the universe, but also a very useful device for adding light to your photos.

FLASH BASICS

Virtually all digital models come with a built-in flash – and it's quite probably the most misused feature on the camera. Its purpose is to illuminate your subject when the ambient light level is too low to shoot without resorting to a slow shutter speed, which would cause camera shake. It will usually give you a result, but often not a pretty one: washed-out faces, dark backgrounds that make brunettes look bald, as their hair blends into the blackness, and of course the demonic red-eye effect. It's not the flashgun's fault, poor thing. It's just too small and far too close to the lens to produce anything better.

Ironically, built-in flash is at its best not in low light but bright sunshine, where it can reduce the unflattering hard shadows that cover subjects' faces and make them look like pandas. For anything more than snaps, you'll need to invest in a proper flashgun if you want decent results.

FLASH RANGE

One of the biggest misunderstandings with flash (built-in or not) is that it has an infinite range – it doesn't. It's like throwing a bucket of water at someone – the further away they are, the less water will hit them. Built-in flash has a useful range of up to 5m, and standalone ones perhaps twice that. So all those flashes that go off at stadiums are a complete waste of battery power.

TAKE CONTROL

To get the best from built-in flash switch out of Auto mode, which sets a shutter speed of around 1/60sec. Reduce the speed to maybe 1/15sec and you'll let more ambient light in, which will soften the impact of the flash. Shutter priority should let you do this. Slow-sync flash takes the speed much lower, but any movement in the shot (including your own) will produce a blurred shot. Increasing the ISO to 400 will help too, but will add noise.

WHY FLASHGUNS ARE BETTER

So why are separate flashguns better than built-in ones? Well, they're much more powerful for a start. Even a basic one will reach 10m, and a big hammerhead more than double that. The lens (face) of the flash is physically bigger, so the light is slightly softer (the smaller the light source, the harsher it is). The fact that they slot into the hotshoe on top of the camera means they're further away from the lens, which reduces the risk of red-eye. You also get many more modes and settings, for more control over the output.

Better flashguns have heads that tilt and swivel, enabling you to 'bounce' the flash from nearby white walls and ceilings, for a much softer and more subtle result. Some flashguns offer settings for remote triggering, so you can fire them off the camera, up to several metres away, for creative side, top or back lighting. You can even use multiple flash, controlled from the camera.

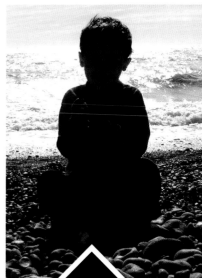
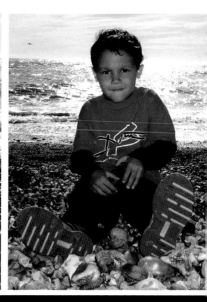

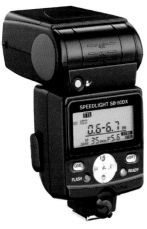

fill-in flash

Direct sunlight, left to its own devices, is never helpful for portraiture. When it's directly in front of your subjects it makes them squint, and to the side or above (where it is during the middle part of the day) it casts ugly shadows over the face (especially around the nose and eye sockets). Turn your subject so the sun is behind them and the face is dark and unlit, and you risk turning them into a silhouette.

But wherever the sun happens to be, if you use flash and balance it properly (this can be done automatically with auto flash), this will light an unlit face and reduce ugly facial shadows. It helps to be able to control the flash output to fine-tune your results.

AUTO

In the default Auto mode, when the light level falls below a certain point, the camera stops down the aperture, sets the shutter speed to 1/60sec and fires the flash. Unfortunately the camera isn't clever enough to know when the subject is out of range, or to detect those occasions when there may be enough light but it's coming from the wrong direction and flash would improve things. Should be used with caution.

FLASH ON (MANUAL)

In the Flash On mode (sometimes called Fill Flash, Force Flash or Manual Flash), the flash fires every time you take a picture, whether the camera thinks it is needed or not. This is the mode to use as a fill-in outside in bright sun, when the camera wouldn't normally choose to activate it. Its job is to push some extra light into the shadow areas, especially in backlit portraits, and add a nice catchlight to the eyes.

FLASH OFF

Whether in a museum, at a concert or on a ride at Disneyworld, you'll see those signs or hear that announcement: no flash photography. But the inability to use the flash does not spell doom for your picture capture hopes. To compensate, the camera lets you use a slow shutter speed so you can shoot by ambient light. Of course you'll need to support the camera against a wall or flat surface to avoid camera shake.

SLOW-SYNC

What if the camera lets you fire the flash and use a slow shutter speed at the same time? That's the slow-sync flash mode, also called night portrait mode on some cameras. It's for those times when your subject is in a dark environment, and you want to use flash to light them, but would like to record some of the surroundings too, rather than be left with a dense black background. Also used as a special effect in sport/action photography.

RED-EYE REDUCTION

This mode is supposed to stop red-eye, but rarely does. Worse, it often produces terrible portraits. Anti-red-eye systems aim to close the pupils prior to the shutter opening by firing a pre-flash, strobe or fixed beam. The effect is to either dazzle your subjects or lead them to think that the pre-flash is the actual picture. In either case, the expression when the actual picture is taken is unlikely to be a good one. Avoid this mode like the plague.

REAR CURTAIN SYNC

Usually found on separate flashguns, a few high-end digital SLR cameras also feature this mode, which is designed for use with sports and action photography. Its function is to fire the flash at the end, rather than the beginning, of a long exposure, so the blur resulting from the ambient light follows, rather than precedes the sharp, flashlit subject, for a more natural-looking result. More suited to separate flashguns.

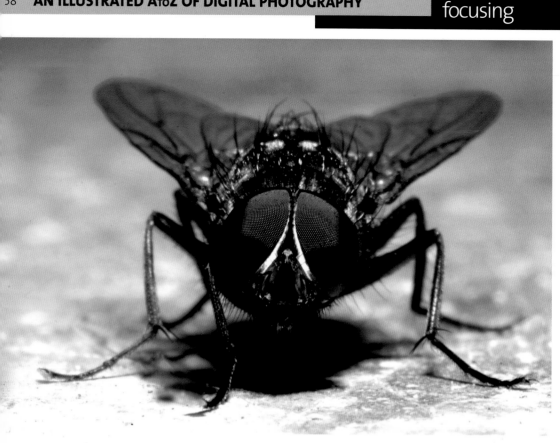

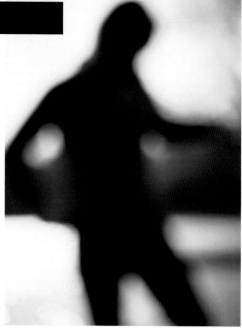

Left: When shooting at close range, focus becomes critical and the zone of sharpness is shallow. Here, the photographer has chosen to focus on the insect's eyes.

Above: Occasionally it pays to throw the subject completely OUT of focus. This usually works best with distinctive shapes.

Focusing

Your pictures can be as beautifully composed and well exposed as you like, but if they're not in focus you've wasted your time.

CHECKLIST

A LENS CAN ONLY FOCUS ON ONE PLANE
USE A SMALL F-STOP TO GET MORE IN FOCUS
MOST DIGITAL CAMERAS USE PASSIVE AF
AF SYSTEMS MAY STRUGGLE IN LOW LIGHT
MANUAL FOCUS MAY NOT WORK WITH LCDS
USE FOCUS LOCK FOR OFF-CENTRE SUBJECTS
CONTINUOUS AF IS BEST FOR FAST ACTION

WHAT IS FOCUSING?

We can forgive many faults in our photos except one: the focusing. If a picture is fuzzy and unclear, it's for the bin. Focusing is vital.

A lens focuses by moving its elements in relation to each other. It can only focus sharply on one plane at a time. Everything around this point will become progressively more blurred.

There are three main types of focusing systems: fixed focus, manual focus and autofocus. With fixed focus, found on very cheap cameras, the lens is preset to a mid-range distance. Using a slightly wide-angle lens and a small aperture, the depth of field (see page 43) ensures everything in the shot from about 2m will be sharp.

But this is rather restrictive. Better cameras allow the user to focus the lens to the specific distance required. Correct focus is indicated either by distance markings on the lens, or by employing some kind of visual indication in the camera's viewfinder.

AUTOFOCUS

The most popular focusing system is autofocus (AF). Not only can cameras focus more quickly than their owners, but usually more accurately too. They do this by one of two methods.

Active AF, found mostly on cheap compacts, uses an infrared beam to measure the camera to subject distance. Most digital cameras, however, use passive AF (also known as phase detection AF), which employs a sensor to examine the edges in your image, and then adjusts the lens to make them as sharply defined as possible.

Autofocus cameras feature a two-stage shutter release. Pressing the button halfway down activates the exposure and focusing, then full pressure takes the picture. With compact cameras you can't tell for sure if the camera has focused correctly. The LCD will give some idea, but you'll need to zoom into the shot in playback mode to be sure. With SLR cameras you will see the image snap into focus in the viewfinder.

MANUAL FOCUS

Despite their sophistication, there are times when AF systems just don't work. Very low-contrast objects with few edges are a typical example. There are other times when it may be desirable to switch to manual focus, such as when you're taking a lot of successive shots at a set distance.

All SLRs offer manual focusing, and it's easy to see in the viewfinder when the subject is sharp. Just to be sure, some provide confirmation in the form of a light or beep.

With non-SLRs, focusing manually is a little more difficult. You can't see the focus in the viewfinder, and the LCD isn't big or detailed enough. Most cameras that offer this feature magnify a central portion on the image on the LCD monitor, allowing you to fine-tune the focus in more detail. Focus is rarely carried out by turning the lens itself – usually it's achieved via a pair of buttons, or the four-way controller.

Above: A lens can only focus on one plane at a time, as this image demonstrates. But by closing down the aperture the depth of the zone of apparent sharpness can be extended (see page 43). In this instance, by focusing somewhere between the bush and statue and stopping well down, it may be possible to render both in focus.

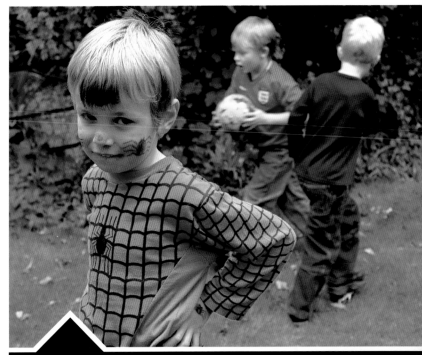

focus lock: off-centre subjects

When shooting off-centre subjects with single-point AF systems, use the focus lock. Point the central focus point at whatever you wish to be in focus, press the shutter halfway down and hold it there. The focus will be locked to that distance. Now recompose, without releasing pressure, and press the button the rest of the way to take the picture. If focus lock had not been used for this shot the camera would have focused on the boys in the background. (For more on how a camera works, see page 10.)

INTELLIGENT AF

Basic cameras assume that the main subject is in the centre of the frame, and use that as their focus point. But this may not always be so, and with a picture of two people, for example, the AF sensor may well point between your subjects and lock onto something in the far distance.

That's why multipoint focusing was developed. With these systems, the camera measures the subject distance from several parts of the scene. From the data it gathers it then makes a decision about which point you want to focus on. In most cases this will be the closest distance it finds, but not always.

With compact cameras the only way to know if the camera has chosen correctly is to look at the LCD monitor. More sophisticated SLRs display the focus points in the viewfinder so you can see which one the camera has chosen. Better still, they allow the user to preselect the AF zone of their choice via the four-way control pad.

FOCUS MODES

Most better digital cameras offer a choice of focusing modes. Which one you should use depends on the type of subject you're shooting:
Single shot: This is the basic, default autofocus mode found on all cameras. You point the camera, press halfway down on the shutter, the focus locks, you take the picture. Simple. This mode can be used irrespective of whether you're using single- or multipoint focusing.
Continuous: That's fine for static subjects but it doesn't work well with fast-moving targets. This is because in the time that passes between the focus-locking and the picture-taking, the subject will have moved position and will now be out of the zone of focus. In continuous mode, the focus does not lock. As long as the shutter is half-depressed, the lens will continue to adjust focus to follow the movement of the subject right up to the moment of exposure – great for action, though less ideal for static shots.

ONE STEP AHEAD

Predictive: Continuous AF is fine as far as it goes, but it's a reactive system and as such will always be playing catch-up with the subject. What if the camera could analyse the speed and direction of movement, predict where it's going to be next and set the focus ahead of the subject so it's ready and waiting when the subject arrives? Like setting a trap.

That is Predictive AF, and it is found on most good-quality digital SLRs. It works especially well with multipoint AF, but it does have limitations. It's intended more for photographing children playing and people running or cycling towards you, than for things like Formula One cars coming at you head-on. Also, the longer the zoom you're using and the closer the subject is to you, the more Predictive AF will struggle, as the AF motor has to move the glass elements a greater distance to swing the lens into focus.

Left: Sun, sea, sand and suntan lotion are potentially lethal to your camera. Excessive heat can damage it too, so keep it protected, and in the shade.

Above: To avoid missing great shots when you're in a hostile environment, why not take a single-use film camera with you?

Holidays and Outings

Holidays provide some of the best photo opportunities, but it helps to be prepared and take a few precautions.

CHECKLIST

- CHECK YOUR GEAR BEFORE YOU GO
- CHARGE YOUR BATTERY/BUY NEW ONES
- PACK YOUR CHARGER AND SPARE MEDIA CARDS
- MAKE SURE YOUR GEAR IS INSURED
- TAKE YOUR INSTRUCTION MANUAL
- BE CAREFUL OF SAND, WATER ETC AT THE BEACH
- KEEP YOUR GEAR PROTECTED AND CLOSE BY

PREPARATION

For many people, the annual family holiday is the year's premier photo opportunity – the one time when everyone is all together, relaxed and having fun. But there are a few things that you can do to make the photography go more smoothly.

First, check your camera thoroughly before you go to make sure everything is working properly, especially if you haven't used it for a while. Fit fresh batteries and take at least one spare set. If you use a Li-Ion battery, it's worth buying a spare. You may be able to get one from airport shops. Remember to pack your battery charger and an AC plug adaptor so you can plug it in. At least one spare memory card is essential. If you have a portable hard disk drive, that would be great, too.

Don't forget to pack your instruction manual, in case you have a problem or forget how to work something. If you usually keep all your gear in a large bag, also take a small case for when you're out and about.

PROTECTION

Your camera is at risk from many dangers when you're on holiday. Make sure it's covered by your household or travel insurance before you go.

Theft: There are no more thieves abroad than at home, but people are often less careful on holiday. Keep the camera with you at all times, either on a belt around your waist or, better still, in your beach or shopping bag. Be wary of dangling it around your neck, especially if you wander off the beaten track. If you sit down at a café, don't leave it on the table when you go.

Damage: Sun, sea and sand can all ruin your camera. Use it with care when on the beach. Make sure your hands are dry and free from oil. Keep it away from direct sunlight as extreme heat can warp it and damage the circuitry. If it's windy, don't use the camera – even a few grains of sand can be fatal. If you want to play safe, buy a single-use film camera for beach use and leave your expensive digital camera behind.

SOME SHOOTING TIPS

If you do take your camera to the beach or a ski slope, you'll find the background to your shots significantly brighter than your family. If you're not careful they'll be underexposed, or their faces will be covered with ugly shadows. Use fill-in flash to light their faces and balance them with the background. For scenic beach and snow shots you may need to use exposure compensation to secure a correct exposure.

A typical holiday record will always have a few shots of people standing in front of the local tourist attractions. A common mistake is to position your family right up against the object of your attention, then move back so far to get it in that your family are barely recognisable.

No matter how far away you are from the attraction, your family should be no more than 2–3m away from the camera. Place them to one side of the frame so you can show off the magnificence of the location.

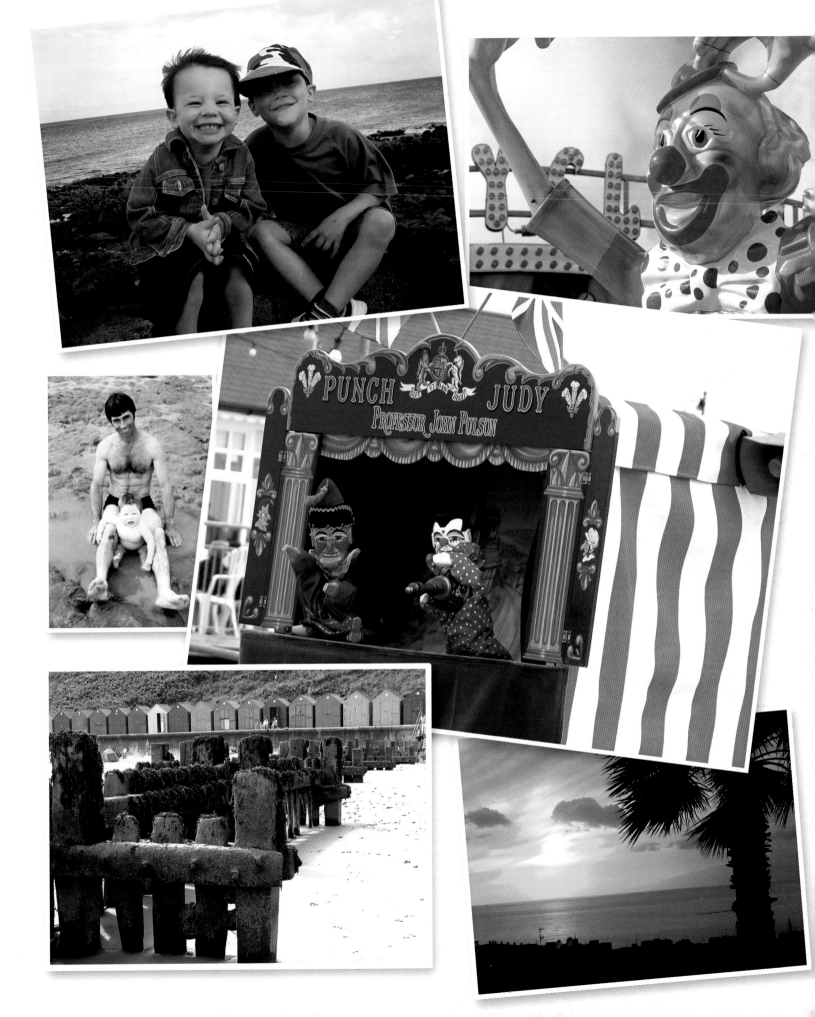

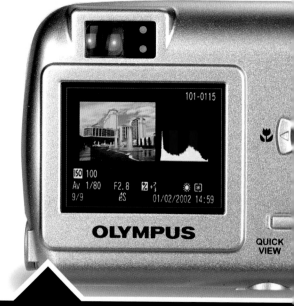

Left: The histogram display in Photoshop, found in Levels.
Below: The histogram display on a digital camera.

camera histogram

Histograms

Beautiful scenery has inspired artists for centuries,
but for memorable photos there are some basic rules.

IT'S ALL ABOUT THE LIGHT

A histogram is a kind of map that displays, in graphical form, the spread of tonal values in a digital image. Histograms can be found in most image-editing software and on some digital cameras, and they provide the user with a precise measurement of the light tones, dark tones and everything else in between.

The X, or horizontal axis, displays the tonal range, with total black at the extreme left and pure white to the far right. The Y, or vertical axis, shows the percentage of the image that contains that tonal value. A typical image will show peaks and troughs along the scale, depending on the tonal values present in the scene. A perfect, well-exposed photograph will have a fairly even spread of tones. A histogram where the peak is well to the left has a lot of dark areas, or may be underexposed, while one with a bias to the right has a high percentage of light tones, or may well be overexposed (if the subject is not unduly light).

SOFTWARE HISTOGRAM

Image-editing applications provide histograms so that photographers can not only check the spread of tones in their photos but also adjust them. In Photoshop this is done via the Levels feature (see page 150).

Underneath the histogram are three inverted triangles, one at each end and one in the middle. These are sliders. The outer ones indicate where on the scale you want the shadows and highlights in your image to fall (shadows on the left). Moving the two outer sliders closer together increases the contrast, as you are compressing the tonal range in the image. The middle slider determines the midpoint and alters the brightness of the image.

Photoshop allows you to adjust the histogram for each of the three colour channels individually.

Histograms are a better way to correct your images than using the simpler but less controllable Brightness and Contrast sliders.

Digital sensors are well known for being unable to cope terribly well with overexposure. The highlights tend to lose all detail, and this cannot always be recovered, even using Photoshop.

One of the benefits of having an LCD screen on the back of the camera is that you can check your shots immediately to see if they're OK, but the screen is too small to provide this kind of critical exposure information.

To overcome this, many cameras feature a built-in histogram display. By reviewing your image afterwards with the histogram, you can see immediately if the distribution of tones is as you want them, so you can adjust and reshoot.

Some cameras go one better and feature a 'Live Histogram'. This lets you view the histogram of the scene in advance, as the camera would record it, rather than the image as it has been captured. This allows you to make any adjustments before you shoot, rather than afterwards. (For more on LCD monitors, see page 11.)

Image Quality

There are several factors affecting the quality of the images from your digital camera.

WHAT IS QUALITY?

People often try to compare the quality of digital cameras with 35mm ones, but in digital there are many variables to consider. The first question to determine the answer to is what actually is quality? Is it sharpness, colour, contrast or a combination of all of these? Because with digital the image that comes out of the camera is often just the starting point.

Many cameras produce deliberately low-contrast images to give the user more options at the editing stage. Most mid-to-upper-end cameras also allow the user to adjust these things in the set-up menu to suit their preferences if, for example, they will print them direct from the card rather than edit them later.

With digital, any judgement of image quality is also tied to the size at which it is viewed, much more so than with film. Pixel-based images are less tolerant of enlargement beyond their limits. Print resolution also clouds the issue.

SIZE, FORMAT AND COMPRESSION

There are several camera controls that have a direct effect on image quality, the main ones include:

Image size: The highest setting provides images that use all the pixels on the sensor. With a 5MP camera this will be an image measuring around 2592 x 1944 pixels. You'll get more pictures on your card (and they'll write faster) if you reduce the size to, say 1600 x 1200, or 640 x 480 pixels but remember you will get a drop in quality though.

File format: If your camera offers it, the RAW file format provides the best quality potential, though RAW files will need some work for best results. TIFF files are a high quality alternative, but most cameras use JPEGs as standard, where the quality depends on the level of compression.

Compression: To squeeze more shots onto your card without reducing the image size, increase the compression (usually via the 'Image Quality' control). The more you compress an image, the more detail (and quality) is lost.

OTHER FACTORS

Processor: The camera's processor plays a vital role in maximising the image quality, since its job is to turn a bunch of electrical signals on the sensor into an image file that can be read by printers and editing applications. Manufacturers are constantly introducing newer, faster and better processors, and will continue to do so.

Lens: Image size and compression are not the only camera-based elements that have a bearing on final quality. The quality of the lens makes a huge difference, and determines the sharpness, contrast, colour, perspective distortion, flare, chromatic aberration and other factors. The bigger the zoom, the greater the challenge to the lens designers to produce high quality. Compact users do not have a choice of lenses, but SLR owners will find that lenses specially designed for digital sensors may produce better quality than similarly priced models that have been borrowed from 35mm cameras.

panorama assist

Many digital cameras take the hard work out of producing stitched panoramas by helping to automate the process. (For more on creating panoramas, see page 94.)

Left: You can create your own special effects without needing any specific effects modes. This was taken using slow-sync flash.

Right: Some cameras offer a black and white or sepia mode. Although this is useful if you wish to print them directly without a PC, it's always better to perform such radical modifications at the editing stage.

In-Camera Effects

Your digital camera can do a lot more than produce
a nice, normal colour photo. It can perform clever tricks, too.

CAUSE AND EFFECT

In general it's always better to produce as normal and as high-quality an image as possible in the camera, and to save any fun and trickery for later on the PC. The main reason is that your PC is more powerful and can do it better, but once you mess with the original image you can't go back and get a normal shot if you change your mind later.

But not everyone owns or uses a PC, and sometimes it's quicker and easier (and more fun) to do it in the camera. And the camera is ready and willing to oblige.

Some cameras offer more of these fun features than others, and almost all allow users to at least set the camera to shoot black-and-white or sepia shots

A SELECTION OF EFFECTS

Panorama assist: You can shoot panoramas on any camera by shooting a series of overlapping images and joining them later, but some cameras have a special mode to do this more accurately. By superimposing a transparent copy of the edge of the previous shot, you can line up the next one precisely. Some cameras even stitch them together for you, saving you the trouble later.

Red-eye removal: A relatively new feature on certain digital cameras, but certainly one of the most useful. With built-in flash red-eye is unavoidable in some situations, and while it can be removed in most editing software, these cameras do it for you automatically.

3D: Three-dimensional photos and movies were all the rage once, and are now making a reappearance in digital form. In this mode you take two shots at slightly different angles and view the result through the supplied stereoscopic viewer.

AND SOME MORE

Slim filter: Ever been to a Hall of Mirrors at a funfair, where curved mirrors distort you in all kinds of directions? Well, that's the idea of this. This mode squeezes or stretches your image (and therefore your subject) in a vertical or horizontal direction. The latter looks like the compressed title sequences in old Westerns, shot in Cinemascope.

Soft focus: Portrait photographers have long used soft-focus filters to flatter their subjects into thinking their skin is silky smooth. Now it's available as a digital filter effect – great for de-emphasising Granny's wrinkles.

Time lapse: We've all seen those time-lapse films showing a flower opening quickly or clouds hurtling across a sky. This is achieved by taking one picture at set intervals (eg one per minute) and running them as a movie. Now some digital cameras offer this great feature.

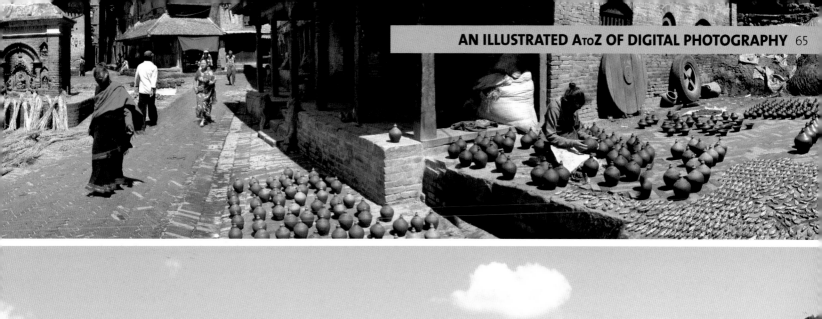

Right: A simple composition grabbed, handheld, in a hotel lobby using natural light. Don't forget to check your white balance settings for shots like this.

Interiors

Shooting indoors poses its own special set of challenges, but the results are ultimately worth it.

Above: This shot of the Opera House in Budapest was also shot handheld, with the ISO increased to 800. Although noisy, it's better than no picture at all.

CAPTURING THE GRANDEUR

There are many beautiful interiors all around us, in cathedrals, stately homes, museums and even modern offices, and most of us have attempted to photograph them at some time, with variable results. Interiors are challenging for several reasons, but the images can be worth the effort.

Firstly, if your aim is to show off the interior itself, take a tripod because light levels will be low and flash inappropriate (and not powerful enough, anyway). To include the entire interior of, say, a church, set up at one end and keep the camera as perpendicular as possible. Stop right down and make a time exposure using the self-timer or a remote release. Try to shoot at a time of day when it is brightest, which will depend on the positions of the windows. If the venue is open to the public, very long exposures will blur them so they're not distracting. Alternatively, return at a quieter time or ask the person in charge about shooting just before or after opening hours.

WINDOWS

Windows pose a problem if they're in shot. It is impossible to balance the exposure for the inside with that of the outside, resulting in a grossly overexposed view outside the window. The answer is either to boost the interior light level, but this may mean using several large studio flash units, or to shoot when the light outside is much lower and even switching on the room lights may be enough. Alternatively, close the curtains, or reposition so the window isn't in shot. Or take two shots from the same position: one exposing for the interior, the other for the view outside, then add the latter to the former in Photoshop.

When they're out of shot, however, windows provide natural light and make the interior more interesting.

Balancing the colour temperature between indoor and outdoor light can be tricky, too. You can turn off the interior lights altogether, but they add atmosphere. Experiment with the white balance settings to see which looks best.

PEOPLE INDOORS

Another kind of indoor photography is more about the people in the rooms than the interiors themselves. You're in a lovely bar or restaurant and want to record the ambience of the moment, or perhaps watching a live band in your local pub and trying to photograph them. Flash may not be permitted in either venue, and it would only kill the atmosphere anyway.

The solution is to rack up the ISO on your camera and shoot by available light. You'll need to get a shutter speed of around 1/30sec so you can handhold it without camera shake, or slightly lower if you can rest the camera on something (bear in mind that your subjects will be moving slightly, too).

If flash is permitted it's still best to follow this procedure to record the surroundings, and leave the flash to light the people. Otherwise your subjects are likely to be recorded against a deep black background.

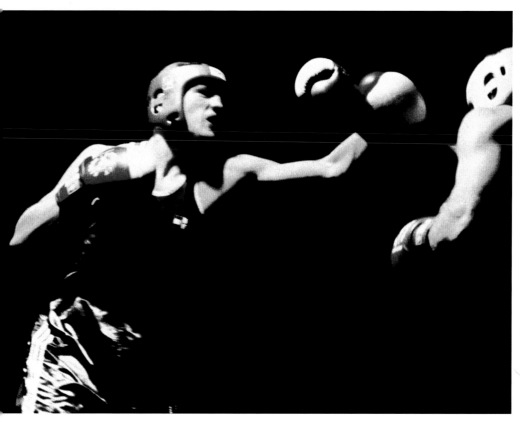

noisy images

With film, the more sensitive the emulsion (and therefore the higher the ISO rating) the more visible the film grain becomes. But photographers are prepared to put up with the grain for the ability to shoot in low light. Digital sensors suffer a similar problem, but instead of grain at high sensitivities they produce 'noise' – which manifests itself in many ways, most often as multi-coloured flecks in dark shadow areas. (For more on image noise, see page 90.)

ISO Settings

The sensitivity of your digital sensor can be adjusted using the ISO setting – just like film cameras can.

ISO AND FILM

Anyone familiar with using film cameras will be familiar with the term ISO. It's an international measurement for recording the sensitivity, or 'speed', of film. When a new film is loaded into a camera, it must be told the sensitivity of the film (either automatically or manually) because this forms the basis of the exposures it sets.

The more sensitive the film (ie the higher the ISO), the less light is required by that film to make an exposure. It is known as a fast film.

Less-sensitive (lower ISO) films require more light to take the same subject, and in low light may not be able to record an image without the use of a tripod. So why doesn't everyone just use high ISO films? Well, because we don't always want to use fast shutter speeds and small apertures, but there's a quality issue, too. High-ISO films have coarser grain, which is visible in the picture. Lower-ISO films are sharper and produce smoother tones.

DIGITAL ISO

Unlike film, the sensors in digital cameras cannot be replaced with a more sensitive one whenever the light levels are low, so camera manufacturers have had to devise new ways to cope with changing lighting levels.

The way they have done this is to enable the user to vary the strength of the electrical signal that goes to the sensor. Increasing the signal makes the sensor more light-sensitive, enabling it to record in lower light levels.

But of course, just like film, there is a price to pay for 'turning up the volume' on the sensor like this. Sensors have their own version of grain, called noise. Not unlike grain in many respects, noise has a visibly negative effect on image quality, reducing sharpness and smoothness of tone, and adding what looks like coloured sand in shadow areas. Some photographers actually like grain and introduce it on purpose. This is rarely the case with noise.

ISO SETTINGS

To make the transition from film to digital more easy for photographers, digital camera designers have borrowed some of the terminology of film-based photography, even though it has no real meaning when applied to digital sensors. The ISO setting is one such area. Most photographers are used to shooting on ISO 100 film in sunshine, or ISO 400 in lower light, such as indoors, so sensors use the same language.

Most digital cameras, however, offer a much narrower ISO range than is available with film. A typical compact may only offer a range of 100–400, or even just a choice of one or the other. Quality prosumer and SLR cameras offer a much wider choice, often up to ISO 1600 which, although likely to be quite 'noisy', does allow the photographer to shoot in very low light or at very fast shutter speeds, or use flash at a greatly extended range – and noise can, to some extent, be reduced using editing software.

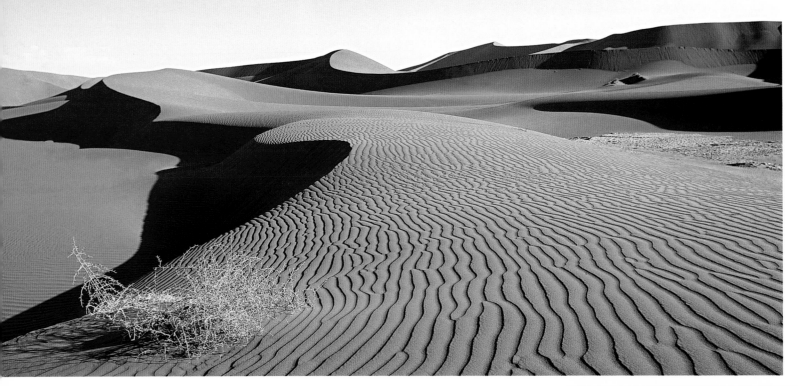

Landscapes

Beautiful scenery has inspired artists for centuries;
for memorable photos, there are some basic rules.

IT'S ALL ABOUT THE LIGHT

What's the difference between a great landscape photograph and a mediocre one taken from exactly the same spot? Chances are it's the lighting. Although we barely notice, the quality of light is constantly changing throughout the day, and the best photographers are those who are prepared to sit and wait for that fleeting moment, perhaps when the sun pokes out momentarily from behind a cloud and bathes the scene below in a warm glow.

You can stack the odds in your favour by shooting early in the morning, or late in the afternoon, when the sun is lower in the sky and casts long, atmospheric shadows on the land. During the magic hours around sunrise and sunset the light is warmer and the sky often ablaze with colour. Even misty winter mornings have their own charm, adding a sense of mystery and romance to an otherwise lacklustre scene.

LINES AND FRAMES

The landscape photographer's task is to arrange the elements of a scene in a way that is pleasing to the eye. A safe bet is to follow the 'rule of thirds', placing important elements at certain points in the frame (see opposite). Conversely, some scenes work better with the main elements placed dead centre, creating a pleasing symmetry.

When composing, try to create visual interest in both the foreground and background, not just on the horizon. Use natural lines, such as a winding road or hedgerow, to lead the eye around the image. A diagonal line travelling from left to right is usually the best. Another trick is to use a natural frame, perhaps an overhanging tree or archway, to enclose the scene beyond.

Sometimes landscapes can be reduced to simple blocks of colour, pattern or shape. A classic example of this is where differently coloured foreground, mid-ground and background zones run in bands across the image like a sandwich.

SEASON'S GREETINGS

A common mistake among novices is to assume that sunny weather is best for landscape photography. In fact, the opposite is more often the case. Cloudless sunny days tend to produce bland pictures. Dramatic light most frequently occurs in dramatic weather. Thunderstorms, gales, snow, rain and fog can all produce great images, although of course personal safety comes first, followed by the protection of your expensive equipment!

WIDE-ANGLE VS TELEPHOTO

The classic landscape lens is a wide-angle, since it allows the photographer to get more into the shot. For general views wide-angles can't be beaten, and they can also be used to create a great sense of perspective from foreground to background. The problem is that truly wide-angle lenses are rare on digital cameras, due to the small size of the average sensor. Interchangeable-lens SLR cameras are best, as these allow the attachment of some very wide-angle lenses, albeit at a price. With fixed-lens compacts, most manufacturers make wide-angle adaptors which attach to the existing lens and produce a similar result.

But don't forget the value of the telephoto end of your zoom. The longer focal lengths are ideal for picking out interesting details in a scene, and the compressed perspective effect they can produce lends a 2D quality which looks great with the right subject.

the rule of thirds

When composing landscapes it often helps to use the 'rule of thirds' devised by classic painters. Mentally divide the scene into a grid of nine equal sectors and place the important elements in the scene either in the lines or the intersections where they cross. (For more on the rule of thirds, see page 36.)

DEPTH OF FIELD

One rule that applies to almost all landscapes is that every part of the image, from foreground to horizon, should be in sharp focus. Few landscapes succeed when there are areas that are unsharp. Simply pointing the camera at the horizon and hoping for the best is not a recipe for success.

The zone of sharp focus in a scene is the depth of field, the distance between the closest area of sharpness in an image and the furthest. For maximum depth of field set your camera to the smallest aperture possible. This will result in a longer shutter speed, so to avoid camera shake use a tripod. If you don't have one, balance the camera on a tree or rock, or just make sure the shutter speed stays above around 1/60sec (depending on the camera and lens used).

Rather than focusing on the horizon, pick a point around two thirds of the way into the scene. This will maximise the depth of field available to you.

CONTRE-JOUR

A classic piece of advice is to always shoot with the sun behind your shoulder, so that light illuminates the aspect of your subject that is facing the camera. While this may produce a technically acceptable result, such images can often tend to lack emotion or atmosphere. Shooting directly into the light (known as contre-jour) can produce beautiful images. Meter off the sky to create silhouettes, or increase the exposure to create a more high-key feel. Try to avoid getting the sun itself in shot, as this can damage the camera.

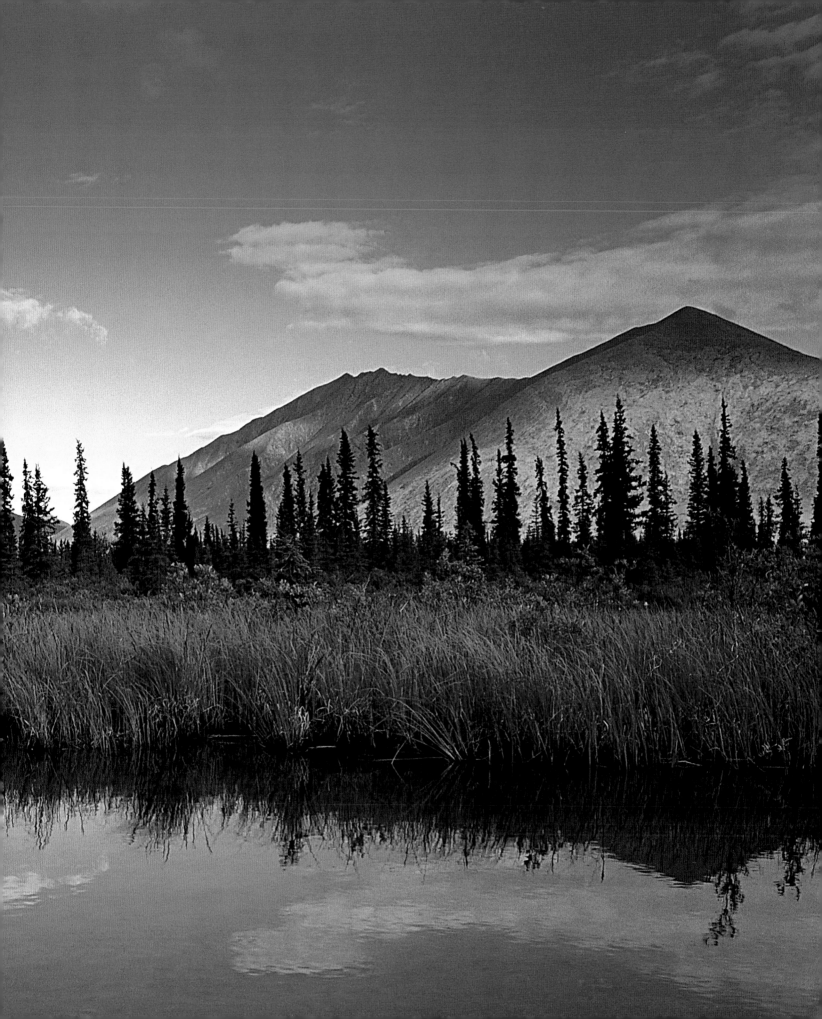

WIDE-ANGLE 28MM
This sequence illustrates the effect of zooming. This position is the widest zoom setting currently available on a digital compact.

STANDARD 50MM
The standard lens (equivalent to 50mm on 35mm film) shows the world roughly as we see it, with objects about the same size.

TELEPHOTO 100MM
This shows the view you'll get at the long end of most 3x zooms. The perspective hasn't changed, just the magnification.

TELEPHOTO 200MM
A 7x zoom lens will produce a crop similar to this at the long end of the zoom range, but will be hard to hold steady without a tripod.

Lenses

One of the most important parts of a digital camera is the complex glass assembly on the front known as the lens.

THE LENS IS KING

The lens is arguably the most important part of any camera, since it is not only the part of the camera that forms and focuses the image, but it also plays a key role in how that image looks – the composition and perspective.

A lens is much more than a piece of curved glass. Under the right circumstances, an image can be formed on a sheet of paper using nothing more than a magnifying glass, but it will bear little resemblance to the highly detailed, colourful images you get from a digital camera.

A typical lens is, in fact, a collection of many different glass elements, some convex (bowing outwards), others concave (curving inwards), set into a complex mechanism that moves them around in relationship to one another. The shape and quality of the glass and the sophisticated coatings on their surfaces determine the final image quality, and the precise combination of elements determines the focal length.

FOCAL LENGTH

Depending on the combination of elements, the viewpoint produced by a lens can vary greatly. These are the main types:

Standard: A lens that shows the world pretty much as the eye sees it, with subjects appearing roughly the same distance away.

Wide-angle: These lenses produce a wider than normal angle of view, and allow you to get more into the shot without having to move backwards. Great for group shots, scenic views and buildings, but they do make things look further away.

Telephoto: With a much narrower angle of view, telephotos make distant subjects appear much closer, as though cropping the middle out of a standard view. They're great for sport, wildlife and other subjects shot from a distance.

Zoom: Zooms offer the best of all worlds in being able to vary the angle of view from wide-angle to telephoto, or from slight telephoto to extreme telephoto. (See page 124.)

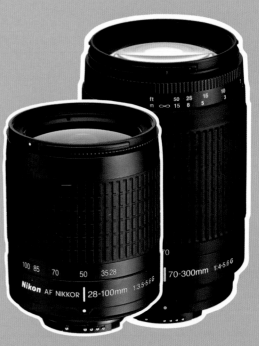

WHAT ELSE IS IN A LENS?

A lens can only focus on a single point at a time, and this point must be adjusted by moving the elements in relation to each other. With AF lenses this is done automatically using tiny motors in the camera or lens. The amount of light passing through the lens is determined not only by the diameter of the elements and the length of the lens barrel, but the metal-bladed diaphram (aperture) that determines the f-stop. Some lenses use special apochromatic elements to bend the different wavelengths of light so that they focus at the same point, increasing the sharpness and reducing the coloured halos that sometimes appear around edges in pictures.

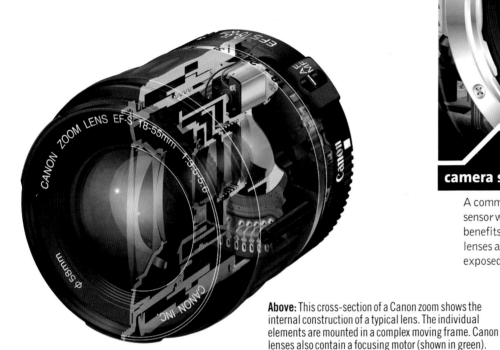

camera sensors

A common problem with digital SLRs is dust getting onto the sensor when the lens is removed. For this reason there are benefits to trying to cover all focal length needs with as few lenses as possible, to minimise the amount of time the sensor is exposed. (For more on sensors, see page 114.)

Above: This cross-section of a Canon zoom shows the internal construction of a typical lens. The individual elements are mounted in a complex moving frame. Canon lenses also contain a focusing motor (shown in green).

SPECIALIST LENSES

Some lenses are designed with unusual characteristics, for specialised applications.
Macro: These lenses are designed for extreme close-up photography, and allow the user to record subjects at life size on the sensor.
Fish-eye: Extreme wide-angles with an angle of view of around 180°, fish-eyes produce circular images with a dramatically distorted perspective (curved lines etc).
PC shift: This features elements that can be moved up/down/sideways to include subjects outside the frame, without having to turn/tilt the camera.

LENSES FOR DIGITAL

Lenses designed for film SLRs can be used on compatible digital SLR bodies, but with some compromises. Digital sensors have specific needs. One is that the light rays coming from the lens should hit the sensor at right angles rather than obliquely, or noise and fringing may occur. Only lenses specially designed for digital do this.

A side effect of smaller sensors is an apparent increase (around 1.5x) in the focal length of any lens attached, as the sensor covers a smaller area. So a standard lens from a 35mm body becomes telephoto on a digital one, and lenses must have relatively shorter focal lengths than their 35mm counterparts to produce the same angle of view. This is an advantage when using telephotos (they become even more telephoto) but a drawback with wide-angles (their angle of view is lessened).

This smaller sensor size does mean, however, that digital lenses can be smaller and lighter than their 35mm counterparts.

SUPPLEMENTARY LENSES

One of the joys of SLR photography is the ability to change the lens to gain a different perspective on the world. But owners of some fixed lens compact digital cameras can join the party too, albeit in a less versatile way, by screwing what are called supplementary lenses onto the front of their existing ones. Some cameras offer a choice of add-on lenses: wide-angle, telephoto and in some cases even a macro lens for true 1:1 ratio photography. These lenses can be expensive for what they are, though, and will never equal a proper SLR system.

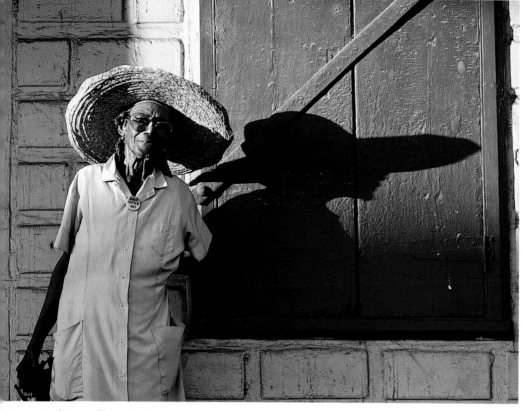

Above: Shooting into the sun can produce a soft, romantic effect, with an attractive halo around the subject's edges.

Left: Strong sidelighting casts long, moody shadows.

Lighting

Artists paint with oils or watercolours, photographers paint with light. It's the fundamental ingredient of every photo.

CHECKLIST

GOOD LIGHT IS ABOUT QUALITY, NOT QUANTITY
EARLY AND LATE LIGHT ARE OFTEN BEST
SMALLER LIGHT SOURCES CREATE HIGHER CONTRAST
SOFTER LIGHT IS USUALLY BETTER FOR PEOPLE
SIDELIGHTING ENHANCES TEXTURE
USE REFLECTORS/DIFFUSERS TO MODIFY LIGHT
USE STUDIO LIGHTING FOR ULTIMATE CONTROL

IT'S NOT ABOUT QUANTITY

A common mistake among those uninitiated to the art of photography is to think that the only thing that matters about the light is that there should be enough of it. The more the merrier. But nothing could be further from the truth. It's the quality, not the quantity that counts.

The quality of light is a well-used cliché that's very difficult to explain, but with practice you'll come to know it when you see it. It's about the direction, angle, hardness and colour, and of course it all depends on the subject because what's right for one thing is totally wrong for another. People, for example, are usually best lit by soft, diffused light. But landscapes tend to look better in low, hard light. It's horses for courses once again.

The really amazing thing you'll notice about light, if you study it, is how it's constantly changing. That's why landscape photographers are prepared to sit for hours in one spot – just waiting for the right moment.

HARD OR SOFT?

Light is often divided, for the sake of convenience, into hard or soft – in other words, high contrast or low. The contrast of a light source, whether natural or artificial, is determined by its size. The smaller it is, the harder (or higher contrast) it becomes. A candle produces a harder light than a fluorescent tube. A studio flash fitted with a 30cm reflector dish creates harder light than the same one fitted with a 1m softbox.

The sun is, to our eyes, a constant size, but it's the atmospheric conditions that change its apparent size. On a clear, cloudless day, the sun is a small but bright ball of light that makes you squint to look near. It is very hard. On cloudy days, when you can't see the sun, the whole sky becomes the light source – like a giant softbox.

Different subjects tend to suit certain types of light, but this is only a guide, and it's easy to find examples where the opposite is the case.

DIRECTION AND ANGLE

The direction and angle from which a light is pointing has a profound effect on the image. There's a rule of thumb for snapshooters that says that, to be sure of good pictures, always keep the sun behind your shoulder. This may be very safe lighting, and the least likely to cause problems for your camera, but frontal lighting is often rather bland. Lighting from the side, for example, can look great in landscapes, portraits, nature shots, abstracts, just about anything. Sidelighting reveals the texture in rough surfaces and lends them a tactile quality. To be its most effective it's often best when coming from a low angle; in the case of the sun, this means near the horizon.

In fact, the one thing that most photographers are pretty much agreed upon is that direct, overhead light cast by the midday sun is good enough for only one thing – sunbathing. Use this time to do something other than take photos.

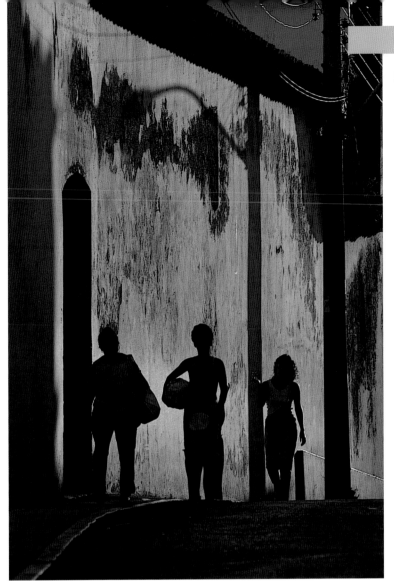

BACKLIGHT

One kind of lighting that often produces great photos is backlighting. Also called contre-jour, this lighting must be treated with care but can produce stunning results in all kinds of situations. The key to its appeal is the fine halo of light that it draws around the outline of everything in its way, whether it be a tree, a blade of grass or a person. This effect is also known as rim-lighting. It is often accompanied by long shadows stretching towards the camera.

The biggest problem with backlighting is knowing what exposure to set on the camera. Meter for the light background, and the subject will record as a silhouette. Expose for the subject, and the background will take on a washed-out look. Or use flash to light the subject (if it's at close range) and balance it with the background. There's no right or wrong. It depends on the effect you want. With backlighting, it's best to bracket your exposures as there's so much subjectivity involved.

Left: Stained glass windows are best lit with diffused daylight.

Far left: Early morning and late afternoon sun provides low, warm illumination that looks great in photos. In this shot, taken with a 200mm lens in Salvador, Brazil, the subjects are almost silhouettes.

MODIFYING LIGHT

There's no rule that says you have to stick with the lighting that you're given. One of the skills of a photographer is moulding and shaping the light to suit the subject. Outdoors this is not as easy as in the studio, as you're not in control of all the factors, but there are methods.

The simplest is to use a reflector. This is simply a sheet of white, silver or sometimes gold material which you hold up beside your subject and allow the light to bounce off and into the shadow areas of your subject. Tiny mirrors (such as make-up compacts) can add small spots of light to selected areas.

An opaque sheet placed between the sun and the subject acts as a gobo, blocking out direct light. A translucent screen in the same position becomes a diffuser. These devices can be bought commercially, or just as easily made from sheets of paper, fabric or tin foil.

STUDIO LIGHTING

This topic could be the subject of a whole book on its own. Studio photography appeals because of the total control it offers over the lighting. In days of old photographers used banks of bright but hot floodlamps, but, although these are still available, flash is now more used because it's cooler and more powerful. Studio photographers can use as many lights as they like to achieve exactly the result required.

Each head can be fitted with one of dozens of modifiers to create exactly the effect required. You want a hard light? Try a dish reflector. Prefer a narrower beam? Use a snoot or focusing spot. Something soft? A white or metallic umbrella. Softer still? One of various sizes of softbox. The hardness of the light can also be controlled by its distance from the subject. The further away it is, the smaller (and therefore harder) it becomes, though for every doubling of distance, the brightness drops by a factor of four.

Left and right: The natural world is, not surprisingly, the most popular subject for macro photographers.

Above: Depth of field is often very shallow at close range.

Macro (Close-up)

There's a whole world of beauty and wonder going on right under your nose, if you can only get close enough to see it.

UP CLOSE AND PERSONAL

Small definitely IS beautiful, and macro photography is the proof. Close-up pictures of small details have an almost universal appeal because they show us a world that we are often too busy to notice as we go about our lives. They are a reminder of what a beautiful and amazing world we live in.

Nature provides a rich mine of potential subject matter, from plants and flowers to tiny insects and animals. As well as photographing very small subjects, macro also lets us magnify the fine detail of bigger ones too: the texture of tree bark, the feathers of a bird, the toes of a baby.

The human landscape makes a great subject for macro, from a close-up of an eye to the pores and goosebumps of skin.

Even seemingly mundane man-made objects, such as cars and toasters , can be shown in a new light by homing in on interesting design details. With macro, the world is your oyster.

GETTING CLOSE

The first place to visit for close-up photography is the macro setting on your camera. Technically speaking, a subject is only at true macro when it is recorded at life size on the sensor, but years of misuse of the term by manufacturers means that it now means anything closer than the norm.

Although all cameras have a macro setting, the actual shooting distance this provides varies between models, encompassing anywhere from 1cm to 50cm. If your camera won't allow you to get as close as you'd like, you can buy inexpensive supplementary close-up lenses (resembling filters) which can be fitted to the front (via an adaptor if you don't have a threaded lens).

For SLR users there's more choice. For serious close-up fans, dedicated true macro lenses can be fitted, providing excellent quality. A cheaper alternative is a set of extension rings which fit between body and lens and reduce the minimum focus distance, with only a minor loss of light.

VIEWING YOUR SUBJECT

The viewfinders of non-SLR cameras are not suitable for use in macro work, because they see a slightly different view to the lens (being positioned to one side of it). In normal shooting this difference is minimal, but up close it's quite significant. The only exception is electronic viewfinders, which do show you the view that will be recorded on the sensor. Otherwise the best bet is to use the LCD monitor on the back of the camera. Obviously SLR users are best served by using the TTL viewfinder .

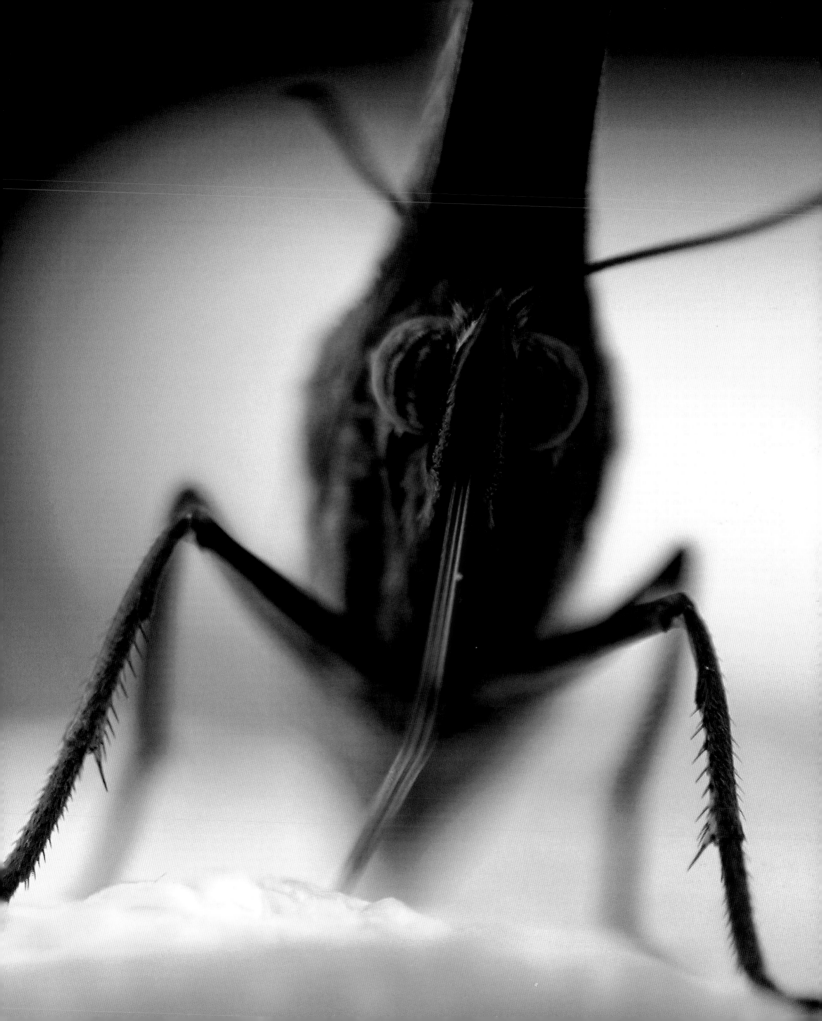

<< LIGHTING

So you can't use flash, what does that leave? As always, natural light is usually the best solution, and it's free. If shooting indoors, work near a window or in the conservatory. Whether inside or out, with intricate subjects diffused daylight is best. High-contrast directional sunlight will make it hard to see fine detail, though it's great for semi-translucent subjects if you get the light behind them. Whatever the lighting, when working at close range there's a risk of you casting a shadow over the subject, so try not to block out the light!

remote release

Camera shake is a big problem with macro photography. Minimise it by using either a remote release to fire the camera or setting the self-timer. Working outdoors, create a simple windbreak to prevent the breeze from blowing the camera at the vital moment.

CAMERA SETTINGS

Apart from selecting the macro position on the camera (in the case of compacts) or on the lens (with SLRs), what else needs to be set? Well, the first thing to do is switch off the flash. At close range the flash is likely to be to one side of the subject, and is liable to miss it altogether. Which is just as well, because fired at such close range it will blast your subject to oblivion, overexposing it and destroying any subtlety and fine detail. Manual exposure is recommended, or at the very least, aperture priority, so you can select the smallest possible aperture. Some cameras have a macro subject mode, which automatically selects the optimum camera settings for you.

Finally, a tripod (or minipod) is an essential accessory. With small apertures come long shutter speeds – probably too long to handhold, and in any case the depth of field will be quite shallow so keeping the subject in focus will be difficult without a fixed support.

DEPTH OF FIELD

A strange side effect of focusing on subjects at very close range is that the depth of field (that zone of sharp focus) disappears from, at its best, several metres (for distant shots) to a matter of millimetres. This phenomenon is both a blessing and a curse. It may not be possible to get everything in focus from front to back (especially with wide subjects such as rose blooms), but the shallow area of focus that you get can not only look great but has the effect of focusing the viewer's attention on exactly that part of the image that you wish them to look at.

There are ways to maximise your depth of field, most notably in the angle that you choose to shoot at. Get the subject more flat-on, and you'll get more of it sharp than if it's at an oblique angle. With more 2D subjects, such as leaves, depth of field is less of a problem, but it's still important to stop down, as this also increase the sharpness of the image towards the edges of the frame.

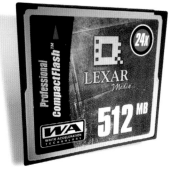

Top: The xD Picture card, developed and used by Fujifilm and Olympus, is the smallest of all the formats.

Left: Memory Stick, in its various forms, was invented by Sony and is used mainly in their own cameras.

Below left: CompactFlash is the most popular format for digital SLRs.

Below Right: Secure Digital (SD) is the most common format for mass market digital compacts.

Memory Cards

The memory, or media, card stores the images taken by your digital camera. There are several different types.

ON THE CARD

The earliest digital cameras had internal hard disks for storing the images that had been taken. The trouble was, once the disk was full you could not take any more pictures until you emptied it.

Removable media cards were the perfect solution since, once full, they could be replaced with a new one. Various manufacturers have invented cards of differing sizes and designs, none of which are compatible with one another. There are currently a handful of different formats in widespread use, and each has its own merits, but none is so superior that it should strongly influence your choice of camera – unless you already have a stack of one particular type.

Whatever card your camera uses, you'll need at least two, not just for when you fill your main one but because, although reliable, they can fail.

Buy as big a memory card as you can afford – at least 128MB is recommended for cameras with sensors over 3 megapixels.

PROFESSIONAL CARD TYPES

CompactFlash (CF): CompactFlash is the largest of the common formats. It was once the most popular but smaller rivals, more suited to use in pocket-sized compacts, have sprung up in its wake. It is still, however, the only real choice for professional and enthusiast SLRs and high-end prosumer cameras, where size is less of an issue and users probably prefer a card that won't get lost in the seam of their pockets.

CompactFlash cards are, per megabyte, less expensive than most other cards and have high maximum capacities too, with 4GB cards in widespread use. There are two types of CF card, Types I and II, with Type II being slightly thicker. Both cards use the same slot in the camera.

Microdrive (MD): These are actually tiny hard drives containing a moving disk in a CF Type II-sized shell. Not being solid state, they're more fragile but offer high capacities at a lower price than CF cards, and fit in the same slot.

CONSUMER CARD TYPES

Secure Digital (SD): The format championed by Panasonic and others, SD is far and away the most popular card choice for consumer compact digital cameras. Like Memory Stick, SD cards also fit a wide range of other devices, from TVs and DVD players to PDAs.

xD PictureCard (xD): A joint venture between Olympus and Fujifilm, fingernail-sized xD cards are the smallest of all (too small, some may say), and have a claimed potential capacity of 8GB!

Memory Stick (MS): Sony's own format, used by a couple of other companies. The original MS card had a maximum capacity of 128MB, but new variations, such as MS Pro and MS Magic Gate, have overcome this problem. MS Duo is a half-size version designed for very small devices.

SmartMedia (SM): Almost no current digital cameras use this format. Its weaknesses are its limited maximum capacity and the possible risk of damage due to its exposed contacts.

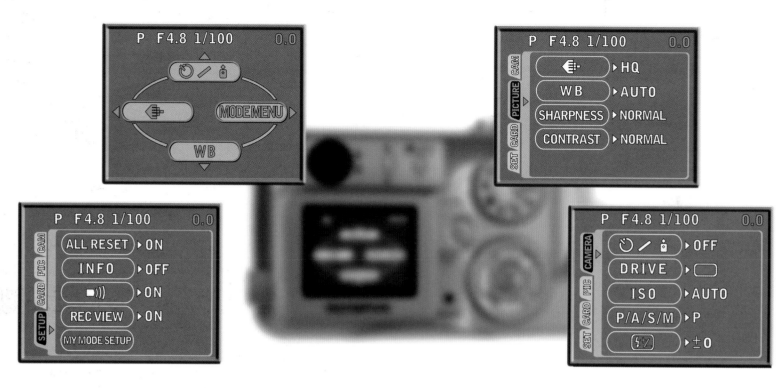

Menu Items

The average digital camera menu seems to offer
everything that you can think of – except a vegetarian option.

WHAT'S ON THE MENU?

Most digital cameras offer many more fea-
tures than can be found via the buttons on
the outside. Within the menu is a feast of
extra functions, many of which allow you to
customise the camera in the way you prefer.

Of course, all cameras vary. Some point-
and-shoot cameras offer only a basic menu,
while others contain three or four pages of
options. Some cameras can have even
multiple sets of menus and sub-menus to
allow complete fine-tuning of your camera s
features. The most common controls are
listed here, though in certain cases some of
these functions can be accessed by buttons
on the camera s body.

Menus are subdivided into categories of
similar functions. The hierarchy tends to
begin in the mode the camera is set to: both
record and playback modes have their own
set of menus and usually share access to the
camera s set-up menu.

THE SET-UP MENU

The set-up menu is the first stop when the
camera is taken out of the box. Among other
things, this menu sets up the camera to work
in your time zone, your language, and to your
country s video standard, NTSC or PAL.
Some cameras allow you to even change the
tones and shutter sounds of your camera, like
changing the ring tone on a mobile phone.
Date and Time: This must be set properly so
that the EXIF header in the image file is
accurate. EXIF is a file format that contains
the shooting data of your image, including
date and time, exposure information, image
dimensions and much more.
Language: Which language would you
like your menu to communicate in? This is
usually set to the language of the country the
camera was bought in.
LCD Brightness: Adjusts the brightness of
the LCD monitor on the back of the camera.

exposure compensation

One of the most useful features within the camera menu is Exposure Compensation, although on SLR cameras it's more likely to be found on the outside of the camera body. This allows users to override the metered exposure by a preset amount – ideal for situations where the camera is likely to get it wrong (as above). A variation on this theme is auto-bracketing, where the camera takes three shots – one at the metered exposure, one above and one below. (For more on metering, see page 82.)

RECORD MENU

In Record mode, the menu's main function is to give you access to the camera's shooting options. Many functions are only occasionally used, so are better hidden away in the menu rather than cluttering up the body as buttons. A few useful ones are:

Metering: The camera's default multi-segment metering is fine for most purposes, but you may wish to switch to, say, spot metering in tricky conditions.

White balance: Daylight and artificial light are all different colours, and the camera needs to know which you're using. Most have an auto white balance, plus presets for daylight, tungsten, fluorescent, cloudy etc.

Image Size/Quality: Allows you to select the image size you want to shoot at, the file type (JPEG, RAW or TIFF) and degree of compression (usually called 'Quality') for JPEG files.

Scene modes: Many cameras have a set of scene or picture modes, giving the optimum camera settings for common subjects. Typical scene modes include Portrait, Landscape, Action/Sport and Night scenes with flash.

Colour: Images don't always have to be captured in their true colours. On some cameras you can change the saturation, add sepia tones and even shoot in black and white. The in-camera contrast and sharpness levels can be fine-tuned, too.

Exposure Compensation: Despite the accuracy of most exposure systems, the camera can sometimes get it wrong. Subjects with a lot of bright or dark areas may need to be compensated for by increasing or decreasing exposure. Some models also feature auto exposure bracketing (AEB), taking a succession of (usually three) shots at normal exposure, plus under- and overexposure.

PLAYBACK MODE

In Playback mode the camera allows you to scroll through your images and, using the menu, you can store, delete or select them for printing.

Delete: One benefit of digital cameras is the ability to delete or 'trash' unwanted photos, saving memory and printing costs. You can delete a single shot or the whole card.

Info: The shooting data can be viewed on screen. Often a histogram, an electronic representation of the image in graph form, can also be viewed as an exposure aid.

DPOF: Digital print order form is a way of preselecting images to print later. High-street labs recognise the DPOF information and only print the pictures you have selected.

Slide Show: A way to view all the images you have taken in a timed sequence.

Folders: Photos can be saved to different folders, to keep them separate.

Metering Systems

How does your camera know how much light a picture needs?
By measuring it using a sophisticated metering system.

OVERRIDING YOUR METER

There are several ways to ensure that the camera gets it right. The first is to learn to recognise the types of situation that cause problems.

When a camera meter is fooled by a subject, the simplest solution is to use Exposure Compensation (assuming it isn't buried somewhere in the menu). This tells the camera that you would like to give the sensor more light or less than it thinks it needs, and you can set any value up to about two stops either way (over- or underexposure). You can leave it set until you no longer need it, but don't forget to reset it for the next time you use it.

With some cameras the exposure lock feature may be more accessible. To use this feature, point the camera at a mid-toned area, such as your jacket, and press the lock. The camera will take a reading and keep a note of it. You can then move the camera to take the picture and shoot at the pre-locked exposure setting. When you let go of the button the camera will reset itself.

CHECKLIST

METERS TRY TO TURN EVERYTHING MID-GREY
MOST SCENES HAVE AN EVEN RANGE OF TONES
VERY DARK OR LIGHT SUBJECTS FOOL THE METER, AS DO BRIGHT OR DARK BACKGROUNDS
MULTI-AREA METERING IS LESS EASILY FOOLED
BRACKET YOUR EXPOSURES IN TRICKY CONDITIONS
TAKE A SPOT READING FROM KEY ELEMENTS

IT'S ALL ABOUT THE LIGHT

A sensor needs just the right amount of light to make a good picture. Too much, and the light areas will be washed out; too little, and the darker areas will not have recorded their presence (see page 48). In order to determine what combination of aperture and shutter speed will provide enough light for the picture (correct exposure), it must measure the intensity of the light present. It does this using light-sensitive cells not unlike those on the sensor. As light hits the cell it produces an electrical signal proportional to the brightness of the scene.

Camera meters work on the principle that most scenes contain a roughly equal proportion of dark and light bits, and that if all the tones in a scene could be mixed together in a bucket, the resulting porridge would be neither light nor dark, but halfway between the two – known as mid-grey. Once a reading is taken the camera adjusts the exposure until the tones on the sensor add up to mid-grey.

WHEN METERS GO BAD

That's all very well in theory, and it works well most of the time. If you go through your photo album and look at your photos in terms of tones rather than colours, you'll see that people, grass, trees, buildings etc all mixed together are pretty grey. But not all scenes contain an even spread of tones. A sandy beach, a snow-covered landscape, a singer spotlit on a dark stage – these are prime examples of scenes that would not add up to mid-grey. The camera, however, not knowing any better, will try to turn them grey anyway.

Some cameras have devised cunning strategies to solve the problem. The first is to take dozens of readings from all over the scene, analyse them and compare them with a database of possible scenarios. This is multisegment metering. Plan B is to offer a spotmeter which measures a tiny portion of the scene, and which the user can point at the most important part of the picture (or an area of mid-grey) for a selective reading.

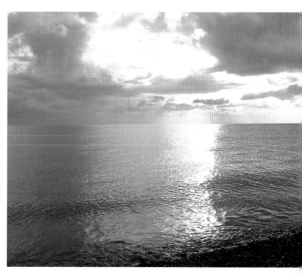

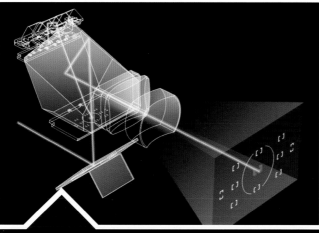

Far left: Very bright subjects such as this sunlit white building cause problems for meters, which tend to try to turn them into a mid-grey tone.

Above: Very dark subjects are equally problematic for built-in exposure meters, which tend to overexpose them.

Far right: In tricky metering situations it's a good idea to bracket your exposures. Shoot one at the metered setting, plus one over and one under that value – adjusting either the shutter speed or aperture.

Left: Situations where the camera's meter is likely to get it wrong include shots of people against very bright backgrounds (top) and very dark ones (bottom).

metering patterns

Most cameras offer a choice of three metering patterns: average, spot and multisegment. For general shooting the latter is the most reliable. If your camera offers auto-bracketing, this can be useful insurance with difficult subjects. The camera takes three or more shots in succession: at the 'right' setting, plus above and below that. If your camera doesn't have this, you can always bracket manually, using exposure compensation. (For more on apertures, see page 21.)

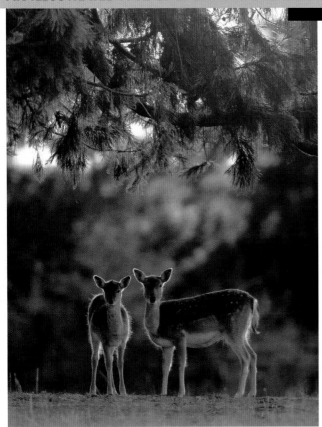

Left: For nature shots you need a long telephoto or zoom lens, plus lots of patience.
Above: The beautiful, rustic colours of autumn make it one of the best seasons for nature photography.

Nature Photography

Getting good pictures of beautiful and exotic wild animals can be very difficult indeed, but the results are well worth it.

CHECKLIST

VISIT YOUR LOCAL PARK FOR SUBJECTS
USE A MACRO LENS FOR FLORA CLOSE-UPS
A TELEPHOTO ZOOM IS USEFUL FOR WILDLIFE
DIFFUSED LIGHT IS BEST FOR DETAIL SHOTS
IN BRIGHT SUN TRY SHOOTING CONTRE-JOUR
SET UP A HOME STUDIO FOR CLOSE-UPS
BE PATIENT AND TAKE LOTS OF SHOTS

BASIC EQUIPMENT

Nature photography is a very broad subject, encompassing landscapes at one end of the scale and wildlife at the other. In the middle is the fare pursued by most amateurs: plants, flowers, trees, small bugs – basically the things that can be found in any park or garden.

These subjects can be pursued with relatively modest equipment and with little or no need to travel great distances, even for urban snappers. Most digital cameras come with everything you need for all but the most demanding subjects: a built-in macro for pictures of flowers, leaves, small insects and so forth; a zoom lens so you can isolate a single bloom and throw the background out of focus, a flash for fill-in on a harshly lit day.

For most nature subjects a tripod is perhaps the single most important accessory, especially when working at relatively close range. Reflectors are very useful too, for filling in shadows or blocking out direct sunlight.

NATURE OUTDOORS

The best kind of light for most nature subjects is soft, diffused illumination of the sort you get on overcast days. In bright sun, head for the shade.

Use reflectors to bounce soft light back onto the subject, and experiment with the placement to see how it changes the modelling. On windy days a reflector can also act as a windshield. Wind is one of the biggest challenges with lightweight subjects such as flowers. Some nature snappers use a thin stick or piece of wire to hold the subject still for long enough to get a sharp picture.

In bright light conditions translucent subjects such as leaves and petals can look great backlit, when they take on a lovely, luminous quality. Care must be taken with exposure in these conditions, though. Bracket your shots and check your LCD screen.

Nature is an all-year-round subject. Autumn colour and winter frost can all show your local green space in a different light.

KNOW YOUR SUBJECTS

The best nature photographers are also good naturalists. You'll dramatically increase your chances of getting good nature shots if you have an understanding of what you're photographing. Many of the world's top nature photographers are actually trained botanists or zoologists.

One way to learn about your subjects is to concentrate, at least to start with, on your local area. Frequent visits and careful observation will enable you to learn what kinds of flora and fauna haunt the locale, whereabouts it can be found and at what time of the year. Visit the library for books on local nature, perhaps join a local nature conservation group (most areas have one), and talk to the other members. Research and study are equally valuable when travelling further afield for your subjects.

wildlife parks

Local wildlife parks and nature reserves are a good place to go to photograph wild animals that would be difficult to capture otherwise. You'll need a decent zoom lens so you can crop in tightly and exclude any unsightly man-made intrusions, such as fences, bars and concrete. Try to find a spot which excludes as much of the environment as possible, unless it's in keeping with the natural habitat of the animal. (For more on wildlife photography, see page 134.)

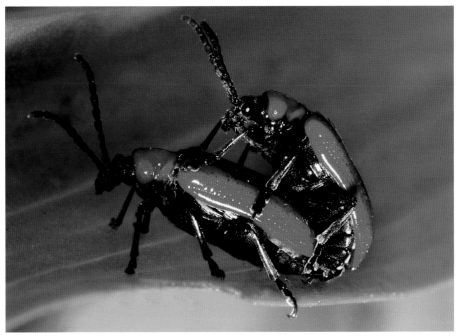

NATURE INDOORS

One of the best places to photograph the natural world is, surprisingly, in the comfort of your own home. Setting up a simple home studio is very easy, offers total control and can be used in any weather conditions, rain or shine.

The easiest place to set up is near a window. North-facing windows offer the advantage of indirect light. Otherwise, a simple net curtain or piece of muslin can be used as a diffuser. Once again a reflector, either bought or home-made, can be very useful. Some photographers use flash or tungsten lights for ultimate control but, while useful, these are by no means essential.

Pick simple, uncluttered backgrounds, or make your own. Plain white is always a good choice. If you have a lightbox you can use this, but mask out the areas around the frame to avoid flare. Wood, leaves and other natural subjects are a good choice, too. Use a tripod, zoom in close, and concentrate on the composition.

Left: Neon lights are a great subject for photography. Here, they were cleverly caught reflected in the bodywork of a car

Above: Buildings often look better at night than in daylight. This was taken without a tripod, by holding the camera against a tree.

Night and Low Light

Who says you need sunshine to take pictures? Some of the most amazing shots are taken at night.

CHECKLIST

- A TRIPOD IS ESSENTIAL
- SHOOT AT DUSK FOR BEST RESULTS
- SELECT MANUAL EXPOSURE IF POSSIBLE
- USE A REMOTE RELEASE OR THE SELF-TIMER
- SHOOT MOVING SUBJECTS LIKE FAIRGROUNDS
- WITH FIREWORKS, GET SEVERAL BURSTS IN A SHOT
- INDOORS, TRY A HIGH ISO AND NO FLASH

NIGHT IN THE CITY

Cities come alive at night. In the daytime they can look dirty, and traffic and crowds can spoil your shots. At night the lights come on and the drabness is lost in the shadows.

The first requirement for night photography is a tripod, as exposure times may be in seconds. Arrive at your location at dusk, before it goes dark. Dusk skies, with their deep orange or blue hues, look nicer than jet black ones, and the light level is sufficient to ensure that unlit parts of the buildings don't disappear into the blackness.

LIGHTS, CAMERA, ACTION

Buildings are obviously the main focal point in low-light photography, both individual buildings and skyline vistas. For the latter it's worth spending time to find a great viewpoint. With coastal cities this may be the waterfront, otherwise a high viewpoint, such as the top of a hill, is an ideal spot. Set up your tripod and compose your shot to exclude large unlit areas, such as parks, as these will dilute the impact. With single buildings try to find an unobscured viewpoint. With tall subjects an elevated position will reduce the risk of perspective distortion – or perhaps you may choose to exaggerate this.

Exposure times at night are a matter of trial and error, but with an LCD monitor you can check on your progress as you go. Stop down to about f/8 and try an exposure of about 5sec as a starting point. Or use Auto and let the camera decide, then make adjustments accordingly, using Exposure Compensation

TRAFFIC TRAILS

One of the most enjoyable activities in night photography is shooting traffic trails, where car head and tail lights make dramatic red and yellow streaks across the frame. For the best results choose a spot with plenty of free flowing traffic, like a busy main road. (Stationary cars obviously don't leave a trail so avoid junctions.) With the camera on a tripod, set the shutter to B (or a speed of at least 5 seconds). Remember that approaching cars leave a yellowish trail, and cars going away from you leave a red one.

slow shutter speed

Fairgrounds are a great place for night photography. The fast-moving lights provide enormous scope for experimentation. Set the camera up on a tripod, stop the aperture right down and expose for several seconds. Review your efforts on the LCD and reshoot if necessary. (For more on shutter speeds, see page 116.)

SHOOT THE MOON

Photographers are often disappointed when they work hard to include the moon in their night shots only to discover that it's just a tiny speck on the print. The truth is, the moon is further away than it appears, and to record it at a decent size you must shoot at the telephoto end of your zoom .

Photographing the moon itself is a different matter. To fill the frame you'll need a lens with a focal length of well over 1000mm (35mm equivilent). With a 10x zoom camera combined with the digital zoom, you may get close but with reduced image quality. If you have an SLR, fitting a teleconverter between your camera and lens will increase its magnification by 1.4x or 2x.

Once you're set up, your exposure will be more brief than you may imagine. The moon is quite bright, and it's moving, so too slow a speed will produce a blurred result. Try an exposure time of around 1/30sec at f/8 (at ISO 100) as a start, and adjust from there.

Right: You need a very long lens indeed to get the moon as big as this in the frame. Moon shots are useful for adding to the skies of other night shots.

LOW-LIGHT INTERIORS

Night photography doesn't just happen outdoors. There are plenty of nocturnal subjects indoors too – rock concerts and stage shows, for example. Assuming you have obtained permission, a key difficulty is that the light may be low, but you can't use a tripod, and your subjects are moving around anyway. Flash is not an ideal solution as it kills the atmosphere and is probably forbidden, which leaves just one option: the ISO rating. Racking up the ISO to 800 or 1600 to give you a hand holdable shutter speed (at least 1/30sec) is a luxury that not all cameras offer, and it also greatly increases the noise (graininess) in an image. But while this does degrade the quality, it can add to the atmosphere.

Experiment with white balance settings. In theory you should be on the tungsten setting, but with gel-coloured lights that's academic really. With other nocturnal subjects, such as candlelit bars, the same principles apply.

FIREWORKS

Fireworks shots can look spectacular. For best results the camera should be on a tripod, set to manual exposure and B. Frame your camera on where you expect the fireworks to be, set the lens to manual focus at infinity and the aperture to about f/5.6. Don't zoom in as it's impossible to predict exactly where fireworks will explode. As the fireworks go off, keep the shutter open for several seconds. If you don't have B, try a time of 5–10sec. If you have a multi-exposure setting, try getting several bursts on a single frame for a more dramatic shot.

Left: The same scene shot on the same camera, but with the sensitivity set to ISO 100 (far left) and ISO 800 (left). Note the increase in noise, especially in shadow areas.

fringing

Most digital cameras can, in some circumstances, produce a visible halo around objects in a scene. Usually a purple colour, this 'fringing' most often occurs with detailed, high contrast subjects (eg foliage against a bright sky). Some cameras suffer more than others with this, but it can be removed at the editing stage.

Noise and Grain

'Noise' isn't about the beep your camera makes when you turn it on. In fact you can't hear it, but you can certainly see it.

WHAT IS NOISE?

Noise can be described as visible electrical interference in a digital image. It manifests itself in various ways, but most often as tiny coloured speckles or faint marbling in shadow areas or large areas of uniform tone. There are several causes; some you can control, others you cannot.

Noise indicates an inherent fault in the sensor. It can be caused by heat generated by the sensor, or contamination from neighbouring pixels. Small sensors are more prone because the pixels are closer together, and the more pixels on a sensor the smaller each one needs to be. Smaller pixels have less light-gathering power so the signal must be boosted, causing more noise. This is why when a camera's sensor is increased from, say, 3–4MP on the same size chip, the noise level rises. Bigger chips have physically larger pixels which are also slightly further apart, producing a better signal-to-noise ratio for each pixel and less risk of cross-pixel contamination.

OPERATIONAL CAUSES

Increasing the ISO rating on the camera also increases the noise level. This is because, when we raise the ISO we are boosting the sensor's sensitivity by increasing the amplification. As we amplify the signal, we are also amplifying the noise inherent in that signal.

Low-light photography also poses problems. The longer we allow the sensor to collect the weak signals from the scene, the more background noise it also picks up, to the point where the background noise level can exceed the signal.

Noise can affect certain colour channels more than others. As most sensors tend to be less sensitive to blue light than to red or green, the blue signal is often amplified more than the others, increasing noise in the blue channel.

The JPEG file format can also make the problem worse, as its compression algorithm does not respond well to noise and creates further distortions to the purity of the image.

GETTING RID OF NOISE

Although noise is inherent in any electrical system, and can never be completely eliminated, some cameras manage to control it better than others, so that in normal shooting conditions it isn't visible to the naked eye.

In order to overcome the problem of noise in digital images, manufacturers have incorporated 'firmware' (software built into the camera) to reduce it. For example, some firmware is programmed to recognise noise in areas of solid black, and 'fills in' these areas.

Other manufacturers apply a slight softening or blurring over the image to hide the noise, which can make the image seem a little less sharp. This filter can usually be turned off in the camera's set-up menu if not required.

Noise can also be reduced after the image has been taken, using editing software such as Photoshop. In addition, various third-party software developers produce anti-noise filters.

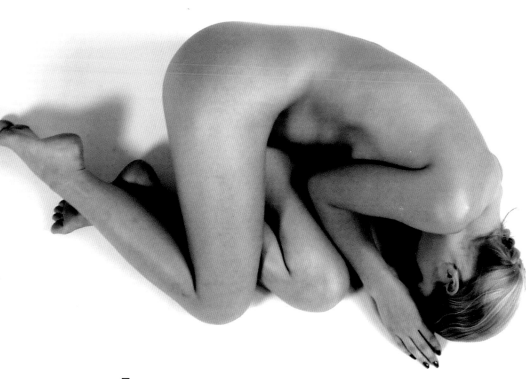

Left: Classic nudes are concerned with the shapes, lines and textures of the human body, and treat the torso as a landscape or still life.

Above: It isn't only women who make good subjects for the nude. Many classic nudes are of men – think of Ancient Greek statues!

Nudes

The nude is, and has always been, one of the greatest inspirations to artists throughout history, and its popularity will never wane.

BEFORE YOU START

The nude can be one of the most challenging, but ultimately rewarding, of subjects. Classic nude photography (as opposed to cheesy glamour photography, which isn't covered here) is about shape and form, light and texture. A nude may show the face, the torso, or just an abstract detail. It can be erotic, but it doesn't have to be.

The first hurdle is finding a model. A professional model is a good idea, especially if you're a novice. Their experience will give you confidence. Asking friends costs less but can be problematic. If you have a portfolio of previous work, this should convince the model of your good intentions.

Before the shoot discuss with the model what you'd like to achieve. Show photos and tear sheets that you may have seen and been inspired by. A planned shoot is more likely to be successful. On the day of the shoot tell the model to avoid wearing watches, tight fitting underwear etc, which will leave unsightly marks on the body.

INDOORS OR OUT?

The easiest place to shoot is indoors, in either a home or hired studio, with lighting and a proper background. In a studio you have the benefit of being able to create exactly the lighting you want. Keep the set warm, not only for the model's comfort but to avoid the problem of goosebumps on the skin.

Indoor locations can be more 'real' than the contrived setting of a studio, and consequently more erotic, but you first need to find a good location where you will not be disturbed. Once there, it's a matter of using the light that's there to best effect, rather than creating it. Window light is always a good choice, but keep a lookout for distracting backgrounds.

Outdoor locations are more problematic due to the need for privacy. Early mornings or isolated locations are best. Ruined old buildings, quiet rocky coves, woodlands and cornfields are all a good place to start.

THE SHOOT

There's a world of difference between the poses and expressions used in glamour photography and in art-based nudes. The latter often takes its cue from fine art, and is as much an exercise in light and composition as it is an appreciation of the human form.

The lighting is crucial to the success of a nude. The human body is full of nooks and crannies that will expose bad lighting. Soft, diffused light is easier to manage, although less dramatic. Make sure it has some direction. Place it to the side and use reflectors to fill in the shadows, or place it behind to create rim lighting and fill in the front. Harder light sources are better at revealing texture, especially glancing across the skin from an angle.

Abstract details are in some ways easier than shooting the whole body, and require less space. Try to create interesting shapes, study the lines and curves, and use the light to accentuate them.

FAMILY ALBUM

A huge growth area in recent years has been in software that enables you to file and organise your photos. These inexpensive programs enable you to create folders, called albums, and view the contents of each one in thumbnail form in the main window. Clicking on the thumbnails opens up the full screen version. Most albums use 'metatags', which allow you to add searcheable keywords to images (these don't affect the file name). Each image can have several keywords, (eg 'kids', 'holiday', 'Jack'). With most album software you can create slide shows, make prints at home or order them online, and burn CDs.

It's essential to archive your images to CD on a regular basis, or you stand to lose them if your PC goes wrong. The software keeps track of which ones you've copied to CD, and reminds you when it's time to burn the next batch. It will also tell you the name of the CD that the hi-res version of each thumbnail can be found on.

Organising and Filing

Shoe boxes under the bed are all very well, but digital cameras make it easier to keep your photos better organised.

AN ORGANISED MIND...

It is estimated that the average British home has around 1,500 photographs knocking around. It's a fairly safe assumption that probably less than 10 per cent of these have found their way into a photo album. The rest are squirrelled away in various drawers and cupboards. Even if they were all in albums it would be difficult, unless you were unusually obsessive about filing, to quickly lay your hand on a specific picture. Should we find that elusive print, and decide that we'd like to make another copy for Auntie Mabel, the next task is to find the negative. Assuming you could find it, you'd then have to hold it up to the window and decide, through squinting eyes, which of the seemingly identical negatives from the sequence is the right one.

Digital photography takes all this hassle out of keeping track of your images, and you can file and organise them for little or no expense. Here are a few tips and suggestions for keeping tabs.

WAYS TO KEEP TRACK

Camera numbering: Every digital photo you take is automatically numbered by the camera.

Normally the numbering starts again from 0001 every time you clear your memory card, but with many cameras you can set it up to keep going from where it left off. The benefit of sequential numbering is that every image you ever take on your camera will have its own unique number, and you won't have several dozen images on your PC all called 0001.

Naming files: Adding a name to each of your files either instead of or preceding the number makes them easier to identify. You could give them categorising names such as 'kids' or 'Lon' to denote London. Or add the year it was taken.

Filing on the PC: Once named, you can easily create a set of folders on your PC for each type of picture you take (one for kids, one for London etc). Naming your files also makes them searchable, so you can find them easily.

Output Your Images

You've got your pictures onto your computer,
you've got them looking just right. So now what?

WHAT IS OUTPUT?

Output is all about what you do with your digital images once you have finished editing them. It's about their final destination. There are various options open to you, the most obvious of which is to print them. You can either do this at home on your inkjet or dye sub printer, or get them done at a high-street or online lab (see pages 106–109 for more on printers and printing). But with digital photography, your pictures do not have to end up on paper at all. Here are some other endings.

WEB AND E-MAIL

There are no statistics on this, but it's quite probable that in the digital age more photos are e-mailed to friends and relatives than are ever printed. Once your shots are on the PC you're only ever a couple of clicks away from sending them to everyone you know. Photos are quite large, however, and can soon fill up your inbox. A better solution for sharing over the Internet is to set up a Web gallery, or use one of the many image gallery service providers on the Web.

MAKE A SLIDE SHOW

Remember the days when photographers would set up the projector, draw the curtains and 'treat' their family and friends to a slide show?

You can now do this digitally. Most photo album applications offer a slide show feature where you create a folder of chosen images, order them and run them on your PC, but you can go further. With the right software you can add fancy titles and graphics plus music, burn them onto a CD or DVD and watch them on your TV.

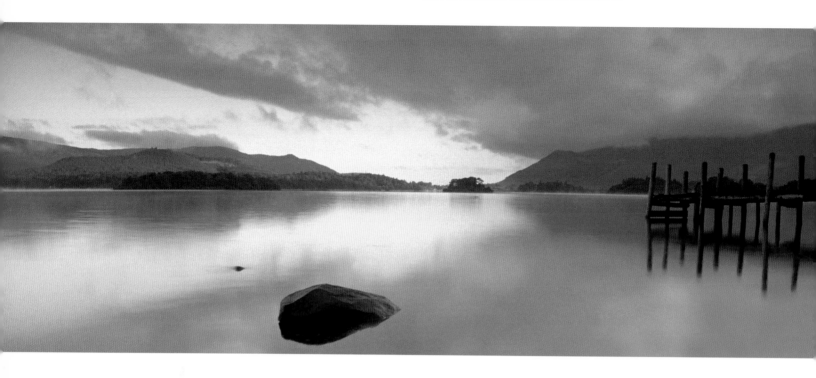

Panoramas and Joiners

Long, narrow, panoramas and multifaceted joiners have
been around for years but now they're easier to do with digital.

CHECKLIST

USE PANORAMAS TO SHOW WIDE VISTAS
LOOK FOR SCENES WITH SEVERAL FOCAL POINTS
USE A TRIPOD FOR ACCURATE PLACEMENT
SET MANUAL EXPOSURE AND FOCUS
OVERLAP EACH SHOT FOR EASIER ALIGNMENT
AUTO STITCH ON SOME CAMERAS CAN HELP
MAKE A JOINER TO CREATE A 'PATCHWORK' LOOK

PLANNING PANORAMAS

Sometimes a lens just isn't wide-angle enough to get everything in that you want. Maybe you just can't get far enough away, or perhaps it's because you're standing in front of a magnificent view that extends all around you.

Photographers have always overcome this by taking a succession of overlapping images and joining them together later in the darkroom to make a very long, narrow print. Now, thanks to image-editing software, this 'stitching' process takes minutes rather than hours.

Most panoramas cover a field of view up to 180°, but it is possible to shoot 360° ones too, as long as you can find suitable subjects!

To make successful panoramas there are a few rules that must be followed. First, a tripod is highly recommended, ideally one with a pan and tilt head so the non-panning movements can be locked. Although with care it's possible to work without one, your results won't be as precise.

SETTINGS

When joining pictures together, it's important that they all be consistent in colour, contrast, brightness and focal length. For this reason you should shoot in the Manual Exposure mode, to ensure that the exposure doesn't vary between shots and that the depth of field is consistent.

Next, set the lens to manual focus, and set the focus distance to the optimum position (probably infinity or slightly closer). You can set the zoom to either the wide-angle or tele position, as long as you stick to the same position. However, it's easier to stitch moderate telephoto shots than wide-angles, as there is less perspective distortion. If the camera has an auto white balance feature, this too should be set to the appropriate manual position.

Once this is done, attach the camera to your tripod, which should be on flat ground so that the camera is perfectly level (a spirit level may be useful here).

PLANNING A JOINER

Joiners share many things in common with panoramas. For a start they're made up of lots of individual shots, but whereas panoramas are mostly joined along a single plane (usually a horizontal one), joiners are free-form. They can be any shape, width or height, and don't need even edges – in fact, the more random, the better. Unlike panoramas, where the point is to produce a seamless blend, joiners are more anarchistic, and revel in their disjointed, overlapping quality. With joiners it isn't always even necessary to ensure consistent colours and densities between images, since the aim is often to celebrate, rather than hide, their multifaceted nature.

That isn't to say that joiners are not planned every bit as carefully as panoramas. There may be anything from 10–10,000 shots to do, and it's important to ensure that all parts of the scene have been covered, with no unwanted gaps, even though gaps may be added later for effect.

SHOOTING A PANORAMA

Starting from the left-hand edge of your scene, take a series of pictures, rotating the camera on the tripod from left to right and taking care to ensure that the field of view of each succeeding picture overlaps that of the previous one by between 20 and 50 per cent. To help you, look for landmarks on the right-hand side of the frame that you can include on the left side of the next one. This overlap eliminates the risk of 'holes' and is used by the stitching software to match and blend the images seamlessly together later. (To learn how to create a panorama with Photoshop, see page 159.)

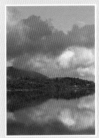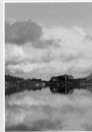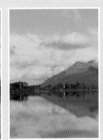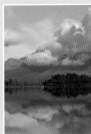

SHOOTING A JOINER

With joiners it's less essential to take every shot from the same viewpoint – indeed, it's usually preferable not to – so a tripod is not necessary.

However, it's a good idea to shoot in a methodical way. Perhaps draw an imaginary grid over your subject, and starting in the extreme top left corner of the grid (or the bottom right, it doesn't matter), shoot in rows, all the way across to the other side. When you reach the other end, move the camera to the next row of the imaginary grid and start again, continuing until the whole scene is covered. As with panoramas, it's best to build in some overlap, because the shots will, after all, be overlapping anyway, and you don't want to be left with any unplanned 'holes' in the subject that you neglected to photograph. Don't forget you can move around at will, tilting the camera if you want to, and even including the same passers-by in different frames.

Right: Panoramas can be vertical as well as horizontal in format.

Left: Joiners revel in their random, patchwork nature, but should be planned just as carefully as panoramas.

AUTOMATIC PANORAMAS

Some cameras feature an automatic panoramic stitching feature that helps you to get the best results with the minimum of fuss. In this mode the camera provides a useful guide on the LCD monitor to what you included in the previous frame, usually superimposing the right edge of the last shot on the screen so that you can line up the next one with it. This reduces the need to use a tripod, since you have a visual reference. Once you've taken the shots, some of these cameras even stitch them together for you automatically!

Left: This is a close up detail of a car tail light.
Right: The cracks of an Alaskan glacier make a dramatic pattern.
Below: A section of painted mural made an interesting image.

Patterns

Patterns are everywhere if we only look for them, and they make fantastic subjects for the camera.

SEEING PATTERNS

Pattern is one of the most powerful compositional tools available to the photographer. Patterns are about repetition – of shapes, colours, textures, all kinds of things. We barely notice the patterns that surround us as we go about our daily lives, but get out the camera and open your eyes, and you'll see them everywhere. As backgrounds patterns are often a bad thing, as they distract from the subject, but zoom in close and make the pattern your subject, and you could strike gold.

PATTERNS IN NATURE

Nature likes patterns, and is very good at making them. The veins in a leaf, bark on a tree, cobwebs, pebbles on a beach, cracks in dry earth... these are just a few examples. Animals are a great source of patterns, too. A visit to the zoo will offer the stripes of a zebra, the spots of a leopard and an infinite variety of other patterns.

Light can cast patterns that can look great in photos. Think of light shining through mesh, window slats or tree branches.

MAKING PATTERNS

The built environment has at least as many opportunities to photograph patterns. Buildings offer lots of potential not only individually (brickwork etc) but collectively (eg rows of windows or doors). Markets offer great opportunities, too.

At home, explore the possibilities of creating your own patterns. Shine a light through a wine glass and see what happens, zoom in on a slice of cucumber or rifle through the kids' toys.

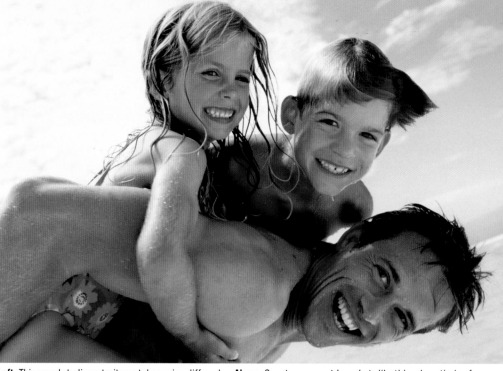

Left: This posed studio portrait was taken using diffused flash. Soft lighting is preferred for beauty photography.

Above: Spontaneous outdoor shots like this rely on timing for their success. Always keep a camera with you.

People and Groups

Here are some tips and techniques for photographing the world's most popular subject – your fellow human beings.

CHECKLIST

- PORTRAITS CAN BE POSED OR UNPOSED
- FOR POSED SHOTS FIND A SUITABLE BACKGROUND
- SOFT LIGHT IS MOST FLATTERING FOR PEOPLE
- HARD SIDELIGHTING SHOWS WRINKLES IN SKIN
- SHOOT CANDIDS FOR NATURAL MOMENTS
- TAKE LOTS OF SHOTS TO GET THE BEST EXPRESSION
- DON'T BE AFRAID TO ZOOM IN CLOSE ON FACES

POSED

There are two ways to photograph people: posed and unposed. With the latter, photographers react to natural situations, but with the former they create them. A posed portrait implies a degree of direction from the person taking the photograph, whether it is selecting the location and background, telling the subject what to wear, whether to sit or stand, and where to put their hands, in addition to creating or controlling the lighting. That's a lot to think about.

When directing a subject, think about whether you want a natural or stylised result. For the former, make sure the model is comfortable. Some people feel awkward standing, others prefer it. If you find that one type of pose is not working for you, vary it. Make sure hands look natural, and if you're struggling, give them something to hold. With the more contrived look of a fashion-type portrait, you're more free to experiment with shapes and poses, if the model has the confidence.

UNPOSED

There's a special skill involved in taking unposed pictures of people, revolving around the abilities of observation and anticipation. Candid photos also require the ability to blend into the background and not be noticed. Our understanding of social history over the last 150 years is based largely on the skills of great documentary photographers, whose images of urchins playing in the street and so forth are etched on our memories. These images also show us that not all unposed shots are taken without the subject's knowledge. Many of them are actually looking into the camera, and have simply been captured going about their business.

Although a long zoom is good for some candids, most documentary photography is actually done with wide-angle or standard lenses, which produce a more involved, less voyeuristic result. In these less innocent times, though, exercise caution when photographing people you don't know, especially children, as motives may be misconstrued.

LENS CHOICE

Tradition has it that portraits should be taken using a short telephoto lens, such as the long end of a 3x zoom lens. This is because this sort of focal length creates a little distance from the subject (for their comfort), produces a shallower depth of field (for less distracting backgrounds) and compresses perspective slightly (for a more flattering look). However, wide-angles produce a more dynamic, in-your-face look which is currently fashionable, though they do tend to elongate features such as chins and noses.

FRAMING

The classic 'telegraph pole growing out of the head' picture is one of the clichés of photography. It's all too easy to concentrate so hard on the subject that we fail to notice the distracting objects behind . The best place for portraits is one with a plain or non-intrusive background. This can be controlled to some extent by the viewpoint. For example, a portrait in a park can have a background of grass if the photographer adopts a high viewpoint, or sky if a low one is chosen. Bearing in mind your lighting needs, position subjects to get a neutral background. Then neutralise it further by selecting a wide aperture to render it out of focus. Don't put them too close to the background, or this won't work. At times when you want to show the background too (eg at the Grand Canyon), place the subject to one side of the frame and use a smaller aperture, but still check to make sure there's nothing sticking up directly behind the subject's head.

Left: This beautifully composed piece of observational photography perfectly conveys something of the subject's character and emotion.

get in close

Don't be afraid to crop in close to your subject, for a more intimate portrait. Zoom right in for facial close-ups. Look through magazines and you may be surprised at how many of the portraits even chop the top of the head off, with no detriment to the overall result! (For more on using zoom, see page 138.)

LIGHTING

Soft, diffused light is generally more flattering to people's faces. Outdoors, an overcast day is ideal, and in sunny weather the shade of a tree or north-facing wall will take the harshness out of the light. Avoid positioning subjects so they're facing into the sun – it makes them squint. If necessary, turn them so the sun is behind them. This produces a nice rim-lighting effect. Fill-in flash will add light to the face and add a catchlight to the eyes. Indoors, position your subject near a window facing diffused daylight.

EXPRESSION

The single most important ingredient in people photography is the subject's expression. It does not have to be a happy one, but it does need to convey some emotion – blank expressions rarely make for great photos. Our expressions are constantly changing every second, even if only in subtle ways. Even something as simple as a smile has an optimum moment for a photo

before it fades and withers. Add to this the fact that we blink every few seconds, and it's easy to see how the chances of success will increase with the number of pictures we take.

Get as big a memory card as you can, and don't be afraid to fill it up! Try different angles and viewpoints, interact with your subject to coax smiles and other expressions out of them. If your camera has a continuous shooting setting, you may find this useful as you can take several shots in quick succession if a great moment happens, such as spontaneous laughter.

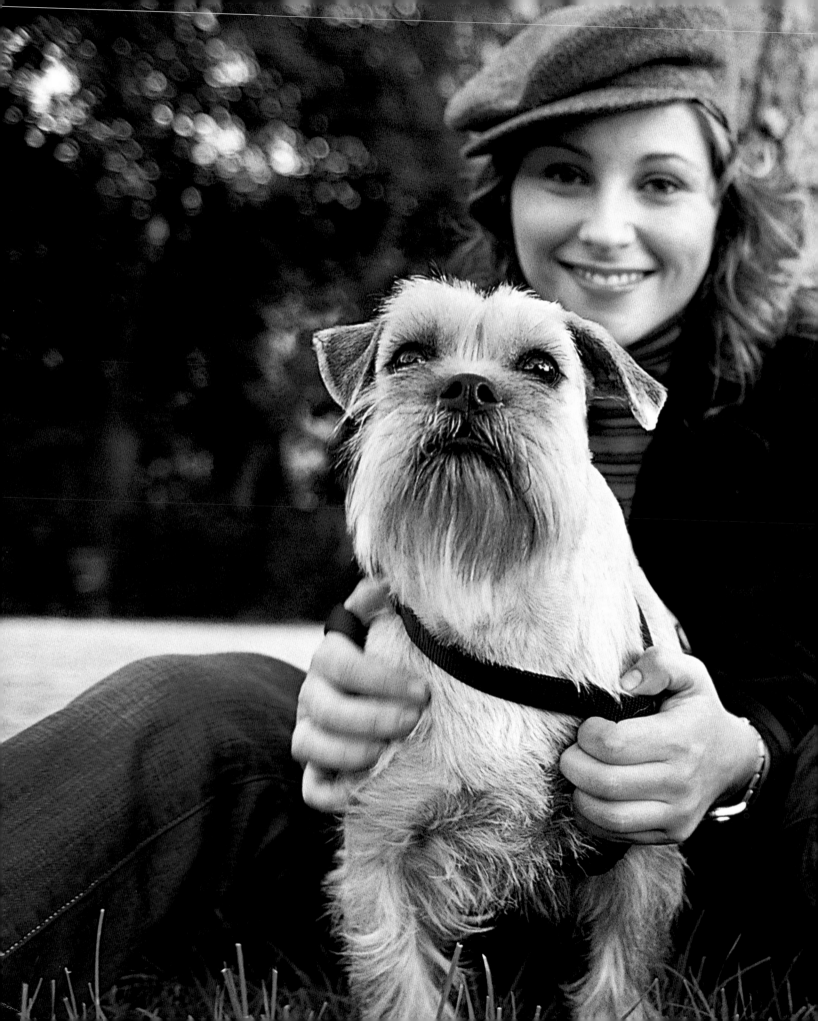

Above: A low viewpoint has emphasised the converging lines of the walkway in this image.

Left: This unusual perspective adds an extra dimension to the image.

Perspective

Perspective and viewpoint are different, but related topics whose paths are inextricably linked.

CHECKLIST

PERSPECTIVE IS ABOUT CONVEYING DEPTH IN 2D
ZOOMING A LENS DOES NOT CHANGE PERSPECTIVE
CHANGE OF VIEWPOINT CHANGES PERSPECTIVE
EXPERIMENT WITH VIEWPOINTS IN YOUR SHOTS
TRY LOOKING UP OR DOWN ON YOUR SUBJECTS
USE A WIDE-ANGLE LENS TO EXAGGERATE PERSPEC
USE A TELEPHOTO TO FLATTEN PERSPECTIVE

WHAT IS PERSPECTIVE?

The real world exists in three dimensions, but photographs only have two. Perspective is all about trying to convey and represent depth on a flat surface.

Viewpoint is a slightly different thing. It's about the exact point from which the photograph was taken. But since perspective can be altered by a change of viewpoint, the two are inevitably intertwined in the minds of photographers.

The first misconception to clear up regards the focal length of the lens. If you were to set up your camera on a tripod and take a succession of pictures of the same view, starting at wide-angle then moving up the range to telephoto, you'd see from the prints that the perspective would not have changed. To prove it, crop and enlarge that part of the wide-angle shot that corresponded to the exact framing of the telephoto shot, and compare the two results. Their perspectives will be identical. Only the magnification will have changed.

LENSES AND PERSPECTIVE

Conversely, if you were to conduct the same experiment but, as you zoomed in, you moved back so that your framing was exactly the same in each shot, you'd get a very different result. Although in each print the subject might be framed in exactly the same way, the images would look very different. This proves that it's the viewpoint that counts.

Wide-angle lenses tend to produce an extended perspective, with a disproportionately prominent foreground. Up close to subjects such as buildings, we can see more distortion in the sides, as they appear to converge inwards. This is due to the sharper viewing angle. If you move back with the same lens, the distortion will diminish, though there will now be a lot more space around the building.

Telephotos appear to compress perspective, to make things appear closer together, but our eyes also play this trick with distant objects.

COMPARISON ONE

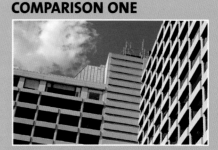

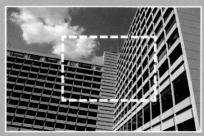

Above: Taken with an 85mm lens.
Below: Shot on a 28mm lens from the same spot. The area inside crop lines is identical to the 85mm shot.

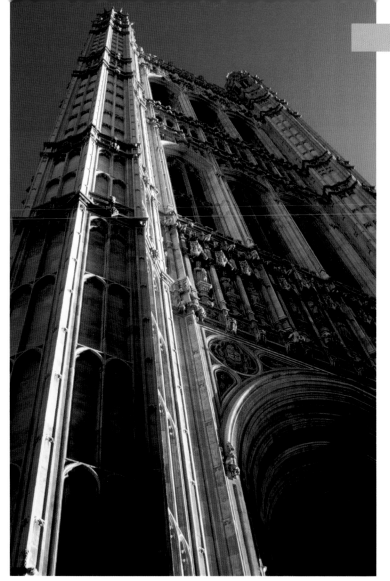

Left: Tilting the camera up at close range works equally well for traditional as for modern architecture.

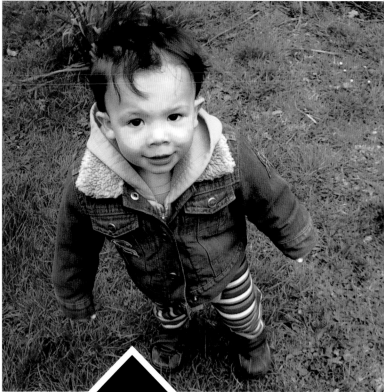

try to vary your viewpoints

Changing your viewpoint is perhaps the best way to bring a fresh eye to a subject. Take that straight shot of that building, but then try framing it between the legs of that bronze statue in the square in front of it.

Try getting very close to the ground and looking up at a person to make them appear taller, or looking down on them from a high spot to shrink them.

When you take the trouble to visit an interesting location for photography, part of the pleasure is in walking around it and viewing it from different angles and with different lenses to see how it changes .

With digital cameras it's easy to shoot every change in viewpoint because you can edit later, keeping the best shots and deleting the rest. This is a good learning process, as it helps the novice photographer to better understand the complex relationship between viewpoint and perspective. (For more on composition, see page 36.)

COMPARISON TWO

Above: Shot with an 85mm lens from a distance.
Below: The same crop shot with a 28mm lens from up close. Note the change of perspective.

OPTICAL ILLUSIONS

So lenses don't actually change perspective as long we don't move our position, but it can't be denied that they appear to. This illusion is caused partly by the fact that different lenses have different optical characteristics too, such as an apparently shallower depth of field caused by longer telephoto lenses.

These traits can be played with to great effect if you know how to exploit them. Filmmakers often use very long lenses in, say, chase scenes, to make it look as though the baddie in the truck is just inches behind the goodie on the bicycle, when the real distance is much greater. In still photos, this apparent compression of distance can be used to your advantage in many ways.

Wide-angles, on the other hand, are great for messing with scale. A man can appear to hold a house in the palm of his hand, or seem smaller than a cat if the relative subject positions and shooting angles are right.

Left: A high resolution image printed at 100 per cent on the page. The pixels are invisible to the naked eye.

Above: Enlarge the image and you can start to see little squares of colour – the pixels.

Above: Magnify the image further and the image is reduced to an abstract arrangement of squares.

Pixels and Resolution

Pixels are the building blocks of digital photos, and the number of pixels in an image determines its resolution.

WHAT ARE PIXELS?

Digital cameras 'capture' the image formed by the lens not onto film but onto a small light-sensitive electronic device known as the sensor. There are a variety of different types, such as CCD and CMOS, but all work on similar principles. The sensor is divided into a chessboard-like grid made up of millions of light-sensitive diodes known as pixels. These are the building blocks of a digital photo – like a Roman mosaic.

Each pixel produces an electrical signal proportional to the amount of light falling on it, enabling the sensor to construct a greyscale tonal representation of the image it 'sees' through the lens. By placing a combination of red, green and blue filters over the pixels a colour image can be formed.

IMAGE RESOLUTION

Sensor sizes are described either by their dimensions, in pixels, or in terms of the total number of pixels they contain, with one million pixels called a megapixel (MP). The more pixels are on the sensor the more detail it will be able to record, and the higher quality the resulting images will potentially be. Most digital cameras today have sensors containing 3–6 megapixels. A 3-megapixel sensor may be composed of a grid measuring, say, 2048 pixels wide x 1536 pixels high. Multiplying the width by height figures will tell you the total number of pixels – in this case 3,145,728, or 3.14 megapixels. A sensor measuring 2592 x 1944 pixels has 5 megapixels altogether.

This figure also serves to describe the image resolution, though this must not be confused with print resolution, which is very different.

RESOLUTION AND PRINT SIZE

When viewing a normal, good-quality digital photograph, it is impossible to see the grid of pixels from which it is made, but as you magnify that image those building blocks start to become visible to the naked eye.

It follows that the more pixels that are condensed onto the sensor, the smaller each pixel will be, so the more you will have to enlarge the image before the pixels become visible – which is why the more pixels there are on the sensor, the bigger the print that can be made from it (and the more finely detailed the image will be at a given print size).

The maximum print size attainable by a given sensor size depends very much on the print resolution required. This is measured in terms of dots per inch (dpi).

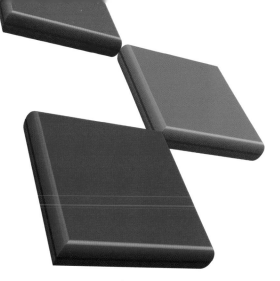

THE NUMBERS GAME

With most sensors, pixels are coloured using a combination of red, green and blue filters. Each colour has 256 tonal variations (from lightest to darkest) which, together, can form up to 16.7 million different colours – enough to produce the appearance of a normal colour photo. Digital images are stored in the binary number

00110110

code and create a lot of data. The colour of each pixel is described by a string of 24 numbers, and a high-resolution image contains many millions of pixels, so you quickly get the picture.

UNDERSTANDING DPI

The more an image is enlarged, the bigger the pixels become, and therefore the fewer the number that can fit within a linear inch. If our 3MP (2048 x 1536 pixels) example were printed at 100dpi, it would be 530mm (20.4in) wide by 390mm (15.3in) high. At a print resolution setting of 200dpi the image would shrink to around 255 x 178mm (10 x 7in), but would be higher quality as each linear inch would now contain twice as many pixels and, therefore, twice as much detail.

The optimum dpi setting for printing is generally considered to be 300dpi (producing a print 170 x 128mm /6.8 x 5.1in) with our 3MP example, although many people would struggle to distinguish a 300dpi print from a 200dpi one.

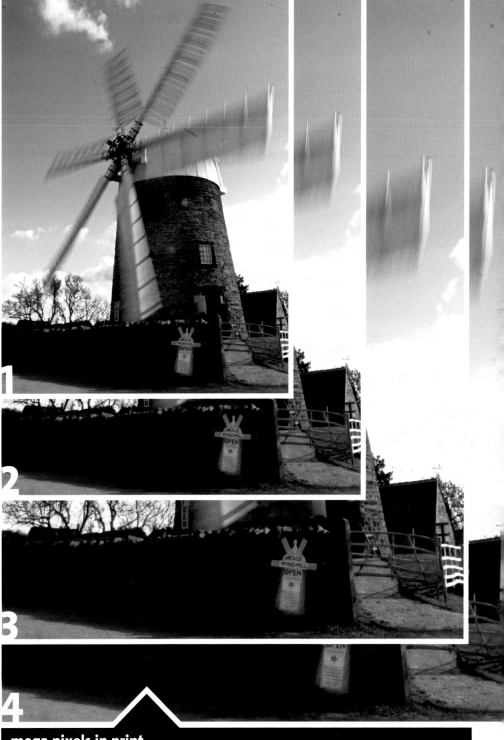

mega pixels in print

The maximum print size you can make from a digital photo depends on the number of pixels on the camera's sensor. More megapixels equals bigger prints. To see how megapixels relate to print size, these examples have been printed at their actual size at 300dpi (the optimum print resolution).

1	**1.2MP**	= 1,280 x 960 pixels
	Print size	= 108.5 x 81.3mm at 300ppi
2	**1.92MP**	= 1,600 x 1,200 pixels
	Print size	= 135.4 x 101.6mm at 300ppi
3	**3.14MP**	= 2,048 x 1,536 pixels
	Print size	= 173.5 x 130.0mm at 300ppi
4	**3.94MP**	= 2,304 x 1,712 pixels
	Print size	= 195.1 x 145.0mm at 300ppi

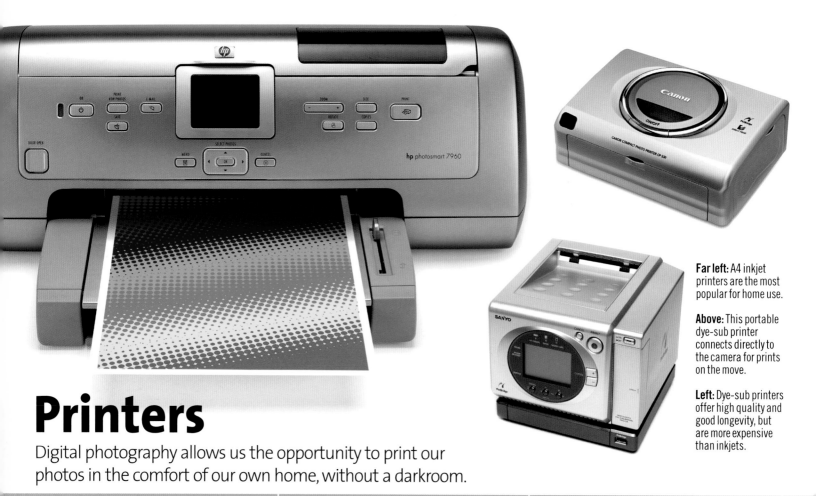

Far left: A4 inkjet printers are the most popular for home use.

Above: This portable dye-sub printer connects directly to the camera for prints on the move.

Left: Dye-sub printers offer high quality and good longevity, but are more expensive than inkjets.

Printers

Digital photography allows us the opportunity to print our photos in the comfort of our own home, without a darkroom.

THE CASE FOR PRINTERS

Although getting prints made by a lab is very simple (see page 109), for ultimate creative control it's much better to print them yourself. Not only can you decide exactly how you want your print to look, and how big you want it, you can add things such as fancy borders and edges – and you can do it all in minutes.

Modern printers aimed at the home user are cheaper than ever, and the quality of many is virtually indistinguishable from the prints made by commercial labs.

Creative black-and-white printing is possible too. Art photographers and traditional black-and-white printers are now finding they can produce digital prints that are very similar in look and quality to their handmade silver prints, but with much less hassle. Colour exhibition prints, previously beyond the reach of most home darkroom users, are possible, too – although printing to this level of quality does involve quite a steep learning curve.

A TALE OF TWO COLOURS

The technology involved in producing prints is quite different to that found in cameras. For a start, digital cameras create colour using combinations of red, green and blue filters (RGB), whereas printers use the CMYK system, comprised of their opposite colours: cyan, magenta and yellow, plus a separate black ink (which cannot be properly reproduced by the other three colours). These are the colours that are used to print most of the world's books and magazines (see page 34).

One of the challenges of printing is in trying to reproduce the image you see on your PC (which is both captured and viewed in RGB) into a print using CMYK inks. Needless to say, the two systems reproduce a slightly different palette and there are some shades in each palette that the other cannot reproduce. This is one reason why it is so difficult to perfectly reproduce in a print the colours you see on the screen.

INKJET PRINTERS

There are two main types of home colour printer suitable for photographic reproduction. By far the most popular is the inkjet.

In the last five years, inkjet printers have come to dominate the home printing market thanks to huge gains in quality and large drops in price. They work by firing microscopic droplets of ink at the paper through hundreds of tiny nozzles in the print head. These droplets are so close together that they create the illusion of continuous tone.

The output resolution can be set in the editing software, with 300dpi being the ideal. Quoted printer resolutions of 1440 or 2880dpi are obtained by counting the clusters of ink droplets that make up the dots.

The ink is stored in separate tanks within user-replaceable cartridges. These vary in number from two (black, one colour) to (currently) eight individual cartridges, depending on the printer.

CHOOSING AN INKJET

There are several factors to consider when choosing a printer. First is the maximum print size you'll need. Desktop inkjet printers are available up to A3 (and bigger, for professional models) though most are A4, and there are a couple of portable 150 x 100mm (6 x 4in) models.

For the most photo-realistic colour get a printer that uses at least six inks, preferably in separate cartridges, as you can replace each individual colour as it runs out. Three-colour inkjets are still very good for most casual users, though.

Printers boast various maximum resolutions and the higher the better, though most people may struggle to distinguish 1440dpi from 2800dpi.

Direct printing is a popular option. Some have card slots for direct printing from media cards, others offer PictBridge for direct printing from the camera via USB cable. An LCD screen for viewing and making adjustments to the image is available on some inkjets.

| Black | Light black | Cyan | Light cyan | Magenta | Light magenta | Yellow |

115_1528.JPG 115_1546.JPG 115_1567.JPG 115_1573.JPG 115_1599.JPG

116_1601.JPG 116_1603.JPG 116_1606.JPG 116_1608.JPG 116_1649.JPG

116_1655.JP 116_1658.JPG 116_1659.JPG 116_1660.JPG

create a contact sheet

Even if you don't print all your photos, which would be costly and time-consuming anyway, consider making thumbnail contact sheets of your files which can be used as a quick reference without having to turn on your PC. (For more on how to make a contact sheet, see page 161.)

DYE-SUB PRINTERS

Dye-sublimation printers have been slower to make inroads in home printing despite the fact that they can produce higher-quality, virtually continuous tone images. This is due mainly to their cost, which is much higher than inkjet for both the hardware and consumables.

For the price of an entry level 150 x 100mm (6 x 4in) dye-sub printer you could buy a pretty high-spec A4 inkjet, and an A4 dye-sub is still a substantial investment, though the price gap is closing fast.

In dye-sub printing, solid dye is transferred from a ribbon to special donor paper using heat. The ribbon holds the cyan, magenta, yellow and black dyes and applies each one separately, so the paper has to pass through the printer four times.

Despite their higher price, dye-subs are gaining in popularity. Currently the most popular dye-sub printers are the stylish portable 150 x 100mm (6 x 4in) models, which are very small and enable high-quality printing on the move.

INK, PAPER AND LONGEVITY

Inkjet printers once had a bad reputation for longevity. Prints would often fade in a matter of months. Recognising how off-putting this was, manufacturers have worked to find various ways of making their prints last as long as silver prints. Many dyes now boast archival properties and are often sold at a premium. An alternative to dye-based inks are the longer lasting pigment inks used in some printers.

Specialist inks are also available from printer companies and third-party manufacturers for applications such as black-and-white printing. Ink sets containing various shades of grey produce better-quality results than colour inks.

The choice of paper is very important in inkjet printing. Papers can be found in a wide variety of surfaces, from high gloss to a rough art finish. Some also boast superior archival properties. Not all papers are compatible with all printers, so some experimentation is required.

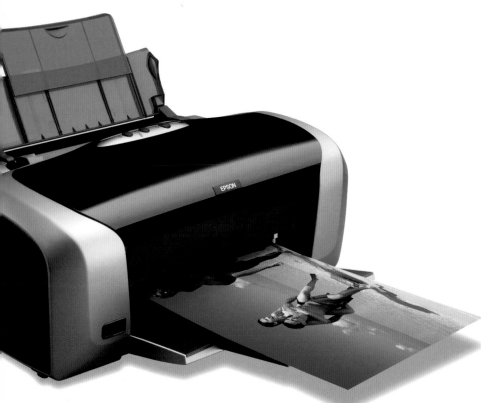

dots per inch

With inkjets the separate colours are laid down as tiny dots which, when seen at a distance, mix together to simulate all the other colours. The resolution of the printer is measured by how many dots of ink per square inch it produces. (For more on producing the perfect home print, see page 164.)

Printing from Home

Home printing is easy, but to get the best possible results requires a little more knowledge.

THE PRINTER DIALOGUE BOX

The basics of home printing are pretty straight-forward. Connect the printer to your PC via the USB ports (or serial/parallel if your PC is very old), install the driver software, insert the paper, press Print – and bingo!

But in order to master the art of home printing you must first master the dedicated software, as it's within the printer dialogue box that you can control the quality of your final result.

For example, it's very important to set the right media setting. Different papers have varying ink requirements. High-gloss papers, for instance, are able to hold more ink than matt ones. With the latter, the inks tend to 'bleed' into each other more, as the paper is more absorbent.

Some printer dialogue boxes have a slider for speed versus quality. Unless you're in a hurry set this to the quality end of the scale. This will lay down more ink, producing better results, but will take longer to complete.

IMAGE RESOLUTION

Before printing you must select the resolution that you wish to print at. This can be done in the Image Size box, found in the Image menu in Photoshop. Although the optimum setting is 300 pixels per inch, bigger prints are attainable at a setting of 200ppi, and most people would struggle to see any quality difference.

Before printing, you need to tell the printer driver the size and orientation of the paper you're using (ie landscape or portrait format). The maximum possible size of your print is determined by the width of your printer carriage, but there's no limit to the length if your printer supports the roll-printing option. Of course you can also print on smaller paper sizes.

To see how your image will look on the selected paper size, select the Print Preview option in the File menu. If the image does not fit, there should be a 'Scale to fit' option, which will expand or shrink the image accordingly.

PRINT RESOLUTION

Finally, choose the print quality setting. This may be the simple speed/quality slider already described, but on better printers will be a drop-down menu of specific resolution options.

A setting of 1440dpi is adequate for most uses. Selecting 2880dpi will provide slightly better quality but will take more time to print, and 720dpi is visibly not as good and will produce less photo-realistic results.

As your printer starts printing the paper will emerge little by little until it is complete. Initially the print will be a little damp, so avoid touching the surface and leave it to dry properly before judging the colour and density, as it may have a slight colour tinge (probably blue).

Also, if colour matching to an existing image or subject of known colour, view the print in daylight. Colour can be adjusted in your editing program, though if your printer is consistently off-colour you can adjust it in the driver software.

online printing

Nowadays you don't have to leave the house to get prints made of your digital photos. If you have Internet access, you can do it all online. There are numerous web-based photo labs (Photobox, Ofoto and Fotango being well-known examples), and all work in a similar way.

Using them is very simple. In most cases, you'll have to register. Once inside, you'll be presented with a list of options. With some labs you'll need to download some software from their Web site to use their service, with others you simply click on the Upload button, having selected the shots you want printed and put them in an album.

Apart from the usual printing size and surface options, most online labs offer other services too, such as printing onto other media, or a free Web gallery where you can display the uploaded images for friends to view. Once ordered and paid for, your goods are sent back to you within days.

Print Services

Only a small percentage of the digital photos taken per year are ever printed. Don't let yours be among the great unseen.

PRINT YOUR PHOTOS!

Film users have no choice but to get prints of their pictures (unless they're using slide film). But with digital cameras, users can see their shots straight away and can download them onto their PCs.

Unfortunately, that's where most of them stay. Of the millions of digital photos taken every year relatively few get printed. This means that they languish, unseen and unloved, on our PCs, always at risk of being lost forever through accidental deletion or computer failure.

Social historians have already expressed concern that the rich visual record that exists of the last few generations through family snaps may not exist for our and future generations.

You can of course print all your shots on your home inkjet, but it would be costly and time-consuming. Many people don't even know how easy it is to take your card or camera into a photo shop and get a set of prints made as though it were film, and it needn't cost any more either.

HIGH-STREET LABS

Everyone knows how easy it is to get a set of prints made from a roll of film, but fewer people are aware that those same labs can also make prints direct from your digital camera or media card. Some outlets even provide a self-service console that allows you to display, adjust, crop and make other minor enhancements before selecting a print size and pressing the Print button. These self-service machines are ideal for those who either don't have a PC or may be away from home. For people unsure of how to use the consoles, staff are always on hand to help.

Even people who do their own enhancements and manipulations at home can enjoy this service. By burning a CD of images and taking it to the lab you can get a set of true photographic prints that not only look better but last longer than home-made inkjets. Why not scan all your old prints and get a set of enprints or blow-ups made from them all?

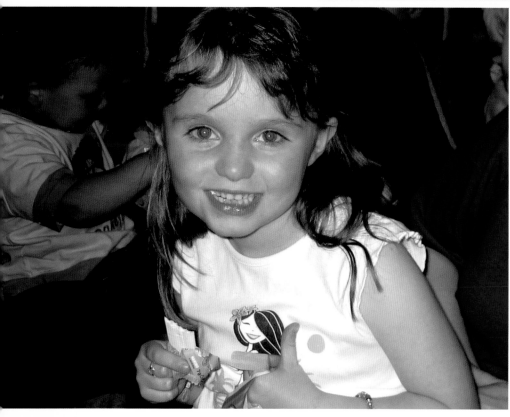

Left: Red-eye is caused by flash reflecting off the blood vessels in the retina, and is an occupational hazard with built-in flash.

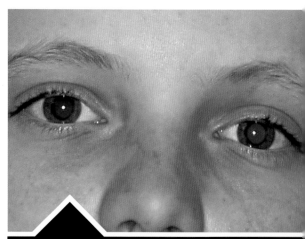

removing red-eye

You can buy red-eye removal pens from most camera shops , and they work surprisingly well. You simply sweep them over the offending eyes, and voilà, the red-eye is gone. You can alternatively remove the red-eye at the editing stage. (For more on red-eye removal, see page 158.)

Red-eye

Red-eye is the curse of all flash photography, but there are ways to reduce the risk of getting it in your shots.

THE CAUSES

There are few more persistent or annoying problems in photography than the dreaded red-eye – that oh-so-common phenomenon that turns your subjects' eyes blood-red whenever you use flash. Red-eye is not a sign that your subject is, in fact, a vampire, or that they've been drinking.

It occurs most frequently in dim light conditions. The pupils in the human eye expand in low light and contract in bright sun, much like the aperture in a lens. When a flashgun is fired from close to the lens axis in dim light, when the pupil is fully dilated, the flash enters the eye and illuminates the blood vessels at the back of the retina, and the reflection bounces back through the lens.

Some people are more susceptible than others: blue-eyed people, whose eyes are lighter, and children, whose eyes are proportionally bigger. And yes, people who are tired or drunk, because their body reactions are slower. But in the right conditions, it happens to all of us.

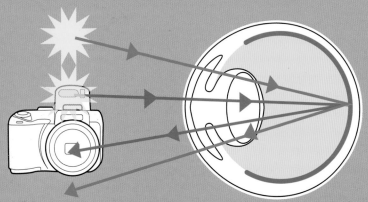

Left: When the flash is close to the camera, the reflection from the retina enters the lens. By moving the flash further away, the reflection will not be picked up by the lens.

THE CURE

There are only two ways to cure red-eye at the shooting stage. The first is to force your subject's pupils to close down. This is best achieved by raising the light level – switching on any ambient lights that are around. Camera manufacturers use this technique in their red-eye reduction systems, by firing a pre-flash, pre-exposure strobe or shining a beam into the eye, but they never really work, and when they do they invariably produce a forced or unnatural expression in the poor victim.

A better solution is to move the flash further away from the lens axis. Since the angle at which a reflection leaves the eye will be the same as that at which the flash enters, the red-eye will not be picked up by the lens (see diagram left). Another method is to bounce the flash off a wall or ceiling. With built-in flashguns this is not possible, so the only solution is to correct it afterwards. (See page 158.)

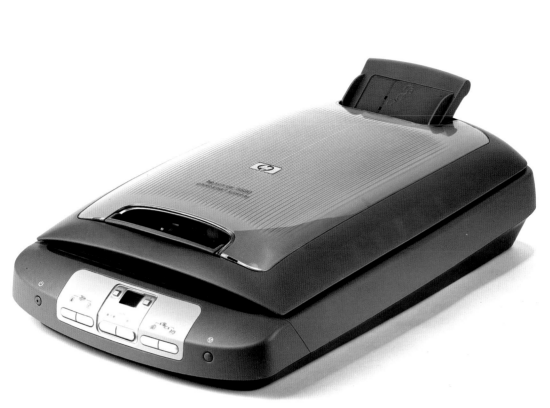

Left: A4 flatbed scanners are the most popular type. This one can also scan enprints automatically, via the feeder on the top, and 35mm film via an adaptor.

Above: Film scanners offer potentially higher quality scans from film originals.

Bottom: This stylish vertical scanner takes up less space on the desktop.

Scanners

If you've got hundreds or thousands of prints or slides squirrelled away in boxes, buying a scanner will give them a new lease of life.

WHY BUY A SCANNER?

So you've bought a digital camera, you're creating masterpieces in Photoshop and printing out super-glossy A4 prints on your inkjet. Who's missing from the party here? What about all those thousands of prints from your hazy, pre-digital past? Don't they deserve some care and attention lavished on them, too?

If you look back through your old prints (and those faded old photos passed down through the generations), you'll find many great shots that deserve to be digitised and archived. You'll also find many other failed shots that, with a bit of Photoshop help, could be turned into winners.

There are lots of reasons for buying a scanner and digitising these pictures. You can improve them, add them to your digital albums, burn them to CD for archiving, create DVD slide shows from them, send them to friends and relatives (as e-mails, CDs or prints). Very old, damaged pictures can be restored. The list goes on.

FLATBED SCANNERS

Of the two main types of consumer scanner, flatbeds are by far the most common. Most flatbed scanners consist of a horizontal glass plate with a moving sensor and a light below it. In many ways they look and act just like a photocopier, except that they produce high resolution scans of your photos. Some flatbeds can also scan film (slides or negatives) thanks to a mini lightbox built into the lid. On other models this is an optional extra.

In addition to the normal CCD scanners there are also super-slim CIS scanners which can be powered from the PC via the USB port.

Scanners come in various levels of quality, with the more expensive models offering higher resolution, but you should consider 1200ppi a minimum for high-quality scans.

Some scanners also come with software which includes sophisticated dust- and scratch-removal features – a great time-saver.

FILM SCANNERS

Transparency film users (former or current) may prefer a dedicated film scanner to a flatbed. Film scanners can scan both negatives and slides, and offer a much higher resolution than the transparency-scanning features found on flatbeds – typically at least 3600ppi.

Film scanners are better, not just for their higher resolution. Negatives always contain much more information and detail than the print that was made from it, and you'll always get better results by scanning from the original source rather than a second-generation copy.

Inexpensive film scanners can often only scan one frame at a time. The better models offer the ability to scan strips and indeed entire uncut rolls in batches, as well as higher resolution and faster scanning speeds – albeit at a higher price.

Most film scanners can only scan 35mm film. Medium-format scanners are available, but are significantly more expensive.

Left: Flatbed scanners are operated in much the same way as a photocopier, by placing the print face down on the glass platen.

software

The scanner software offers variety of controls and options which must be set correctly to obtain the best results. Advanced options are accessed via additional buttons. Some scanners feature shortcut buttons on the front for one-touch scanning to preset default settings, avoiding the need to open the software.

Scanning Images

With a scanner, every picture you've ever taken can join the digital party. You can even digitise and restore faded old pictures of your ancestors.

SETTING UP

To anyone who's used a photocopier, scanning a photograph will have an element of déjà-vu about it. You lay the print to be scanned face down in the corner of the glass platen, close the lid and press the button. With most scanners, the button is a virtual one in the software interface.

The software is usually accessed through your editing application. Once selected, a dialogue box will appear offering various controls. One of these is called Preview. Pressing this button allows you to see how your scan will look. If your print is crooked, you'll be able to see this.

The image will have a box over it, indicating the area that will be scanned. Drag the box to the outside edges of the photo or, if cropping, to your preferred crop area.

Before you scan, you must also indicate your preferred scan resolution, in pixels per inch. For print-quality scans select at least 300ppi; for Web sites or e-mailing, 72ppi is sufficient.

MAKING THE SCAN

If your scanner can scan transparencies too, you need to tell it which kind of media you're scanning (print or slide) using the drop-down menu. The other question you'll be asked is what scale you wish to scan at. Normally this should be no more than 100 per cent. If you only need a small scan, select a lower value. If you'll be enlarging the image to more than its original size, select a larger one, but be aware that the scanner will use interpolation to achieve this, which will diminish the quality somewhat.

As you become more experienced, you may wish to explore some of the advanced manual options that many scanners offer, but features such as colour balance, while desirable to have in the right ball park, are best left to your editing software for fine-tuning.

When everything is ready, press the Scan button and wait. The scan time will depend on the size and resolution selected.

SCANNING FILM

Film scanners work in much the same way as flatbeds, with some minor differences. The image must first be placed in a carrier to hold it flat and aid insertion. You'll have a choice of holders: one for strips of film, one for mounted transparencies.

Having selected the appropriate holder and placed your image into it, the holder is then inserted into a slit in the front. It will be drawn into the scanner, and from here the process is much the same as for flatbed scanners.

Remember to select Transmissive (for film) rather than Reflective (for prints), and set the resolution to a minimum of 2000ppi, and preferably over 3000ppi.

If scanning film on a flatbed scanner, you'll still have a holder, but will have to lay it on the glass platen in the right place to correspond to the location of the lightbox built into the lid. The rest of the procedure is as already described.

Selling Your Photographs

Not long ago, digital images were considered to
be of insufficient quality to be saleable – but no longer.

PHOTOS FOR SALE

Any way you look at it, photography is an
incredibly expensive hobby, even without the
added expense of film and processing that 35mm
users still have.

It's natural, then, that once many keen
hobbyists feel that their skill level has reached
a high enough standard, their thoughts might
turn to how they can recoup some expenditure.

But it isn't just about the money; it's an ego
thing, too. Every creative person likes to see their
work being enjoyed and appreciated by others.

Photography presents numerous opportunities
to see our work in lights, and to make some
money out of it. Many even make a good living
out of what they do in their spare time. That's the
good news. The bad news is that the competition
is fierce. Once you start investigating the market,
it will seem as though everyone with a camera
fancies themselves as David Bailey. The trick is
to identify your niche and go for it.

FINE-ART MARKET

So you've got some great photos and you think
they'd look good on the walls of your local wine
bar. Fine-art photography is about selling prints
for the wall. You'll need a portfolio of exquisite
images plus either a good grasp of archival
printing to exhibition standard, or access to
someone who does (eg a pro lab). Art and craft
fairs are a good place to showcase your work, as
is a Web site, but don't expect to get rich.

WEDDINGS AND PORTRAITS

Many keen photographers see weddings as a
means of making a quick buck, and the market is
filled with cowboys with little skill. If you fancy
doing weddings, remember you could ruin the
most important day of someone's life if you mess
up, so study, read books and practise at friends'
weddings (for free) to build experience and a
portfolio. When you're ready, advertise in local
papers, shop windows and the phone book.

STOCK PHOTOGRAPHY

There are over 400 picture libraries in the UK
alone (go to www.bapla.org for a list), all of
which sell a vast range of imagery on a one-use
or royalty-free basis. Many libraries have tens of
millions of images of every conceivable subject,
even mundane ones such as drain covers. If you
want a slice of the action, identify the right
library for your style (one that takes digital files)
and present a large quantity of high-quality work.

PUBLISHING

There are tens of thousands of books, magazines
and other publishing companies out there with
an insatiable appetite for new images. Many use
stock libraries, but most are open to direct
approaches from photographers who can provide
the right work. Research the market. The
Bureau of Freelance Photographers
(www.thebfp.com) can help here. Make your
initial contact with an e-mail or a CD.

HOW SENSORS WORK

The sensor is what digital cameras have instead of film. It's the part of the camera that receives the light coming through the lens. Unlike film, the sensor can't be taken out and replaced with another one, so it's imperative that the one in your camera does its job well.

A sensor is basically a grid containing millions of tiny light-sensitive cells called pixels. Each of these pixels responds to the light that falls on it by generating an electrical signal proportional to the brightness of that light. The processor then builds up a map of brightnesses across the sensor to form an image. Filters over each pixel help the processor to work out the colour.

The more pixels there are on a sensor, the more detail it is possible to resolve. Too few pixels will produce blocky images with stepped, rather than smooth curved edges. Each million pixels on the sensor equals 1 megapixel. At least 3 megapixels are recommended for photo quality.

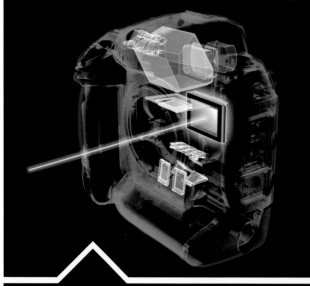

through the viewfinder

The sensor sits in exactly the same place in the camera occupied by the film in a traditional camera, and receives light in the same way. With SLR cameras there is a mirror in front of the sensor at a 45° angle which reflects the image onto the focusing screen and, ultimately, to the viewer's eye. At the moment of exposure the mirror flips up out of the light path, and the shutter opens, exposing the sensor for the duration of the exposure. (For more on how cameras work, see page 10.)

Sensors and CCD

The sensor is at the very heart of a digital camera. What does it do, and what are the factors affecting performance?

SENSOR SIZE

The more pixels that are on the sensor the better the quality, but how do manufacturers manage to squeeze more pixels onto the sensor? There are two ways. First, they can make the sensor bigger. There are several sensor sizes in current use, but using a bigger sensor inevitably means the lens and everything else will have to be bigger, too. Since compact cameras should, by definition, be small, many manufacturers prefer to shrink the pixels instead.

Being able to fit five million pixels into the same space previously taken up by four sounds great, but for every positive there's a negative. Smaller pixels have a smaller surface area, so they're less sensitive to light. To get the same ISO rating as the sensor with fewer pixels, the signal must be boosted, so although you get more definition, you can also get more noise, as well as other potential problems like fringing. Nothing is straightforward in digital technology!

Above: Most sensors are made of a grid of RGB pixels.

Above: Fuji's Super CCD SR uses two diodes at each site.

SENSOR TYPES

There are several distinctly different types of sensor in current use. The most common is the **CCD** (charge coupled device), found in video cameras, light meters and many other devices, as well as a majority of digital cameras.

A variation is the **Super CCD** developed by Fuji, which uses a different pixel arrangement and, in the case of the SR chip, two photodiodes at each site. **CMOS** (complementary metal oxide semiconductor) chips work differently, and are known as active pixel sensors (APS) because the pixels contain their own processing circuitry. Initially used in cheap cameras because the quality was lower, they have been refined and adopted by Canon for their top end SLRs.

Foveon sensors are based on CMOS technology, but use three layers of silicon to capture the different colour channels. Nikon, meanwhile, spent ten years developing the snappily titled **JFET LBCAST** sensor used in their pro SLRs.

Left and below: Sharpness is affected not only by the quality of the lens and the ability of the user to both focus properly and hold the camera still during the exposure, but by the processing software in the camera. Many digital cameras offer the ability to adjust the degree of sharpening applied at the processing stage. It is generally better to perform any sharpening at the editing stage.

Sharpness

Lens designers, camera makers, sensor producers...
everyone is after the same thing – ultimate sharpness.

IN-CAMERA SHARPNESS

One of the worst things anyone can say about your pictures, apart from a blanket 'they're rubbish', is that they're not sharp. We can forgive almost anything except out-of-focus images. But sharpness and focusing are not the same thing. An image can be in focus but not very sharp. This may be because of camera shake, or because the lens simply isn't very good. Or perhaps it's a sensor or processor issue.

Assuming that the internal electronics are good, sharpness at the shooting stage can be maximised by using the best lenses possible, by keeping them clean and free from fingerprints, and avoiding the use of cheap filters on the front. It can be improved by always using a tripod, especially at moderate to low shutter speeds, by stopping down to a smallish aperture (f/8–f/11 is fine) and by taking great care over the focus. What has the lens focused on? Is this the right point? Would it benefit from fine-tuning?

SHARPENING

Unlike film images, digital ones can be further sharpened after the image has been taken. This sharpening is actually about altering the pixel information, using software analysis to increase contrast around well-defined edges and so forth.

Many cameras offer the ability to fine-tune the sharpness within the set-up menu, usually on a scale of 1–5. It's best to minimise the in-camera sharpening and to apply it later on the PC, though if you don't want to post-process your images you may find a higher sharpness setting produces more pleasing results straight out of the camera. Most consumer digital cameras are pre-sharpened by the processor.

Sharpening permanently alters the image, so in an ideal world this is best carried out on the PC using Unsharp Mask, which offers more fine control than just auto sharpening. You should always apply the sharpening after your other enhancements, and on a copy of the original.

WHEN SHARPER ISN'T BETTER

Despite the desire for razor-sharp images, sometimes photographers do the opposite and strive, for creative reasons, to produce images that are completely unsharp.

This may take the form of using an ultra-wide aperture to achieve just a hair's width of focus, fitting a soft focus filter to create a 'romantic' look or, at its most extreme, focusing on an entirely different plane so that the image takes on a totally blurred quality which, with shiny, colourful or well-defined forms, can look great.

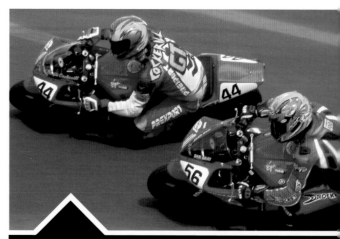

Left: A slow shutter speed of 1/30sec was deliberately selected here so that the moving Tokyo subway train would be blurred by the motion, while the stationary man remained sharp.

Below: For this shot a fast shutter speed of 1/500sec ensured that the racing motorbikes would be frozen in sharp focus.

bracket your speeds

Experiment with different shutter speeds by bracketing your exposures. Try using both very fast speeds and low ones on the same subject (setting the corresponding aperture of course), then study the results to see which you like best. (For more on apertures, see page 21.)

Shutter Speeds

One of the two most important exposure controls, the shutter speed has many creative uses, too.

WHAT SHUTTERS DO

The shutter speed dial on a camera can be equated to the timer on an oven. Depending on what you're baking, you could choose a low heat setting (the camera's aperture) for a long period of time, or a high heat setting for a short period of time. Both may produce the same amount of heat overall, but one will ruin your cake and the other won't.

There may be a whole range of shutter speeds you could use to produce a correct exposure (assuming you use the correct corresponding aperture) but will the resulting image be a bland representation, or could it have been a more interesting picture if you'd chosen a different combination for the shot?

As well as controlling the duration for which the shutter on the camera is left open, the shutter speed (as with the aperture) can actually have a profound effect on how the picture looks. Some subjects cry out for one speed or another, but often the decision is purely a matter of choice.

FAST SHUTTER SPEEDS

Everyone knows that fast shutter speeds are for fast action photography. Speeds as high as 1/8000sec can be used to catch a skateboarder hanging in mid air, render the spokes on a fast-turning bicycle wheel, even freeze the individual droplets in a splash of water.

Or are they? Certainly fast shutter speeds are an option, but so are slower ones. And fast shutter speeds can be used for other things. Even a flower blowing in the wind, while not moving fast by Ferrari standards, could be rendered unsharp if the shutter speed isn't fast enough. If you're using a long telephoto lens without a tripod, your shutter speed should be at least as high as the lens' focal length to avoid camera shake. So a 400mm lens needs a shutter speed of 1/500sec to guarantee sharpness.

With flash, your shutter speed is limited by the synchronisation speed of the flashgun, which is usually, at best 1/250sec, but in some cases higher.

SLOW SHUTTER SPEEDS

Slow shutter speeds have many uses. The obvious one is for shooting in low light, when it simply isn't bright enough for faster speeds. Or perhaps they've been imposed upon you due to your desire to use a small aperture. In these cases a sturdy tripod is essential, if camera shake is to be avoided.

But there are creative uses, too. Although the first instinct when shooting fast action may be to set a fast speed, this can sometimes result in a static-looking image, especially if the subject is a car, for example. A slow shutter speed will introduce a little creative blur to indicate to the viewer that the subject was moving.

At the far end of the shutter speed scale most cameras have a B setting. In this mode the shutter stays open for as long as the button is depressed – for hours, if necessary. This setting is perfect for night shots of moving lights, such as traffic trails, fireworks and fairgrounds.

Right: To be successful, silhouettes should have a recognisable shape, such as these cyclists.

Below: For this shot the camera was pointed directly up at the sky and the shot taken on autoexposure.

Silhouettes

Here's a technique that's been popular since the dawn of time, and no wonder – it's easy to do and produces great results.

IT'S ALL ABOUT THE LIGHT

From the erotic title sequences in the James Bond films to stark, leafless trees against a barren landscape, silhouettes are all around us.

A silhouette is an image where the subject is totally black and recognisable only from its shape. This is the first clue when looking for suitable subjects for silhouettes – seek things with an interesting shape or outline. In the case of James Bond it's a voluptuous nude woman, but you could equally use a vase, a tree, a castle or some other feature of the landscape. Flowers and nature subjects can make great silhouettes, too. Avoid subjects with boring or unidentifiable shapes (such as cubes), as these will not make exciting silhouettes.

A variation on the total silhouette is to shoot translucent subjects. With the light shining through them, these can be shown in an entirely different and more interesting light.

SHOOTING A SILHOUETTE

A silhouette is, in effect, a subject which has been grossly underexposed. It can really only be done when the background light level is much brighter than on the subject itself. There are several ways to achieve this. Find a sunlit white wall or other bright location, or turn the subject so the sun is behind it (facing the camera) and frame it against the sky. Sunsets make an especially good backdrop for silhouettes. Do not shoot with the sun itself visible in the frame: either keep it just out of shot or position yourself so that your subject is blocking it from view.

Once located, take your exposure reading from the bright background, excluding the subject, and set this on your camera. You can do this either using the exposure lock or by setting the camera to manual exposure. There should be at least three stops difference in brightness between subject and background.

INDOOR SILHOUETTES

You can shoot great silhouettes indoors, even on relatively dull days, by using the window. Keep the room lighting as low as you can, and position your subject in front of the window. The view outside should be as unobtrusive as possible.

Once again, take your meter reading from the window, excluding the subject, and set this on your camera. You can either exclude the window itself from the shot or make a feature of it, perhaps including the frame or net curtains.

INSTALLING SOFTWARE

Before buying software check the requirements panel on the box or Web site to make sure your PC has the right specification.

Assuming that it has, first turn off your virus protection software. Follow the instructions in the Read Me file on the disk, then start to install. You can usually choose to either custom install selected bits to selected locations or go with the default install.

If installing an upgrade version of an existing application, don't forget to remove the old version, using the Uninstall function.

Downloaded software may mount on your desktop or onto your hard disk. It may be a stuffed file (which has been compressed to keep it small for downloading). If this is the case, unstuff it first.

Some applications automatically check the internet for updates every time you open them, but this can be switched off if it is irritating.

Software for Your PC

Without the right software on your PC, you can't do much with your photos except admire them – and maybe not even that.

WHY SOFTWARE?

Digital cameras offer many advantages over film just within the camera itself, but it's once you've downloaded your pictures onto a PC that the real benefits of digital photography become apparent. Your operating system should allow you to at least view your pictures, but to really have fun you'll need some additional software. Your camera may have come with some free software to get you started, but you may soon outgrow this.

DOWNLOADING SOFTWARE

Not all software comes in boxes and is bought in shops. Most imaging applications can also be downloaded on the Internet, and in fact some programs can only be acquired this way. Most plug-ins are download only, for example. Downloading is easy. You'll have to pay online (unless it's free) then simply click the Download button. Some programs are quite big, and slow to download without Broadband.

TYPES OF SOFTWARE

Editing: Also known as image-manipulation or image-processing software, this is what you use to improve, adjust and generally muck about with your photos, from simple corrections to complex montages. Adobe Photoshop has a virtual monopoly among professionals, but there are many cheaper alternatives for the consumer.
Album: These applications are for organising your pictures. They provide an easy interface for displaying, searching, filing and archiving your images, plus slide shows and online printing.
Burning/Archiving: This is specifically designed for creating CDs and DVDs of your images, not only for safe keeping, but so you can produce fancy slide shows etc to play on your TV.
Plug-Ins: These add functionality to Photoshop and other editing applications – additional filters and special effects, enhanced versions of standard features etc. Some are free, others cost more than the editing program itself.

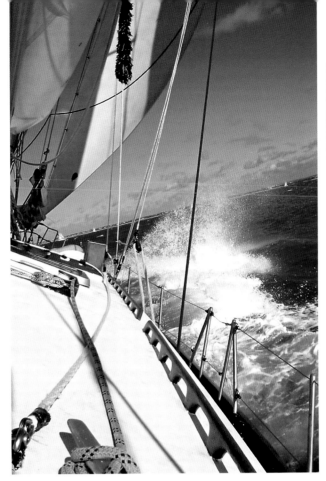

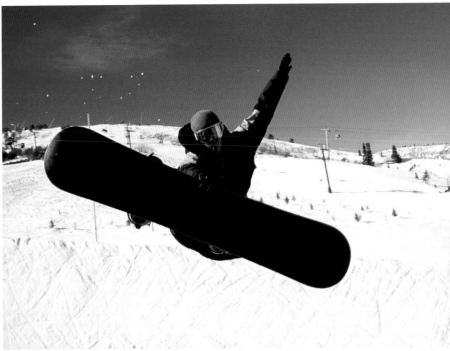

Left: A telephoto lens is great for when you can't get close to the action.
Above: Use fast shutter speeds to freeze action, like this midair snowboarder.

Sports and Games

Football, tennis, golf, motor racing – sports are tough subjects to photograph, but these tips should help you to succeed.

CHECKLIST

PICK A SPORT YOU KNOW SOMETHING ABOUT
ARRIVE EARLY ENOUGH TO GET A GOOD SPOT
USE A LONG ZOOM LENS TO FILL THE FRAME
PICK A FAST SHUTTER SPEED TO FREEZE ACTION
CHOOSE A SLOW ONE TO CREATE MOTION BLUR
PAN WITH THE SUBJECT TO BLUR THE BACKGROUND
USE SLOW-SYNC FLASH FOR A DRAMATIC EFFECT

PREPARATION

Sports photography is among the most difficult and challenging of genres to master, but for those who love sport it's ultimately the most rewarding. It helps to have a specialist knowledge of your chosen game, because this will make it much easier to anticipate what will happen next, so you can be ready for it.

There are many similarities between sport and general action photography, certainly in terms of techniques, but when you're shooting the kids in the park you're not generally forced to sit 50m away behind a fence, or jostle for a spot with lots of spectators, as you are with sports. Preparation is crucial in this field, as is knowing where to stand to get the best shots. With motor racing, for example, it may be on a sharp corner, where you know the cars will slow down. At a football match it may be on the halfway line or behind the goal. Wherever you choose, you may not be able to relocate once there, so choose well!

SHUTTER SPEED

To get sharp pictures of moving subjects, select a fast shutter speed (eg 1/250sec) to 'freeze' the action. This technique works best with animate subjects such as people and animals. With mechanical subjects like cars, motorbikes etc, it can easily make it look as though they're stationary. Here a slower shutter speed is preferable (try 1/30sec as a starting point), as this will result in some blurred streaks to convey the subject's motion.

Either keep the camera still so the subject is blurred as it streaks past, or move it with the subject, keeping it at roughly the same spot in the frame as you press the shutter. This method, known as panning, will result in a relatively sharp subject and a blur-streaked background, and is usually the more effective method. The beauty of digital is that you can experiment with shutter speeds and panning techniques, and check your results as you go.

OTHER SETTINGS

While the main focus is on the shutter speed, the choice of aperture is also important. At wide apertures the zone of focus (depth of field) is very shallow – the subject only has to move a small amount to fall outside this zone. By choosing a slightly smaller aperture the depth of field is extended, allowing more room for movement without the subject leaving the zone of sharpness.

Another consideration is the light level. If it isn't bright enough to set both a fast speed and mid-range aperture, then perhaps you could consider increasing the ISO rating, although this may reduce image quality.

Of course it goes without saying that you will want to set the drive to continuous, for rapid shooting (at least 3fps is preferable) and the lens to servo (so it keeps refocusing on the subject as it moves) rather than single focus (which doesn't).

>>

FILL THE FRAME

Most action photography depends for its visual impact on taking the viewer right up close to what's going on. If it's happening far away the picture is unlikely to convey a sense of drama, so fill the frame. Try to get as close to the action as you safely can, and use a good zoom lens to take you the rest of the way. With some subjects you may still end up having to crop into the shot later in Photoshop. With closer subjects, remember to leave enough space around the action to give you some breathing space if something unpredictable should happen.

With some sports you might be lucky enough to be close enough to use a wide-angle lens. This will add a terrific sense of drama to your pictures. Don't forget to also take a few cameo shots of the athletes and performers, as well as the action. These add colour, flavour and personality to any portfolio.

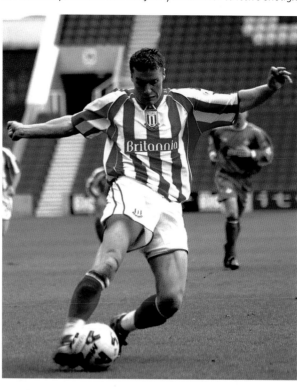

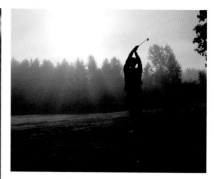

Above: Not all sport is fast-moving. This early morning silhouette has a serenity appropriate to the subject.

Left: Professional football is difficult to shoot during matches, due to restrictions. It may be easier to shoot practice sessions and amateur matches, at least to build a portfolio.

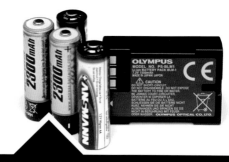

camera power

Sports photography consumes a lot of battery power, because the servo motors in the lens are constantly active as they follow the subject around. If flash is used the consumption is even higher. Make sure that your batteries are fully charged before you start, and keep spares handy. (For more on batteries, see page 29.)

FLASH IN THE PAN

With close-range subjects a useful technique for action is slow-sync flash. This entails using a slow shutter speed combined with a burst of flash and, depending on the subject, panning. The effect is to 'freeze' the subject while blurring the background and, sometimes, creating a blurred ghost image of the subject, too. Most digital cameras have a slow-sync flash mode which does this automatically.

Some also offer a rear curtain (also known as 'second curtain') sync feature, too. This basically sets the flash to go off at the end of a long exposure, rather than the beginning.

The practical effect of this is to ensure that the blurred motion streak resulting from the slow speed follows behind the sharp, flash-frozen image, rather than precedes it. In the latter case it may look as though the subject were travelling backwards, which may not be what you want.

PRE-FOCUS

Most digital cameras are too slow to react to fast-moving subjects, and by the time they have locked onto the subject and focused, it has already moved on. One technique that works very well is to set the lens to manual focus and preset the lens distance to a point at which you expect the action to appear. By focusing on, say, a corner at a Grand Prix you will reduce the shutter delay time, as the camera will not have to focus first when you want to shoot.

Right: Panning using a slow shutter speed blurs the background to create a sense of motion.

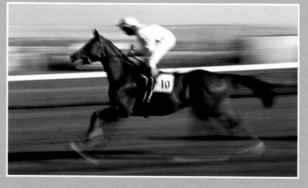

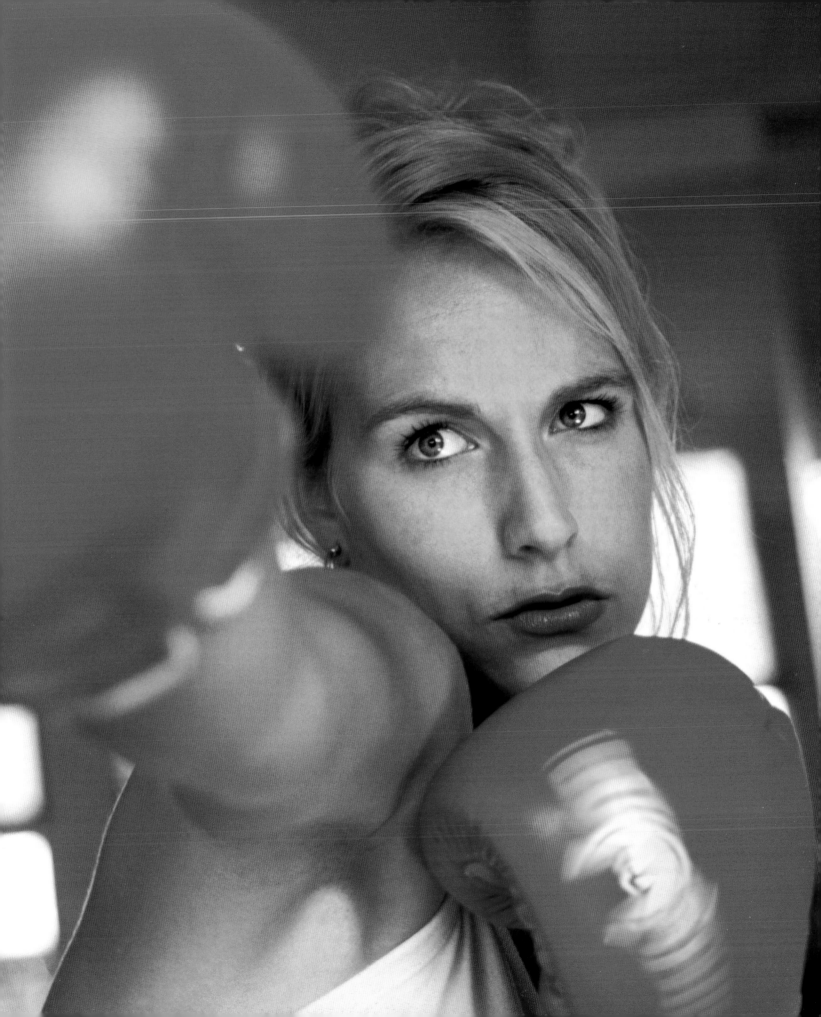

Right: Flowers are among the most popular subjects for still-life photography.

Below: You can make a still life from virtually anything, as long as the styling and lighting are right.

Still Lifes

Let your creative juices flow by creating a still life from scratch, either on the kitchen table or in the great outdoors.

FINDING SUBJECTS

With still-life photography, light and composition are everything. You can make an interesting shot from a handful of buttons if they're arranged nicely and lit well. This means that there is an infinite variety of subject matter to choose from. Of course if the subject is beautiful this makes things easier for the photographer, which is why flowers are probably the most popular subject. Close-ups of colourful blooms adorn the walls of a million homes.

Fruit (and food in general) is a good subject too. Study the glossy food and drink magazines for inspiration on subjects, props and arrangements. Still-life photographs don't have to be collected and arranged on a table indoors though. Found still lifes are equally rewarding. Isolating that interesting shell or rock, that gnarled driftwood, that display of fish on a market stall, can result in artistic images that you'll want to put on the wall.

BACKGROUNDS

With still life the background plays a key role. For tabletop shots the background need be no larger than about 500mm square. Plain white paper is always useful, and a lightbox makes a good alternative. Textured or coloured paper from art shops is a good choice, as are fabrics from haberdashery shops. Attractive pieces of wood, especially gnarled, weather-worn ones, can add character to a still life, while sheet metal gives a high-tech feel that suits certain subjects.

LIGHTING

The best and most natural form of illumination is daylight. If working indoors, the natural light pouring through a window or conservatory is perfect, and its directional nature can enhance the form and texture of your subjects (as long as the light is fairly diffused). On sunny days, harsh window light can be softened by hanging net curtains or a white sheet in front of the window.

Try to position your subject so that the light glances across it from one side, rather than flat on, or use a blind to cast patterns of light and shade over the set (cut your own out of card if you don't have one). The natural light can be modified where necessary with the use of small mirrors, foil or white card as reflectors of varying qualities.

Alternatively, use household lamps to create your own directional lighting, but don't forget to set your white balance to tungsten first.

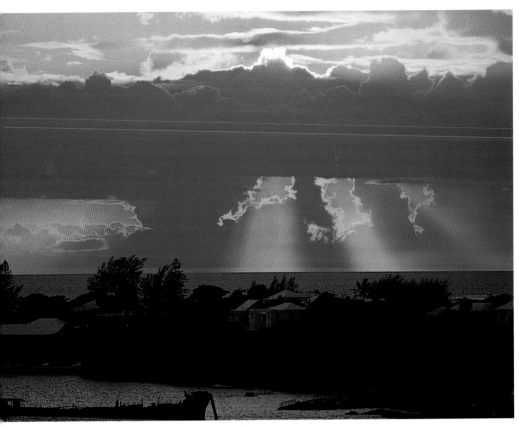

Sunset Skies

There are some clichés in photography that will never go out of fashion. Chief among these is the good old-fashioned sunset.

KEEP IT REAL

Who can resist a fantastic sunset? There's something about a sunset which just makes us feel glad to be alive, which is odd when you think about it because it's only a red sky after all, and is not uncommon.

But of course that's the first mistake. Sticking a red filter over the top half of your picture does not a sunset make. The quality and direction of the light is different at sunset, too. Sunsets can be enhanced, but rarely faked – not in-camera, anyway. So the first rule of sunsets is to actually be there at sunset – unless of course you'd rather get there at sunrise, which can sometimes be even more spectacular, but involves rising before dawn. Mornings, however, do have the advantage of being quieter and less crowded.

Haze and atmospheric pollution can sometimes enhance a sunset, giving it a more diffused look.

With sunsets, don't pack up your camera as soon as the sun has dipped below the horizon. Some of the most dramatic lighting happens afterwards, in what is known as the afterglow.

CHECKLIST

- SHOOT REAL SUNSETS, WHICH CAN'T EASILY BE FAKED
- FIND AN INTERESTING FOREGROUND
- METER OFF AN AREA OF SKY
- CONSIDER A GREY GRAD TO DARKEN A SUNSET
- BRACKET EXPOSURES TO SEE WHICH LOOKS BEST
- KEEP SHOOTING UNTIL THE AFTERGLOW HAS GONE
- FILE SHOTS TO ADD TO OTHERS LATER

AESTHETIC ISSUES

One of the most common mistakes in sunset photographs is to assume that it's enough just to get the sunset, and ignore everything else. Sticking a camera out of the bedroom window is fine if you don't mind a foreground composed of your neighbours' roofs and the allotment at the back, but this is hardly the stuff of postcards.

So pay attention to the foreground. It doesn't have to be dramatic (though this helps), but, since the foreground detail is likely to be recorded in silhouette, it needs to be simple and identifiable. Avoid foregrounds that will record as a confusing mass of blobs. An expanse of water always makes an excellent foreground, since it reflects the sky and provides, in effect, a double sunset.

Once you're in position and the sunset is upon you, keep shooting. The sky will be constantly changing until well after the sun has gone. Wait for the afterglow, and shoot until it gets dark.

TECHNICAL CONSIDERATIONS

With sunsets there isn't really such a thing as a correct exposure, though there can be an incorrect one. One problem with sunsets is that the sun is so bright that it can unduly influence the exposure. It's best to take a meter reading from an area of sky adjacent to the sun, but excluding it. Once you've done this, use it as a starting point. If you have auto bracketing, try this, as you'll get different effects at different exposures. The main thing is not to overexpose, as this will cause a washed-out, lacklustre sky.

Another auto function to keep an eye on is the white balance. Set to Auto it may try to neutralise the colours in your sunset, reducing its impact. Set the white balance to daylight or cloudy, and see which looks best.

Shoot at a mid-range aperture and remember that once the sun goes down, you might need a tripod to avoid camera shake with the resulting longer exposure times.

Left: Telephoto lenses are useful for picking out and isolating distant details that cannot be reached simply by moving closer – such as this shot, taken at South Miami Beach.

Above: Telephotos are good at flattening perspective to create a two-dimensional feel.

Telephoto Lens

Can't quite get close enough to fill the frame? Want to focus on distant objects? You need a telephoto lens.

WHAT IS TELEPHOTO?

A standard lens 'sees' at about the same degree of magnification as the human eye. Objects appear similar in size and distance. Telephoto lenses have a smaller angle of view, and have the effect of magnifying distant objects, making them seem much closer. The narrower the angle of view, the greater the magnification.

With 35mm cameras, a standard lens has a focal length of about 50mm. Telephoto lenses are longer, with the most popular 'tele' focal lengths between about 85mm and 200mm.

Because digital sensors come in all different sizes, the actual focal length of the lenses is pretty meaningless, so 35mm equivalents are usually quoted. Most 'standard' zooms end at around 105mm, so those seriously interested in telephoto photography should invest in a second lens in the 70–200mm or 70–300mm category or, if convenience is more important than image quality, a single 28–200mm lens.

TELEPHOTO WITH DIGITAL

Telephoto users enjoy a special advantage when using smaller-than-film digital sensors over film – their lenses increase in magnification by a factor of at least 50 per cent. So a 200mm lens on a 35mm SLR becomes the equivalent of 300mm when used on a digital one. This also means that, for a given magnification, telephoto lenses can be much smaller and lighter on digital cameras than on 35mm ones.

ULTRA-TELEPHOTOS

Telephoto lenses with focal lengths from about 400–2000mm are considered ultra-telephotos, and are not very practical for day to day shooting due to their size and weight, and also the fact that, as the focal length increases, the subject isn't the only thing that's magnified – your shaky hands are, too. A tripod is almost essential with these sort of lenses, and they're usually fixed to the lens rather than the camera.

TELEPHOTO APPLICATIONS

Because telephoto lenses enable users to get frame-filling shots of subjects some distance away, they appeal to those who, for whatever reason, cannot get as close as they'd like to be.

Sports photographers are major users. In team sports such as football, telephoto lenses enable photographers to get close-up shots of the action from the sidelines. With motorsport, where it's dangerous to be close, photographers can fill the frame with individual cars.

Wildlife photographers are another group who rely on telephotos. It's rarely possible, or even desirable, to disturb wild animals by getting close to them (especially dangerous ones such as tigers), and telephotos enable photographers to photograph them without being seen.

People, too, are spied upon with super telephoto lenses – whether celebrities by paparazzi, or suspects by security services.

TRAVELLING OR HOLIDAYING?

The difference between travel photography and holiday photography is one of attitude and philosophy as well as application.

Holiday photography is primarily about yourself and family: what you did, where you went, what you saw. Travel photography is more about the place itself. It's about trying to convey something of the culture, flavour, architecture and scenery of a place. It encompasses many different types of subject – people, architecture, landscape, nature etc, so a broad range of photographic skills are required to carry it off. Other necessary qualities include an open mind, a sense of adventure, a friendly and tolerant disposition and a degree of resourcefulness, as things don't always go to plan.

Left: Even the big tourist honeypots can yield great shots if you work at it. This is London's Trafalgar Square.

Below: Abstract detail shots help tell the story of a place. These were taken in Bermuda (top) and Guatemala (bottom).

Travel Photography

Travel photography is one of the most exciting and stimulating genres of all, but requires a mastery of many different subjects.

CHECKLIST

CHOOSE A DESTINATION SUITABLE FOR PHOTOGRAPHY
DECIDE WHEN TO GO FOR THE BEST SHOTS
KEEP YOUR GEAR WITH YOU AS HAND LUGGAGE
TRAVEL LIGHT WHEN OUT SHOOTING, BE UNOBTRUSIVE
TAKE PLENTY OF SPARE BATTERIES AND MEDIA CARDS
RESEARCH LOCAL LAWS REGARDING PHOTOGRAPHY
RESPECT SUBJECTS, ASK PERMISSION WHEN APPROPRIA'

WHEN AND WHERE TO GO

There are two approaches to travel photography. You can go for a warts and all reportage style, or the glossy magazine and brochure look. Both are equally valid, and if you're looking to sell your work you'll find the latter much easier than the former. But your chosen style may have some bearing on where you choose to go, as some destinations are, by nature, glossier than others.

As well as deciding where, it's important to know when to go. Some countries have very dramatic weather patterns, for example. It's fine to go to India in August, as long you know before you go that it's the middle of the monsoon and you're likely to encounter torrential rain and floods. That may even be why you want to go.

Most parts of the world have special festivals and events which would add an extra dimension to your photos. Planning a trip to Rio de Janeiro? If you go in February, you'll be able to capture the amazing colour and spectacle of the famous carnival.

WHAT TO TAKE

A major conundrum facing SLR users planning a photo expedition is knowing how much gear to take. You want to travel light, especially if you're backpacking or on the move a lot, but you don't want to miss any great shots by not packing your big tele or super-wide-angle. You could take just one superzoom that does it all, but the optical quality may not be up to scratch, especially if you hope to market your efforts.

The best solution for those based in one place is to take a large bag that can be left securely there, and to select just what you need for the day's shoot. For those on the move, a smaller outfit is the only practical solution. In any event, take as many spare batteries and cards as you can, as they may not be readily available at your destination, and pack a tripod, even if it's only a tabletop one. It goes without saying that you should always take your gear with you as hand luggage when you fly.

>>

bags and pouches

A small pocket digital camera is a useful accessory, even when you're laden with a full-on SLR kit. There will be occasions where you won't want to take all your gear: perhaps you want to go out in the evening for a meal and drink. With a small compact in your pocket, you'll always be ready for that unexpected shot. Make sure you carry a suitable bag or pouch to protect it. (For more on bags, see page 28.)

Opposite: Travel photography encompasses many skills: landscapes, architecture, interiors, portraits, reportage.

Far left: Reflections add an extra dimension to night shots. This is the Capitol Building, in Washington, DC.

Left: An almost biblical scene, apart from the plastic cans. Taken outside Cairo, Egypt.

RESEARCH YOUR SUBJECT

To get the best from your chosen destination, it's vital to do your homework before you go. Read the guidebooks, look on the Internet, seek out the work of other photographers who've been there. An insight into the social, political and cultural history of a place will help you a great deal. This will help you to make the most of your time and to recognise the significance of a building or monument when you see it.

Look at maps to see which way specific buildings face, so you know what time of day you need to be there to photograph them. Seek out not just the obvious landmarks, such as cathedrals, but other potential subjects, such as local markets, historic houses, colourful backstreets. Find out where you can get good panoramic views, such as a nearby hill or a tall building with observation area. And find out the law on shooting in places like railway stations — in some countries, doing so can get you arrested.

RESPECT THE LOCALS

It can be embarrassing watching some photographers abroad — shoving their cameras in the locals' faces without so much as a 'Hello, can I take your photo?' or expressing surprise when someone takes offence at being photographed washing their underwear in the river. Simple courtesy goes a long way.

That isn't to say that all your portraits should be posed. In fact, some people become very self-conscious and unnatural when they are posing, and candids produce more 'real' images. But if a potential subject is looking directly at you and you're within speaking distance it's much better to ask, even if that means holding out the camera with a sort of 'Do you mind if I photograph you?' expression.

One of the great things about digital cameras is that you can show people the shot you've taken, and this can be a great ice-breaker — but don't promise prints unless you really intend to send them.

CAPTURE THE ESSENCE

The essence of a country or region is expressed in more than just the costumes of its people, the style of its architecture, the food in its markets or the beauty of its scenery. It's impossible to tell the whole story in a single image.

Aim to produce a varied set of images: scenic views, small details (such as a simple doorknob), candid street scenes, head shots, architectural exteriors and interiors, early morning street scenes and floodlit night shots. Work to convey your feelings and impressions of the place for the benefit of those who have never been there.

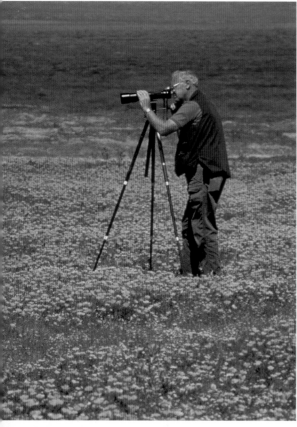

mini tripods

A tabletop tripod fits into a pocket but can hold the average digital camera steady and can be placed on a wall or postbox outdoors, or even turned sideways against a wall. Monopods are surprisingly stable down to shutter speeds of about 1/4sec, and are no trouble at all to carry.

Tripods

Probably the most useful accessory you can buy, this faithful three-legged friend has many uses.

TRIPODS

As its name implies, a tripod is a three-legged camera support that lets you work at shutter speeds that would be too slow to handhold without getting camera shake, and enables you to hold long zoom lenses steady. Tripods come in all shapes, sizes and materials (including metal, plastic and wood), and the bigger they are the sturdier and more stable they are – although, needless to say, big ones are less appealing to carry around. The best material, for its rigidity-to-weight ratio, is carbon fibre, but this is expensive. However even a cheap tabletop tripod or a single-legged monopod can be used for emergencies.

A tripod will open new genres of photography to you – night and low-light photography, obviously, plus sport, wildlife and anything else that uses big telephoto lenses that must be held steady. Tripods are also useful for portraits, allowing you to interact more readily with your model.

KEY FEATURES

Head: Tripods have either a pan-and-tilt head (which can be individually rotated on three axes, for up/down, side to side and tilt adjustment) or a ball-and-socket head, which rotates freely in all axes, and can be locked in any position by a turn of a screw. The latter are quicker to use than the former, but harder to adjust on a single axis. Better tripods feature interchangeable heads.

Legs: Most tripods have telescopic legs that fit inside each other for storage. Some have two sections, others have three or more. Legs are usually locked by twisting a collar around each column, but quick-release legs can be unlocked at the flick of a lever. Some tripods are connected to the centre column by braces, which makes them more stable but bulkier. Conversely, legs without braces can often be splayed wide for low-level shooting, or a single leg raised to a 90° position for placing on, say, a table.

Centre column: This is what the camera is attached to, and it comes in two styles: geared and non-geared. Geared columns are toothed and are raised and lowered by turning a handle. Non-geared columns have to be raised and lowered manually. Centre columns should not be raised too much, as they become unstable. Some centre columns can be reversed, enabling the camera to be placed close to the ground.

Platform: Some tripods feature a removable platform which can be detached in a second by flicking a lever. This saves a lot of time screwing the camera on and off the tripod. For tripods that don't have this feature it is possible to buy a separate universal quick-release platform.

Feet: Rubber feet for use indoors or spiked feet for extra grip on soft ground? Some tripods feature both: rubber feet that screw up to reveal spikes beneath.

Above: Everything underwater looks blue and green because water absorbs the other wavelengths first. To restore the true colours of the subject, flash must be used.

Right: Because water is inherently less clear than air, underwater photographers use wide-angles and try to get as close to their subjects as possible to ensure maximum quality.

Underwater

Photography can be challenging enough on dry land, but underwater it's much more so. Digital can make life easier.

CHECKLIST

- USE A WATERPROOF HOUSING OR POUCH
- CHECK THE SEALS CAREFULLY BEFORE USING
- STICK TO WIDE-ANGLE LENSES OR SETTINGS
- GET AS CLOSE AS POSSIBLE TO THE SUBJECT
- USE FLASH TO REMOVE THE BLUE CAST
- COMPOSE AND REVIEW USING THE LCD SCREEN
- KEEP AN EYE ON TIME, DEPTH GAUGE ETC

WHY DIGITAL?

Snorkelling and diving are among the world's most popular sports, and it's easy to see why. The underwater world is a wonderful and fascinating place, filled with amazing fish, beautiful coral formations and dramatic wrecks. Understandably, divers want to record these awesome sights for landlubbers above the surface, but it isn't easy.

Photography can be complicated even above water, what with composition, lighting, focusing, exposure and other things to think about. Scuba divers have just as much to think about, so put the two activities together and you have a whole lot of things to remember, plus a few new ones.

Digital cameras make underwater photography so much easier. The LCD screen not only makes viewing easier but, given the effort involved in getting the shots, the instant visual confirmation of an LCD is a huge asset. And with a big media card, the shoot doesn't have to end after 36 shots, as it does with film.

PROTECTION

There are several specific problems faced by underwater photographers. The most obvious is that water and electronics don't mix. There are no commercially made true underwater digital cameras but there's a wide range of waterproof housings. For snorkelling or working near the surface you can buy special plastic bags for your camera, but at greater depths the increased water pressure makes a proper rigid housing a necessity. Tough plastic cases are custom-made to fit literally dozens of digital camera models, and allow access to the key controls on the camera via cams and rubberised connections. These tend to be very expensive, sometimes more so than the camera.

OTHER PROBLEMS

Visibility underwater is nowhere near that of air, even in the clearest ocean, so to obtain maximum clarity and image quality it is necessary to get as close to the subject as possible to reduce the amount of water between camera and subject. This is why very wide-angle lenses are favoured for this type of photography.

The underwater world appears blue because water absorbs the other wavelengths much more quickly. To restore the natural colour to your subjects, a flashgun is essential. Flash range is diminished underwater, and with built-in flash it wasn't great to start with – another reason for getting very close, or using one of the many dedicated underwater flashguns available.

Viewing is a problem underwater; with your mask and the camera housing, it's impossible to get close enough to the viewfinder to see through it. The LCD screen solves this problem, but will of course reduce battery life.

REFLEX VIEWFINDERS

This is the type of viewfinder used by SLR cameras. Reflex finders are by far the best because they show you, optically, exactly what you're going to get. They work by using a 45° mirror behind the lens which bounces the light upwards to your eye, via a focusing screen and prism, and flips up as the shot is taken. You can see the effect as you zoom and focus and preview the depth of field, and you can also get full shooting data down the side of the screen. They are big and bright to see through (usually even for spectacle wearers), yet they consume no power.

There are minor downsides: the cameras need to be large to accommodate the mirror and prism assemblies , the mirror action makes them slightly noisier and more prone to camera shake (although it can be locked up on some models for tripod-based shooting), and for the fraction of the second that the mirror flips up the screen goes black, so you can miss people blinking etc.

Viewfinders

Digital cameras offer several ways to view your subject before shooting, but which is the best?

OPTICAL VIEWFINDERS

Optical viewfinders: With these you're viewing the scene through a piece of glass linked to the lens (so it zooms as the lens does). Easier to view in bright light than an LCD, but being next to the lens, optical viewfinders show a slightly oblique view to the one you're actually taking. The difference between the image and your view of it is called parallax error and is greater at close range. Optical finders consume no power.

Electronic viewfinders: With EVFs you're viewing a smaller version of the LCD through an eyepiece. This means you're seeing the exact shot you're going to get, plus the shooting data, and can view adjustments in real time. On the minus side, the clarity isn't as good, making it hard to see facial expressions etc, and slow refresh times (how many times per second it updates) cause a brief 'drag' when you move the camera. The quality of EVFs vary greatly in pixel count, refresh time and power consumption.

LCD MONITORS

Once, mime artists wishing to simulate the act of taking a photo would make a frame with their hands and put it to their eye. Today they'd still make that frame, but may well hold it out at arm's length. Such is the power of the LCD screen. Having a big screen on the back of the camera is one of the biggest benefits of digital cameras, though for reviewing rather than shooting.

But many compact users prefer to shoot this way, too. This is because, unlike the optical finder on most compacts, you see exactly what you're going to get, with shooting data too. You can adjust things such as exposure compensation, and often see the effect on the screen immediately.

Some LCDs are difficult to see in bright sun, but better ones have non-reflective coatings and automatic brightness adjustment for outdoor use. Many also offer tilting, swinging screens, so you can shoot holding the camera up high, down low or to the side.

THE UNDERTAKING

For most couples, their wedding is the most important day of their lives and can never be repeated, making it a huge responsibility for whoever has been untrusted with the task of recording it.

Whether you're the 'official' photographer or are just hoping to get some good incidental shots, there are a few tips and techniques that will increase the chances of a successful outcome.

First, discuss the couple's needs with them beforehand. Check your equipment to ensure everything is working properly, and make sure you have a spare camera, just in case. (Borrow one if necessary.) A spare media card of a suitable size and an extra set of batteries should also be on your list of essentials.

If you can, check out the venue beforehand to scout for suitable locations, and on the big day get there in plenty of time – especially if you're the official photographer.

It's fashionable to ask for weddings to be shot in black and white. Resist the urge to set your camera to black-and-white mode. It's easy to make mono prints from colour images, but impossible the other way around.

Wedding Days

Few assignments in photography are as challenging as a wedding, but here are a few tips to ease the stress.

CHECKLIST

TALK TO THE COUPLE BEFORE THE BIG DAY
CHECK EQUIPMENT, SECURE THE USE OF A SPARE CAMERA
CHARGE/REPLACE BATTERIES, BUY SPARES
VISIT THE LOCATIONS BEFOREHAND IF POSSIBLE
WORK QUICKLY AND UNOBTRUSIVELY
SHOOT A FEW POSED GROUPS FOR POSTERITY
SHOOT CANDIDS TO CAPTURE THE EMOTION OF THE DAY

POSED SHOTS

Nobody wants a wedding album full of rows of posed groups any more, but despite the vogue for reportage-style weddings, only the most devoutly trendy couple would want to entirely eschew at least a few of the classics. For a start, you simply have to get a posed shot of the couple in full attire. Choose a shady location with a pleasant background and use a wide aperture to throw it nicely out of focus (to keep the attention on the couple). Shoot them full-length to show off the dress (make sure it isn't creased etc), then at half length for their faces. Have them look either at the camera or each other (or both). Allow 10 minutes for these shots, but don't take too long or you'll annoy the guests.

You should make at least one record of the guests, too, even if you don't do all the individual groups. Arrange them all so that everyone is visible and not squinting into the sun. With big groups, take at least three shots.

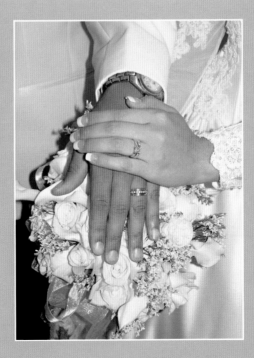

MOMENTS

If the story of a wedding is told in the photos, the posed shots establish the characters and the plot – the who, what and where – but the candids are the narrative – they describe the colour and flavour. A good story needs both elements.

It's quite difficult to shoot both styles at the same time, so it's easier to concentrate on the candids if you're not the main photographer.

Choose a camera with a good zoom lens, from wide-angle to telephoto. Watch the bride and groom for moments of spontaneous interaction (loving glances, laughter etc), but don't get in the pro photographer's way.

Indoors it's better to set a higher ISO than to resort to flash, which will kill the mood. Observe the interaction around you, and be ready for brief moments. Try to get the guests' reactions to what is happening, and shoot candid shots of the children. Often, the hired photographer doesn't stay for the reception, so cover this well.

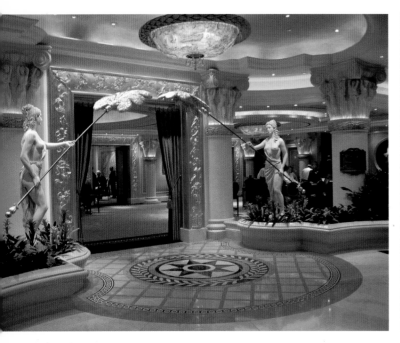

Above: These interiors, taken at Caesar's Palace, Las Vegas, were lit by tungsten lighting, and show the effect of white balance on the image. The shot on the left was taken at the daylight setting, the one on the right on the tungsten setting. The latter provided the more accurate rendition, although in some cases the 'wrong' one may look aesthetically more pleasing.

White Balance

Lurking within the dark recesses of your digital camera's menu lives the white balance setting, but what does it do?

THE COLOUR OF LIGHT

As discussed on page 34, light comes in many different colours. Daylight is much more blue than a lightbulb, but a candle is more orange than both, and fluorescent strip lights often give off a green hue. The colour of light is described as its colour temperature, using the Kelvin scale.

Except in extreme cases, such as sunsets, our eyes don't usually notice these changes in colour, because our brain has a built-in automatic white balance control which neutralises them all.

Our cameras are less sophisticated. Although most cameras do have an automatic white balance setting, these are really only able to cope with different hues of daylight, not dramatic changes, which is why they also have a selection of preset colour temperature settings for the most commonly encountered conditions. Some cameras also have a manual white balance option which allows you to measure the specific colour temperature for more precise colour.

SETTING THE WHITE BALANCE

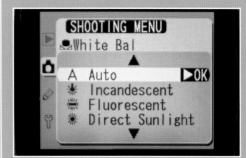

If you don't set a white balance appropriate to the prevailing lighting conditions, your pictures will probably turn out with an unpleasant colour cast. Left in the daylight position, photos taken indoors by artificial light will suffer from a strong orange hue; in fluorescent light they will be a sickly green. Although these casts can often be removed at the editing stage, this is time-consuming and not always successful – and if you've taken a lot of shots on the wrong setting you'll have to correct them all individually.

THE SETTINGS

The range and names given to white balance settings vary between cameras, but include:
Auto: The camera adjusts the white balance as the light changes. OK for daylight shooting, but may struggle to cope with extreme changes.
Daylight: Sets a colour temperature of around 5,500K. The best choice for those who like to know what their camera is up to on their behalf.
Cloudy: In cloudy conditions, light is often bluer. This mode selects the camera to about 6000K.
Tungsten: Also called Incandescent, this is the mode for domestic lights and lamps (bulb or halogen), and sets a temperature of about 3200k.
Fluorescent: Fluorescent tubes produce an unpleasant greenish tinge. This mode adds some magenta to counteract this.
Custom/Manual: For those who demand precise colour accuracy, in this mode you point the camera at a neutral area in your scene (eg a sheet of white paper or grey card), and it sets the precise temperature to remove any cast.

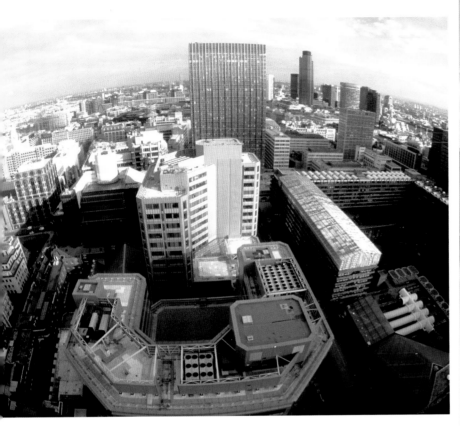

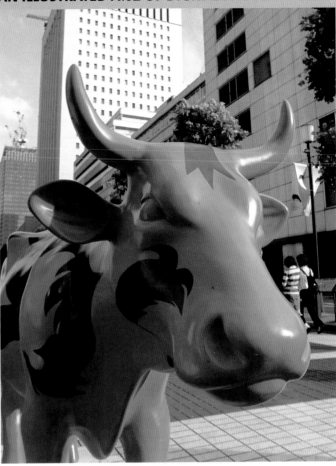

Left: Semi-fish-eye lenses produce curved horizons and verticals when the camera is tilted. Fish-eye shots are completely spherical.

Above: Wide-angles make close objects appear disproportionately large, and have more depth of field.

Wide-Angle

Can't quite get everything you'd like into your shot?
Can't step back far enough? You need a wide-angle lens.

WHAT IS WIDE-ANGLE?

A standard lens 'sees' at about the same degree of magnification as the human eye. Objects appear about the same size and distance. Wide-angle lenses have a greater angle of view than standard, making things appear smaller and further away.

The greater the angle of view, the more extreme the wide-angle. Most have an angle of view of between 65° and 90°, compared with a standard lens' 45° view), so they're great for times when we just can't get everything in shot .

With 35mm cameras, the focal length of a standard lens is about 50mm. Wide-angles start at about 35mm and go down to about 14mm, but 24mm and 28mm lenses are the most popular.

With digital cameras these focal lengths don't apply, as sensor sizes vary from camera to camera. To simplify things, digital compacts quote their 35mm equivalent, and SLR owners know to multiply the focal length of their lenses by a factor of 1.5x or 1.6x to find the equivalent.

WIDE-ANGLE WITH DIGITAL

For a wide-angle point of view, the main problem with digital sensors is their size. Being smaller than 35mm film, they show only the central area of the image produced by the lens, reducing the wide-angle effect dramatically. To get the same angle of view on these smaller than film sensors, focal lengths must be much shorter. For example, a digital 12–24mm lens produces a similar angle to an 18–36mm on a 35mm camera.

EXTREME WIDE-ANGLES

Lenses with a focal length of below 24mm (on a 35mm SLR) are known as extreme wide-angles. A drawback of wide-angles is their propensity to produce image distortion in some situations, and the wider the focal length, the greater the risk. At their most extreme, fish-eye lenses produce images with a dramatically curved and bulbous perspective. Some fish-eye lenses produce an entirely circular image with a 180° angle of view!

WIDE-ANGLE APPLICATIONS

Because wide-angles enable users to fit more into the shot than with other lenses, they're useful in confined spaces, such as architectural interiors; large group photos are easier, as you don't have to step back so far to get everyone in.

But they aren't just about cramming more into the shot. By moving in a lot closer to the subject , so you get the same field of view as a longer lens from further away, you get a very dramatic 'in your face' perspective which cannot be achieved using other types of lens.

For this reason wide-angles are popular with photo-journalists, who like the sense of being 'in the thick of things' that they provide. Fashion photographers are also drawn to their dramatic and eye-catching qualities, and landscape photographers like them for their exaggerated sense of perspective and their enhanced ability to emphasise the foreground at the expense of the middle distance.

EQUIPMENT

Wildlife photography is generally conducted from some distance away, using big telephoto lenses. One of the big advantages of digital cameras is the ease with which great magnifications are possible. Even some budget compacts boast 10x zooms, and digital SLR owners enjoy effective focal length increases of 50–60 per cent, turning a 400mm lens, for example, into the equivalent of 600mm or more. These are the sort of focal lengths you'll need for more timid subjects, although shorter lenses are also useful for closer range work. Wide maximum apertures are useful, not only for low light shooting but also for throwing the background nicely out of focus.

Teleconverters are a useful accessory, as these increase the focal length by 1.4x or 2x, with only a minor loss of light and quality. Other essentials include a sturdy tripod to hold that lens steady, and a couple of high-capacity memory cards, to hold all of the shots you'll be taking.

Wild Animals

Getting good pictures of beautiful and exotic wild animals can be very difficult indeed, but the results are well worth it.

CHECKLIST

STUDY YOUR SUBJECTS BEFORE SHOOTING
USE A LONG ZOOM LENS TO REMAIN UNOBTRUSIVE
TELECONVERTERS EXTEND THE RANGE OF YOUR LENSES
USE A STURDY TRIPOD FOR SHARP, STABLE PICTURES
CONSIDER USING A HIDE FOR ELUSIVE WILDLIFE
USE BAIT TO DRAW SUBJECTS TO YOU
YOU CAN GET GOOD SHOTS AT WILDLIFE PARKS/ZOOS

PATIENCE

Few areas of photography are as popular with the public as wildlife. Most of us enjoy a love affair with the natural world and are fascinated with images of exotic, rare or just plain beautiful animals that we rarely, if ever, see in the flesh. Who can resist a close-up portrait of a tiger or even a fox? Some subjects are more difficult than others to photograph. With subjects such as big cats, the zoo is a good place to start honing your skills (see page 18), while other, native, animals may be found in a local nature reserve.

Birds are an especially challenging subject in that they are very small, move extremely quickly and are usually framed against a bright sky – so some manual exposure adjustment is necessary.

Whatever your chosen subject, the single most important quality you will need is patience. The top wildlife photographers spend days, weeks or even months getting their shots, and shoot a lot of pictures once they have their prey in the frame.

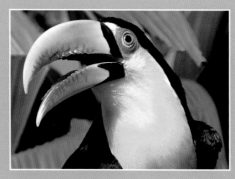

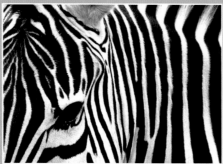

HIDE AND SEEK

Apart from your equipment requirements, the biggest challenge of wildlife photography lies in finding, and getting close to, your subjects. The more you know about the habitats, feeding habits and other facts about your chosen subject, the greater your chances of success. Familiarity with a particular terrain also gives you a great advantage, making locations close to home a good place to start.

One way to increase your chances of a close encounter is to set yourself up at a spot where you can be confident your prey will appear – a watering hole, for example. To help things along a bit try leaving out appropriate food in a favourable spot, and waiting.

Many wildlife photographers use hides or blinds in which to wait, unseen, until the animal appears. Some can be carried like a tent and set up quickly, others are more permanent, home-made constructions.

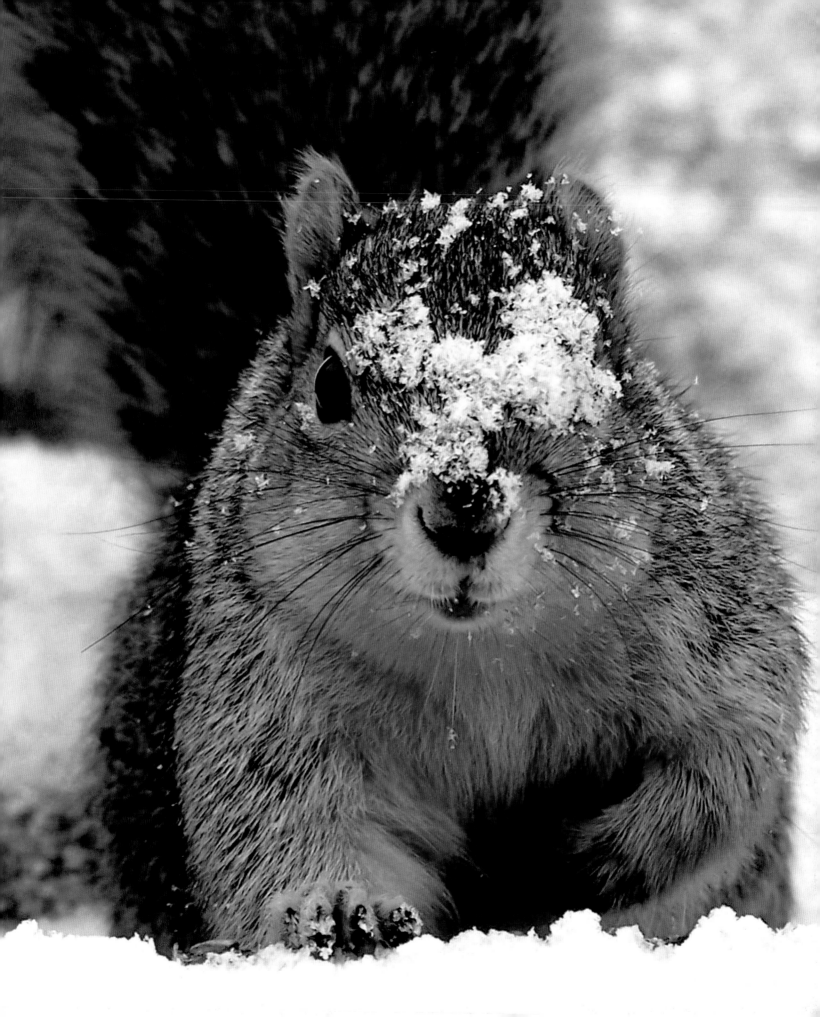

WINTER LIGHT

There's a popular misconception among the public that photography is something you do in sunny weather. Yet, as any landscape or nature photographer will confirm, summer is probably the worst season for quality photography. It's hazy, contrasty and bland.

Winter is superior by far. Why? Well it just has so much to offer. First, there's the light; there may be many days of semi-darkness, but a surprising number where the sun makes an appearance, too, and winter sun is like no other kind. Its low angle casts long shadows over the land and reveals the texture in grass, bark, stone and every surface it touches. The air is clearer and less hazy, too.

Even when the sun isn't shining, other kinds of winter weather offer loads of great atmosphere: fog, mist, snow, even rain, in the right situation.

Often to get the best winter light you need to be up and in position by dawn. Luckily, this is much later in winter than in summer.

Left: Landscapes look radically different when covered with snow, but care must be taken with exposure.

Above and below: Look out for small details, such as a leaf (above), or icicles (below).

Winter

Digital cameras are not like squirrels – they don't need to hibernate in winter. Take yours out for exercise and get some great shots.

CHECKLIST

SHOOT SNOW-COVERED LANDSCAPES
SEEK OUT DETAILS SUCH AS ICICLES
FROST-COVERED COBWEBS ARE PHOTOGENIC
TAKE CARE WITH EXPOSURE
TAKE METER READINGS FROM MID-TONES
PROTECT YOUR CAMERA FROM THE ELEMENTS
KEEP YOUR BATTERIES WARM. CARRY SPARES

WINTER SUBJECTS

Winter landscapes exude tremendous power. Covered with snow the world looks so different – even dull places can look beautiful. Snow fills us with a childlike sense of excitement.

Frost can be just as photogenic with the right subject. Don't just go for the big wide shot. Look for small frost-covered details – leaves, grass or even the bonnet of your car. Cobwebs can look amazing when covered with frost, too.

Frozen water is another good subject: the surface of the local pond, perhaps with leaves frozen into the surface, or a fracture caused by the touch of a heavy object.

Trees look just as good in winter as they do in summer. Gnarled, twisted branches framed against a winter sky or shot in silhouette make good subjects for the camera.

But it isn't just about landscapes – portraits, still life, wildlife, reportage all take on a different hue in winter, so get shooting.

WINTER TIPS

If you happen to venture out with your camera during the winter months, keep your camera protected from the more inhospitable elements. In cold weather, keep the camera warm and dry under your jacket between shots. Batteries often fail in very cold weather, but keeping them in your pocket will preserve them (make sure your pockets are free of metal objects, first though). In wet weather, try to keep the camera dry; perhaps shoot from under an umbrella.

Winter weather can play havoc with your exposures, especially snow. An all-white landscape will probably fool your meter into underexposing the image as it tries to turn your crisp white scene into a dull mid-grey. Increase the metered exposure by between one and three stops, depending on how much light the snow is reflecting.

With fog, bracket your exposures, because the definition of what is 'correct' is very subjective.

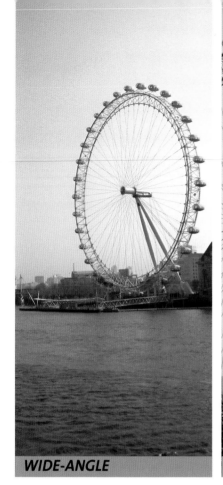

WIDE-ANGLE

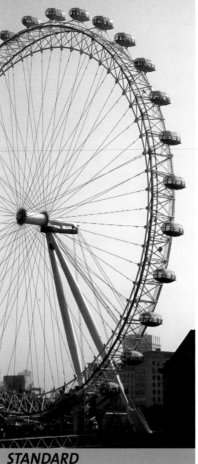

STANDARD

TELEPHOTO

DIGITAL ZOOM

Zoom Lenses

Almost every digital camera worth its salt has at least
one kind of zoom. But what's the difference between them?

ZOOMS TAKE OVER

Once upon a time, lenses only had one focal length. There were standard lenses, wide-angle lenses and telephotos. If you wanted to switch from one view to another, you had to take the lens off and replace it with a different one.

The zoom lens was invented in 1932, but it wasn't until the 1970s that lenses filtered their way down to the consumer photography market in a major way, but they were big and slow and their optical quality left a lot to be desired.

Even quite recently, quality-oriented photographers always chose prime (fixed focal length) lenses over zooms for their superior sharpness, higher contrast, wider maximum apertures and better control of distortion. Prime lenses are still better in absolute terms, but zooms have improved so much in recent years that the difference (with good zooms) is indistinguishable to the average eye, and the benefits (cost and convenience) outweigh the disadvantages.

OPTICAL ZOOMS

A highly effective way to enhance a panned photograph is to add a burst of fill-in flash to the mix. Using flash at slow shutter speeds is called slow-sync flash, and it's done in the same way as straight panning but with a flash attached, or with the camera set to its slow-sync flash mode. When you press the shutter the long speed records the background as a blur and the flash 'freezes' the subject, making it stand out more. If you choose not to pan, your subject can be recorded as both blurred (the ambient exposure) and sharp (the flash), which can also look great.

Some cameras and flashguns offer a second (or 'rear') curtain sync option, which fires the flash at the end of the exposure, rather than the beginning. This is better for action shots since the sharp image precedes, rather than follows, the blur, creating a more natural look.

Obviously these techniques only work when your subject is within the flash range.

DIGITAL ZOOMS

Digital zooms simply zoom in on the centre of the sensor and enlarge that part of the image up to full frame. It is no different to just cropping your shot on the PC and blowing up the middle section, with all the reductions in image quality that entails. For this reason, digital zooms are greatly frowned upon by photographers.

But the case for digital zooms has improved with the growth of high resolution cameras. Yes, with the digital zoom you're using only a fraction of the sensor's pixels and blowing them up, reducing sharpness, increasing noise and making the pixels more visible. With a 3MP camera you could easily end up with a picture of less than 1MB, but with 5–8MP cameras you can still get a 2–3MP image – ample for printing to 150 x 100mm (6 x 4in). It may be better to do this on the PC but not everyone has one, and others want to get the picture they want straight out of the camera, without having to post-process first.

PHOTOSHOP
TUTORIALS

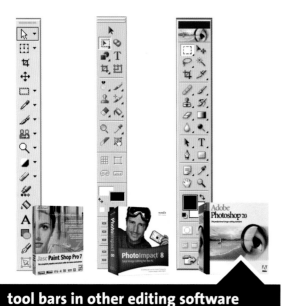

tool bars in other editing software

Toolbars in similar image-editing software are laid out roughly in the same order. They are the most important palette of all and need to be open at all times. (For more on editing software, see page 47.)

The Image-
Editing Toolbar

The toolbar is the centre of the image-editing universe. It is here you'll find almost everything you'll need to fix your photos.

TOOLS OF THE TRADE

The Photoshop Elements 2.0 toolbar is typical of most image-editing software packages. The tools are positioned in various work groups down each side of the bar, starting with **Selection tools**. When a selection is made with any of these tools, the result is called a Marquee, a thin line of flashing black-and-white dots.

The next set of tools includes the **Brush tools**. These all behave in a similar way by manually changing the size and softness of the brush. The Text tool is also found in this group.

Image Correction tools are great for achieving overall effects to make your pictures perfect. Then come the **General tools**, which are a set of tools that help you navigate around your image, select colours and even repair unsightly blemishes. Lastly, you have the foreground and background colour swatches.

PHOTOSHOP ELEMENTS TOOLBAR

1. MARQUEE TOOLS
2. LAYER TOOL
3. LASSO TOOLS
4. MAGIC WAND
5. SELECTION BRUSH
6. CROP TOOL
7. SHAPE TOOLS
8. TYPE TOOLS
9. PAINT BUCKET
10. GRADIENT TOOL
11. PAINT BRUSHES
12. PENCIL TOOL
13. ERASERS
14. RED-EYE TOOL
15. BLUR
16. SHARPEN
17. SPONGE
18. SMUDGE
19. DODGE
20. BURN
21. STAMP CLONE TOOLS
22. EYE DROPPER
23. HAND
24. ZOOM
25. F & B SWATCHES

SELECTION TOOLS

1. MARQUEE TOOLS
These tools are used to select rectangular or ellipse-shaped areas, which can then be worked on without affecting the rest of the image. They are defined by a thin line of flashing black and white dots.

2. LAYER OR MOVE TOOL
When a layer is selected, this tool allows the image on the layer to be moved in any direction.

3. LASSO
These useful tools allow you to 'draw' around irregular shapes within the image, such as people. Variations on the basic lasso include the Polygonal Lasso (which traces from point to point) and the Magnetic Lasso (which 'sticks' to lines and edges).

4. MAGIC WAND
The Magic Wand lets you select pixels of a similar colour. The degree of colour similarity of selected pixels can be adjusted, and the tool can be set to select pixels from anywhere within the image or just those adjoining the point that you choose to click on.

5. SELECTION BRUSH
The useful Selection Brush enables you to 'paint' a selection marquee anywhere on your image. Ideal for irregular shapes.

6. CROP TOOL
The Crop tool allows you to crop any part of an image by drawing a selection box around the required area. The area outside the selection will be deleted. (See page 148.)

BRUSH TOOLS

7. SHAPE TOOL
The Shape tools enable you to draw paths. There are seven variations in this nest – this is the Custom Shape tool.

8. TYPE TOOL
Not actually a Brush tool, the Type tool is used to put text onto the image. Nested variations include Vertical and Masking type tools. (See page 163.)

9. PAINT BUCKET
The Paint Bucket fills any selected area with one of a set of predetermined solid colours.

10. GRADIENT
Again, not really a brush tool, the Gradient tool graduates a colour or effect within a selection and is great for making backgrounds.

11. PAINT BRUSHES
The Brush tool 'paints' colours, masks etc onto the image. Its size, shape etc can be adjusted. It can also be set to act like an airbrush.

12. PENCIL
The Pencil tool is similar to the Brush, but has different qualities. As with the Brush tool the size, shape etc can be adjusted.

13. ERASER
The Eraser removes pixels with a mouse-click. It can take on several forms such as an airbrush, a pencil or a block.

14. RED-EYE
You will be amazed at how the Red-eye tool simply wipes away annoying red-eye effects that occur in many flash photos. (See page 158.)

IMAGE CORRECTION

15. BLUR TOOL
This has the ability to soften pixel areas giving them a blurred feel.

16. SHARPEN TOOL
This has the ability to sharpen pixel areas and make them more crisp.

17. SPONGE TOOL
The Sponge tool literally washes – desaturates – your image, and affects the contrast.

18. SMUDGE TOOL
The Smudge tool allows you to 'push' pixels around, treating the image something like wet sand.

19. DODGE TOOL
This holds back light digitally, creating an underexposed effect.

20. BURN TOOL
This darkens the image, creating an overexposed effect.

21. CLONE TOOL
This picks up pixels from an area of your image and 'puts' them down again. (See page 153.)

22. EYEDROPPER
This allows you to select a colour and place it into either the foreground colour or background colour swatch.

23. HAND TOOL
This enables you to scroll around the image to see different parts.

24. ZOOM TOOL
This behaves exactly as you would expect, zooming in and out of your image so you can see detail.

25. F & B SWATCHES
The foreground swatch is the colour you paint with; the background is there as an alternative choice.

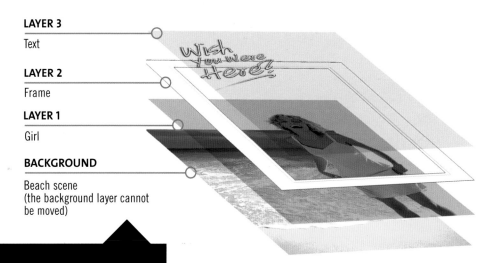

LAYER 3
Text

LAYER 2
Frame

LAYER 1
Girl

BACKGROUND
Beach scene
(the background layer cannot
be moved)

layers exploded

This illustration shows exactly how a layer stack
works. Each separate element is contained on a
layer surrounded by transparent pixels. All
layers are independent of each other and can be
moved in the stacking order, either up or down.

Using Layers

Layers act Like a stack of clear
sheets, one on top of the other.

IT'S SO TRANSPARENT

It doesn't take long before you want to do more
with pictures than simply download and print
them. Before you know it you will want to add
text, combine several images together, and even
add fancy borders.

In some image-editing packages these sorts of
activities are performed directly on the picture,
which means that making corrections at a later
date is difficult, if not almost impossible.

Leading programs, such as Photoshop,
provide a Layer system to their files. This
enables users to separate different components
of a picture onto different layers. Each layer can
be moved and edited independently.

Though each program handles this system
differently, all provide a palette that you can use
to view each of the layers and their content.

The layers are positioned one above each
other in a stack, and the picture you see in the
work area is a preview of the image with all the
layers combined.

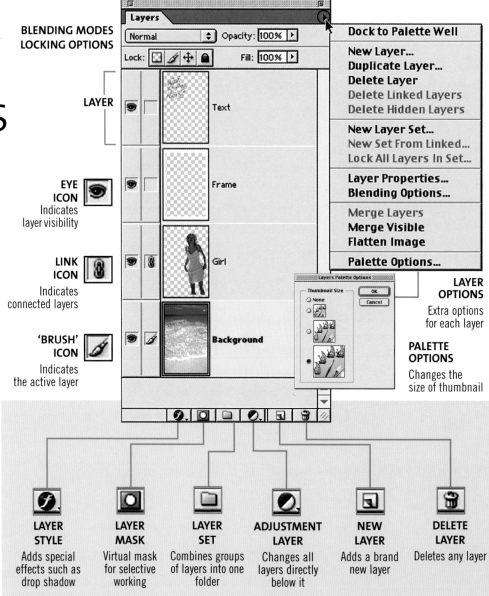

BLENDING MODES
LOCKING OPTIONS

LAYER

EYE ICON
Indicates
layer visibility

LINK ICON
Indicates
connected layers

'BRUSH' ICON
Indicates
the active layer

Dock to Palette Well

New Layer...
Duplicate Layer...
Delete Layer
Delete Linked Layers
Delete Hidden Layers

New Layer Set...
New Set From Linked...
Lock All Layers In Set...

Layer Properties...
Blending Options...

Merge Layers
Merge Visible
Flatten Image

Palette Options...

LAYER OPTIONS
Extra options
for each layer

PALETTE OPTIONS
Changes the
size of thumbnail

LAYER STYLE
Adds special
effects such as
drop shadow

LAYER MASK
Virtual mask
for selective
working

LAYER SET
Combines groups
of layers into one
folder

ADJUSTMENT LAYER
Changes all
layers directly
below it

NEW LAYER
Adds a brand
new layer

DELETE LAYER
Deletes any layer

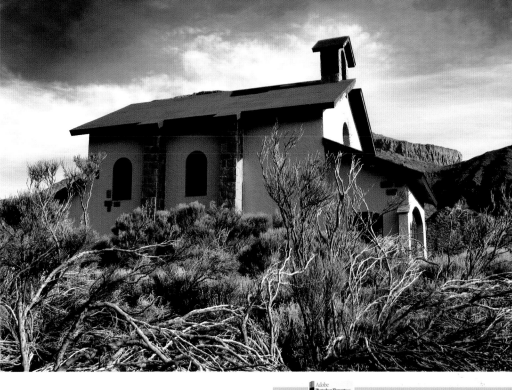

choose an image that will benefit

When looking for a colour image that will benefit from greyscale conversion, try looking for contrasting light and dark tones. These become accentuated and add the 'punch' to the image.

Converting to
Black and White

Here's an easy way to give your colour shots a whole new lease of life, by turning them into mono masterpieces.

CHECKLIST

PHOTOSHOP ELEMENTS & CS
PAINT SHOP PRO

TOOLS & SKILLS
GREYSCALE
LEVELS
HISTOGRAM
EYE DROPPER

SHADES OF GREY

Converting your colour photos to black and white can add great drama to an otherwise average image. There are many ways to digitally convert your images to greyscale, but in this tutorial we will convert a colour photo using Levels and the Convert to Greyscale command.

This is a great exercise that will help you learn about levels and how to look for contrasting light and dark tones in an image before conversion. Easy examples to try first are landscapes, with the obvious contrast between the land and the sky.

As with all enhancing and editing projects, it is a good idea to save your image as a duplicate file first. If anything goes wrong or you don't like the finished result, you can still revert to the original.

STEP ONE

Before you start, decide if your colour image needs more contrast. From the Image menu, select **Levels**. This will bring up a window displaying the image's **histogram**, which is a graphic representation of the tones in a digital image. It has reasonable tonal range, but we can give it a little more 'snap' by adjusting the black-and-white ends of the histogram. Drag the white slider a bit to the left, and the black slider to the right.

STEP TWO

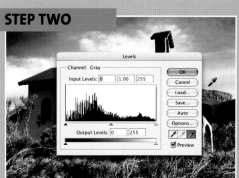

Go to **Image > Mode > Greyscale**. This will strip away all the colour. Go back to the **Levels** window and adjust the sliders again until you have the perfect range of tones. To get a 'pure' white and black, use the **Eyedropper** in the Levels window. Select the White dropper, find something in the photo that you think should be pure white, and click on the area once. This makes your selection and all tonal values less than this, white. The same applies for the black. Click **OK.**

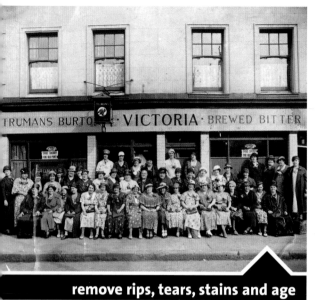

remove rips, tears, stains and age

Here we show you how to restore an old and damaged photograph, scan it with optimum resolution for your output and enhance the black-and-white tonal qualities by using Photoshop Elements 2.0. (For more on black and white, see page 30.)

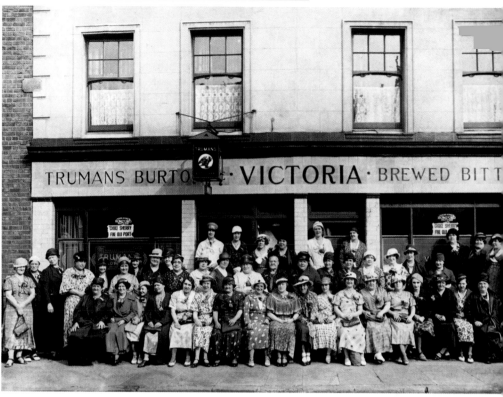

Image Repair

Old photos will, in time, be lost forever, but with the help of Photoshop, they can be restored to their former glory.

GETTING STARTED

Old photos don't stand the test of time very well. They become faded, ripped, bent and stained until eventually the photo is discarded or the image is lost forever.

With Photoshop Elements 2.0 you can restore them to their former glory. Extensive use of the Rubber Stamp tool will enable you to repair the damaged image and remove spots of dust, scratches, tears and stains.

This can be a very involved project, taking up more time than most. Attention to detail is very important, especially in tricky areas around faces. So don't expect to get it right first time – make good use of the Undo function if you're not happy with each removal.

As they say, practice makes perfect !

STEP ONE

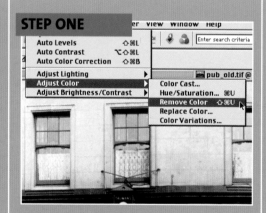

Scan your image using the scanner's Auto Scan Mode set for 'inkjet print' (see pages 106-108). With your scan saved to your hard drive, open it in Photoshop Elements.

To remove the yellow cast, discard the colour using **Enhance > Adjust Colour > Remove Colour**. Your image should now be greyscale.

STEP TWO

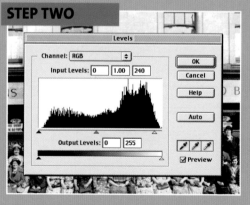

To further enhance your image, use Levels to increase the tonal value using **Enhance > Adjust Brightness/Contrast > Levels**. Adjust the sliders to create a pleasing tone that's to your taste.

Try to be subtle, and don't make the image too contrasty or you will lose highlight detail.

STEP THREE

Now it's time to clean up the dust and scratches. **Zoom** right in to the top left corner, so you can just see the pixels. It helps when working with small details to work visually this size. Work across the image from left to right in sections. This will help confine the restoration to manageable areas.

STEP FOUR

Select the **Rubber Stamp** and a **Soft Brush** from the top menu. Set the **Mode** to **Normal**, leave the opacity at 100% and check the **Aligned** box is checked. Hold down the **Alt** key (Option on a Mac) and click an area next to a dust spot. This will become the area that is applied over the spot. Dab, rather than stroke, over the dust spot until it's covered.

STEP FIVE

Zoom out every now and then to assess your progress. As with all Rubber Stamp 'sampling' it is always best to **Option/Alt** click as close to the original as possible, but with rips and tears, this may not be possible. If they appear on solid background, try experimenting with sampling further away, keeping the same tones.

STEP SIX

Damage may be so bad in an area that all information is lost. Try sampling from sections of the image that are similar. In this example, the left of the dress is intact and will allow you to duplicate on the right side.

STEP SEVEN

Start at the bottom and work your way up, taking your time and zooming right in when things become tricky. When restoring detailed work like this, it's best to keep the brush very small and sample just a few pixels. Avoid area repetition.

STEP EIGHT

With stains, use the **Pattern Stamp** by using a selected area as a repeating pattern. Select the **Marquee** and draw a square over an uncluttered area. Select **Edit > Define Pattern**. Click **OK** to name the new pattern you have now created.

STEP NINE

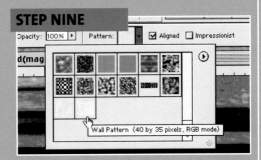

Having created your pattern, click and hold on the Rubber Stamp in the tool bar. The **Pattern Stamp** option will appear. Select the tool and create a suitable brush size for the area you're about to work on. In the top menu bar you will see the option for the pattern. Click and hold, and the **Pattern Palette** will appear. At the bottom of the preset list, you'll see your newly created pattern. Select the pattern.

STEP TEN

Using the **Pattern Stamp** is slightly different from the Rubber Stamp, as there's no need to Option/Alt click. Just dab away over the stain.

Try not to make large strokes as you will notice the pattern repeating. Adjust the brush size as you progress around detail and tight spots. Remember to zoom out every now and then to see the overall effect. And always remember to keep **SAVING!**

FINISHING TOUCHES

You have many options to output, but burning to a CD is the first choice, as it's always essential to back up your work, especially if you treasure your newly restored photo.

Equally, you might want to print out the image and frame it – but do bear in mind that not all inkjet inks are water-resistant or colourfast.

If you scanned at 1:1 resolution, look at the document dimensions at the bottom left corner of the Image window. This will tell you if your document will fit onto an A4 sheet of inkjet paper. Choose a suitable paper. As you've spent some considerable time getting the picture exactly how you want it, buying a pack of fine-art paper would make an excellent idea (see page 108).

vignette frames

why the image needs a vignette

This image needs a vignette frame because the background is very fussy and cluttered. This can distract the eye away from the focus of the central characters. Vignettes are very easy and quick to make and can transform any image into a timeless work of art! (For more on backgrounds, see page 26.)

Vignette Frames

Sometimes all a photo needs is a simple finishing touch. A soft vignette frame is just the thing.

CHECKLIST

PHOTOSHOP ELEMENTS & CS
PAINT SHOP PRO

TOOLS & SKILLS
NEW LAYER
MARQUEE
FEATHER
GAUSSIAN BLUR

TIMELESS QUALITY

To give your portrait image a timeless quality, sometimes just a soft-edged frame called a vignette is all that is required to lift it from being an otherwise standard image. Vignettes help draw the eye into the image and give a central focal point. They also help to distract from any cluttered and unwanted background.

This frame effect was used from very early on in photographic history as a way of softening studio portraits. Vignettes are very quick and easy to make. This tutorial shows you how to make a white frame, but you can use any colour you like if you feel it enhances the image.

This example can be achieved in just about any image-editing software, as long as it supports Layers.

STEP ONE

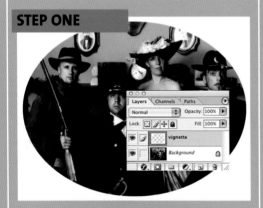

Create a new layer from the menu bar, **Layer > New > Layer,** or click the new layer icon at the bottom of the Layers palette. Make sure that the new layer is active (highlighted). Select the **Elliptical Marquee** tool from the toolbar. Draw an oval marquee over your image. Start in the top left-hand corner and drag down to the bottom right to get an even oval shape. Click and hold down the mouse, dragging inside the selection to move it into position. Try not to let go, as this will deselect it.

STEP TWO

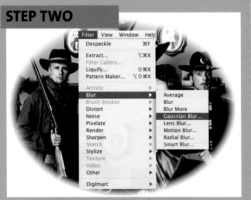

Now invert the selection **Select > Invert**. Choose **Edit > Fill > Foreground colour,** making sure your foreground is white. This will fill the selection. Now deselect the Marquee **Select > Deselect**. Now choose **Filter > Blur > Gaussian Blur** and select a pixel value that will soften the edges. Flatten the layers and save the image.

it's not just black and white

Duotone images are strictly speaking a greyscale image which has two spot colours added to it. To make a great duotone, start with your colour image and follow the tutorial on page 143, then follow the steps below. Remember to save a duplicate file before you start.

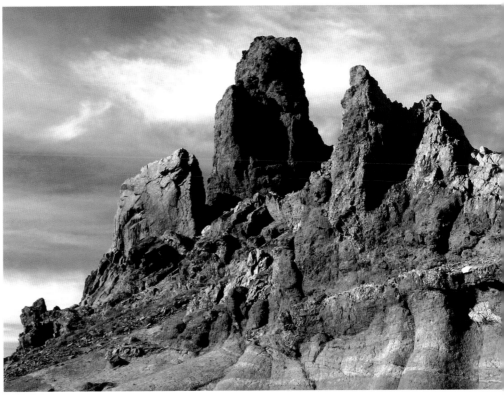

follow the tutorial on page 143

Duotones

If converting to black and white is not enough for you, open your image up to the world of duotones.

CHECKLIST

PHOTOSHOP CS & PAINT SHOP PRO

TOOLS & SKILLS
CONVERT TO GREYSCALE
DUOTONE DIALOGUE BOX
COLOUR PICKER

MORE ATMOSPHERE

Black-and-white images can be dramatic and totally transform an average colour photo. But sometimes you might feel that the drama has left your image feeling a little cold.

Duotone can add warmth and a little more atmosphere by adding selective colours back into the image. For more impact, use one dark colour, such as black or blue, and one light one. Pick colours that are complementary to each other. Try to avoid using primary colours unless you wish to gain a more stark effect.

This tutorial makes a duotone with two colours, but you can experiment with just one, a monotone or perhaps three colours, a tritone, or even four, a quadtone. Either way, when you have finished creating your toned image, make sure you choose a fine-art paper to gain the best results with your print.

STEP ONE

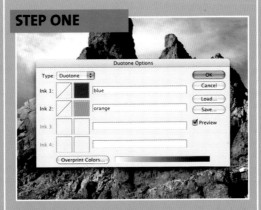

Convert your colour image to a greyscale file (see page 143). Save the image. Now choose **Image > Mode > Duotone**. The dialogue box that appears will have Duotone as the default, but the drop-down menu will give you the other options. Click on the blank right square, which will bring up the colour picker window.

STEP TWO

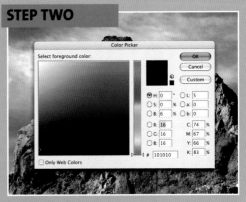

With the picker window open, choose your first colour, preferably the dark one . Click **OK**. In the Duotone dialogue box, name the colour. Now click on the square underneath and pick your complementary colour. As you pick the colours, you will notice your image change colour automatically. Click **OK** and save the image.

tools of the trade

The Crop tool is found in the image-editing toolbar. When an image is cropped, the unwanted part of the image is discarded. So make sure you are happy with your chosen composition before you select the final result. (For more on composition, see page 36.)

Cropping

Probably one of the most important tools in image-editing, the power of the Crop tool is not to be underestimated.

CHECKLIST

PHOTOSHOP ELEMENTS & CS
PAINT SHOP PRO

TOOLS & SKILLS
CROP TOOL
SELECTIVE AREAS
GUIDES
HORIZON CORRECTION

GOOD USE OF CROP

The Crop tool is one of the most important and widely used tools in any image-editing software. This most basic tool is used to remove unwanted sections of your image.

An average image can be totally transformed into something quite different with good use of cropping. You can reposition subjects in your image to either left, right, top or bottom, or even into the middle. Subtle tricks can also be done, such as straightening a crooked horizon. Use the Crop tool by clicking and holding down the mouse and dragging across your image.

You will notice that the crop selection is a thin dotted line with 'handles' on each corner and on all four sides. Use these handles to adjust your selection to the desired shape and size.

To give you a guide, the unwanted sections of your image are darker, helping you visually determine where to place the crop selection.

CROP ONE

Simple cropping is performed by selecting the Crop tool and clicking in a top corner of your image and, holding down your mouse, dragging down and across. You can now release the mouse. Click and drag inside the selection to position the crop. Hit the **Return** key on your keyboard to accept the crop.

CROP TWO

To reposition your subject, select the Crop tool and drag a selection across the image. Click on one of the handles on the edge of the selection and hold down the mouse. Drag the handle out and position to the desired area. Notice that even the corner handles adjust by always keeping the selection a uniform shape.

Drag the selection around the image to reposition your subjects. Hit **Return** to accept it.

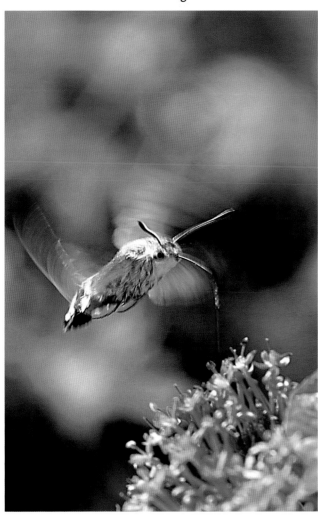

Above: Horizontal cropping can help give a sense of width. The focal point is the bud of the flower, but the small bee in the background with the large wide petal gives an idea of scale. Wide cropping on a landscape can also be an easy way of producing a panorama.

Left: Vertical cropping can enhance unusual compositions. In this photo the hover fly is given space above to accentuate the flight. It still falls neatly into the rule of thirds (see page 36).

go in tight

Cropping in tight can take the focal point in another direction. This example shows how the contrasting yellow leaves and blue sky are now the focal point, rather than the whole flower.

STRAIGHTEN UP

We all have done it – we're so focused on the subject that we fail to notice that we aren't keeping the camera level. As a result the horizon slopes down to the left or right. Now this can look very dramatic when trying to convey movement (especially on, say, a yacht), but most of the time it's an annoyance. But once you've noticed it, your eye will always be drawn to that irritating slant.

Fortunately, this fault can easily be corrected in editing programs such as Photoshop, albeit with a slight loss of the sides. There's more than one way to do it, but this method is the quickest and easiest.

With the offending photo open on screen, select the Crop tool and draw a selection to mark your desired crop, leaving enough space outside the selection to allow for its rotation.

STEP ONE

Click and drag a guide down onto the wonky horizon. Drag a crop selection so it's within the image area. Move your cursor to one of the corners until the pointer turns into a double-headed curved arrow icon. Now drag the icon in an arc in the direction you wish to rotate the crop selection.

STEP TWO

Rotate the selection until the top and bottom edges and the guide are parallel to the horizon. When you've got the angle just right, hit the **Return** key or double click inside the selection. The photo will now be cropped with a straight horizon but some loss of edges.

get clearer tones

Some images don't have any great impact because they have a slight greyish cast over them. This can be corrected many ways, but using the Levels is a more controllable method. (For more on contrast, see page 42.)

(For more on contrast, see page 42.)

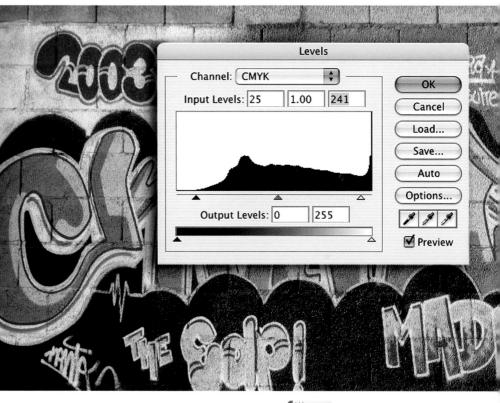

Using Levels

If your photos lack that 'punch', it's probably because you need to adjust the Levels. It's all about the tones.

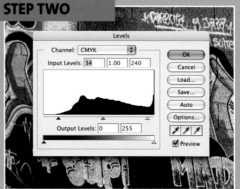

CHECKLIST

PHOTOSHOP ELEMENTS & CS
PAINT SHOP PRO
TOOLS & SKILLS
LEVELS
HISTOGRAM
TONAL RAGE

USE IT SPARINGLY

There are lots of ways to improve the tonal range in your images. It is essential to get a good balance of light and dark pixels if your image is to have any reasonable impact. Some images can feel slightly dull, due to lighting and weather conditions, or even down to the camera itself. Levels is a particularly useful command to learn, as the dialogue box gives you total control over the light and dark pixels. This is done by sliding the little arrows under the histogram (see page 62). The arrow on the left is the highlight, the middle arrow represents the mid-tones , and the right arrow is the shadows. Sliding these arrows by just a little amount can change the image quite dramatically, so use Levels sparingly.

Levels will change the image in real time on the screen as you adjust the arrows.

(see page 62).

STEP ONE

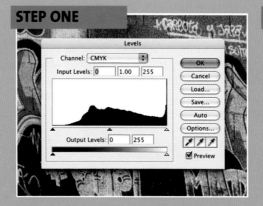

With your image open, choose **Image> Adjustments>Levels** from the menu bar. You can see your histogram in the dialogue box. Move the **left arrow** towards the build-up of the histogram, watching the image as you go. Don't go too far or your highlights will burn out and start to disappear.

STEP TWO

Now move the **right arrow** away from the 'peak' of the shadows. The mid-tones will automatically follow as you adjust. Every image is different and your histogram will look different too. Try to keep the histogram arrows within a fairly even build-up, but mainly watch the image itself for the best results.

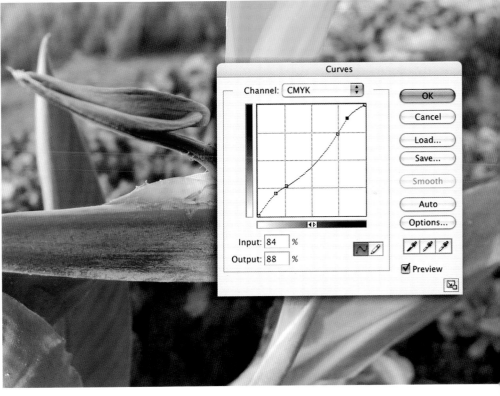

subtlety is the key

Curves is a very useful and powerful way of adjusting the overall tone and colour of an image in just one hit. As with the Levels command, it must be used with subtlety and sparingly to gain maximum effect. You can change individual colours or the image as a whole. (For more on colour, see page 34.)

Using Curves

This is a one-stop, fix-all command; well, almost. Once mastered, this will become an invaluable tool for correcting images.

CHECKLIST

PHOTOSHOP CS &
PAINT SHOP PRO
TOOLS & SKILLS
CURVES
COLOUR CORRECTION
SELECTIVE COLOUR

WHAT, NO CURVE?

Most images will need some attention before you can print: the highlights are too bright, shadows too dark or the contrast may be off.

When you use Curves, you can adjust the overall contrast or tonal range, adjust the local contrast and adjust the colour too – all in one go, through the Curves dialogue box.

As you open the Curves dialogue box, you will see a graph with a diagonal line running from the bottom left to the top right. The horizontal axis represents the current brightness of the pixels, with the shadows at the bottom and the highlights at the top. The vertical axis is the amount of change. The most obvious thing about this box is that there is no curve!

This example shows you how to improve the colour range.

STEP ONE

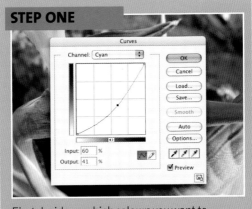

First decide on which colours you want to improve in your image. In this example, we want to remove the blue and increase the yellow. Choose **Image > Adjustments > Curves** and move the dialogue box to one side, so you can see your image more clearly. From the drop-down menu choose the blue (cyan). Click in the middle of the line and drag down to form the curve. This will decrease the blue.

STEP TWO

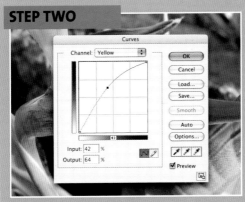

Then, from the drop-down menu, select the yellow and again click in the middle of the line , but this time drag upwards, so to add more yellow, making the image warmer. Click **OK** when you're done. Overall colour changes can be carried out with the composite colours by not selecting an individual colour and just dragging the curve up or down.

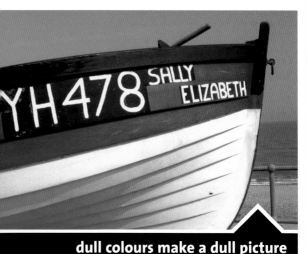

dull colours make a dull picture

Sometimes it is necessary to adjust the colours of an image to remove an underlying colour cast. This can be down to a poor white balance or bad lighting conditions. Even scanned images can contain a cast. You can easily see the cast colour by using the colour picker and moving it over white areas; the colour value will show up in the info palette. (For more on lighting, see page 74.)

Colour Cast Removal

Sometimes an image can be dominated with a colour cast right across it. Photoshop can fix this in many ways.

CHECKLIST

PHOTOSHOP CS & PAINT SHOP PRO
TOOLS & SKILLS
LEVELS
AUTO COLOUR CORRECTION
SELECTIVE COLOURS

CAST OUT THE CAST

So you've taken the perfect picture – great subject, great composition – and you're ready to print it. But wait...there is a nasty blue colour right across the image. This is called a 'cast'.

Casts can appear for differing reasons (see page 132). There are lots of ways of removing a cast in Photoshop, but it helps to start with a simple method first. You can go straight to the Image menu and choose the Auto functions, Levels, Contrast and Colour. Or, if you are still not happy, go to the Curves dialogue box and manually adjust the correct colour channel.

Either way, removing the cast is one thing, but deciding on how the end result should look is another. When you remove a certain colour, remember that the other colours are directly affected. Try to keep skin tones warm, with a little yellow, and skies blue.

STEP ONE

Open the image and choose **Image > Adjustments > Levels**. Adjust the tones until you are happy with the result. Then click on the **Options** button before the **OK** button. You should see the **Auto Colour Corrections** dialogue box.

STEP TWO

You have three options in the top part of the new dialogue box. Try each one to immediately see the result. When you're happy, click **OK** and then **OK** again in the Levels box. This auto function can be gained straight from the Image menu or also with the Curves dialogue box. It's worth going through either the Levels or the Curves, as you can still manually change any further cast that is required before hitting **OK**.

sample new pixels

The Clone or Rubber Stamp tool is a great way of erasing unwanted sections of an image. By holding down the option key and sampling a new area, close by, you can paint over the top of your affected section. As it copies existing pixels, be aware of obvious repetition. (For more on pixels, see page 104.)

The Clone Tool

Remove unwanted elements from your photos quick and easily with the help of the Clone tool.

CHECKLIST

PHOTOSHOP ELEMENTS & CS
PAINT SHOP PRO

TOOLS & SKILLS
CLONE TOOL
OPTION CLICK
BRUSH APPLY
BLEND SECTIONS

OPTION CLICK

When you take photos, you always have a certain degree of control. You can set up the composition, adjust the camera settings and wait for suitable lighting. But there are some things you can't control. It may be that unwanted elements are spoiling your perfect photo: birds in the sky, people in your landscape or even telegraph poles. Whatever the problem, the Clone or Rubber Stamp tool can fix this.

It works by selecting an area of the image and copying straight over the top of the unwanted subject. The tool is a brush and needs to be correctly sized to gain the maximum control. It's best to keep the brush size smaller than the area to be covered. Don't go too far in one go, as the pixels are repeated and you will get obvious repetition across your image.

For smaller areas, try 'dabbing' rather than long strokes, which helps blend in the new area.

STEP ONE

For greater control, zoom right in on your unwanted area. Choose the **Clone** or **Rubber Stamp** from the toolbar. Select a suitable brush size and softness from the brush palette. Hold down the **Option key** and click on an unaffected area that you wish to clone, as close to the unwanted area as possible.

STEP TWO

Either dab or use small strokes over the unwanted area. If you make a mistake, remember to choose **Undo** and try it again. Keep zooming in and changing the brush size as the detail becomes more complicated. Some areas will be easier to clone than others, but always make sure that verticals or horizontals line up, such as on the horizon.

combine all your favourite snaps

Create a brand-new image from all your favourite holiday snaps . With the use of layers, the Transform tool and the Eraser tool, you can make a simple holiday montage in Photoshop. (For more on Layers, see page 142.)

Holiday Montage

Don't hide all those holiday snaps away after everyone has seen them; make a fantastic holiday montage.

CHECKLIST

PHOTOSHOP ELEMENTS & CS
PAINT SHOP PRO
TOOLS & SKILLS
LAYERS
COPY AND PASTE
ERASER
OPACITY SLIDER

GETTING STARTED

Memories are made of this, so the song goes, and your photos are no exception. These treasured snapshots of our lives can all too easily be forgotten when the initial excitement is over. If you put your holiday pictures away in an album, never to be seen again, making a holiday montage allows you to give them a new lease of life.

This tutorial shows how to add a number of your images together to create one larger one, create soft edges to blend in the subjects and make pleasing joins.

It may be a good idea to start with just five or six images, so as not to get too complicated too quickly. You will be dealing with multiple layers and this may become confusing. Make sure you name each layer as you go. This will help you arrange the images into the final montage.

STEP ONE

First, open all the digital images that you have decided to use in your montage.

Create a brand new blank document window of a desired size.

With each open image, **Select > All** then **File > Copy** and then click on your new document and **File > Paste** each of the images into the new document.

You will notice that each of the images appears on a separate layer.

STEP TWO

Select **Edit > Transform > Scale** to resize the image to the desired size. With the **Move** tool, move each image roughly, to a position that seems to work for you as a layout. Turn each layer on and off so you can see where you want.

You can also adjust the opacity of each layer to see the underlying image.

STEP THREE

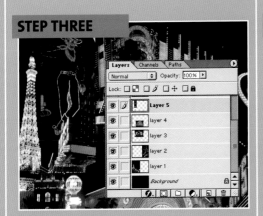

Give each of the layers a relevant name, which will make navigation easier when moving the stacking order. Double click the active layer, enter the title in the dialogue box and click **OK**.

Remember that when you position your images, each one must overlap the other so the edges will blend together better.

Take your time positioning them. Look for elements in an image that will draw your attention into the final picture. In this example, the casino neon sign is placed on the right edge of the image and faces inwards, making a natural frame.

STEP FOUR

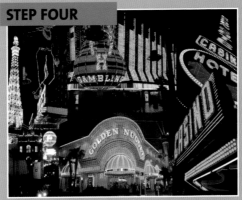

You could stop here and print out your simple montage. If you do want to finish, it will help to flatten all layers. This will collapse all the layer stack into one, **Layer>Flatten Image** and **Save** – you won't be able to access the layers again, but it will make a smaller-sized file.

If you want to come back to the image later on, try **Save As**, which will save a copy. Name the image a different title to the original, eg: 'Montage copy'. This will make a separate flattened document, allowing you to reopen your layered image.

Here, we will continue to blend the images to create a more pleasing finish.

STEP FIVE

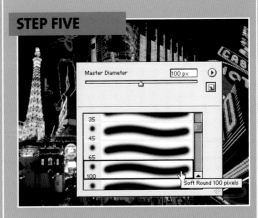

One way to blend in the image edges is to erase them with a soft brush. Select the **Eraser** tool from the tool menu. Choose a suitable brush size with soft edges and an **Opacity** of 100%.

Begin to gently sweep the eraser round the edges of the pictures. Take your time and make sure you're happy with each stroke. You can adjust the **Opacity Slider** so less is erased with each stroke to give you more control.

Remember to keep **Saving** your work.

STEP SIX

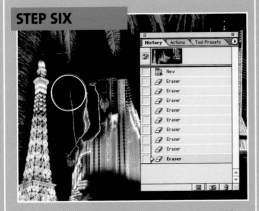

Experiment with erasing close to the edges of your subjects. Try different sized brushes to get different results, going smaller as you get near an edge. **Zoom in** to help make more accurate strokes. If you make a mistake or you're not happy, open the **History Pallet,** select **Window >History** and click on a step to take you back.

STEP SEVEN

When you have finished softening all the edges, make sure the background is not showing through. You can still resize and move each of the layers to cover over any mistakes.

The holiday montage is now complete. Finish off by flattening the image **Layer> Flatten Image** and **Save**.

FINISHING TOUCHES

You can go a stage further with your holiday montage by adding a personal touch. Try scanning in tickets or wrappers, brochure covers or postcards, and adding them to your finished montage. We added a pair of dice to give our Las Vegas that extra casino touch!

You can even try adding text to give it that special touch. See how we did it on page 163.

Montages can be fun and a great way for a real understanding of how layers work. It's worth practising and trying several attempts before committing yourself to a finished result.

Don't just stick to holiday snaps; try making montages of family weddings or Christmas parties, your children or pets, or even a montage of ALL your favourite photographs.

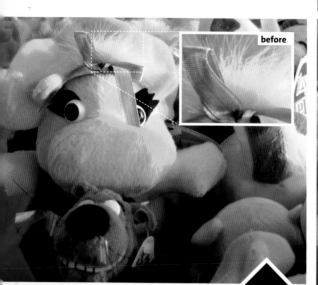
before

just a little bit more

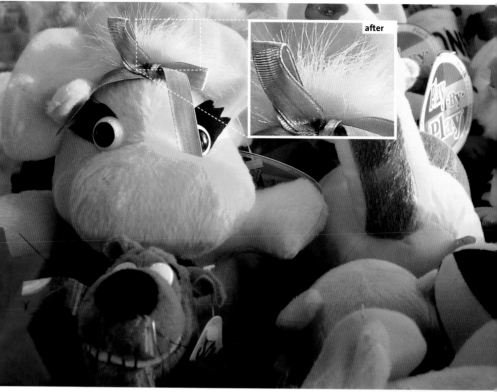
after

Most digital cameras have an autofocus function, which is fine in a lot of cases, but it only needs to be slightly out and your subject becomes soft. Even with manual focusing, it can be trial and error to gain a pin-sharp focus. Unsharp masking can rectify this problem in one easy step. (For more on focusing, see page 58.)

Unsharp Mask

Photo-editing software can help you achieve a pin-sharp focus after you have taken the image. How? Unsharp Mask.

CHECKLIST

PHOTOSHOP ELEMENTS & CS
PAINT SHOP PRO

TOOLS & SKILLS
UNSHARP MASKING
IMPROVE SHARPNESS
ENHANCE CLARITY

IMPROVE CLARITY

Unsharp Mask can be one of the most useful filters to help you in improving your images. Used correctly, it can sharpen and improve the clarity of fine detail. It works by increasing the contrast between light and dark neighbouring pixels. You can see in this example how the hairs on top of the soft toy have become more accentuated. It is quite easy to recognise when the filter has been over applied, as the contrast becomes very noticeable.

Unsharp Mask is particularly useful when correcting scans as scanners can produce a slightly soft image. (For perfect scanning, see page 112.)

(For perfect scanning, see page 112.)

STEP ONE

From the menu bar choose **Filter > Sharpen > Unsharp Mask**. In the dialogue box, check the Preview button, this will give you a clear view of the filter. Drag the **Amount** slider or enter a value to determine the amount. Look for fine detail, as this will help you apply correctly. The radius slider should be set at about 2 and the threshold at about 15.

STEP TWO

The other Sharpen filters – **Sharpen**, **Sharpen Edges** and **Sharpen More** – can be found with Unsharp Mask. They are all auto filters and require no input. They improve clarity but also increase the contrast of adjacent pixels, so use them sparingly or the filter will become obvious.

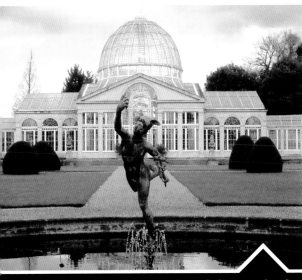
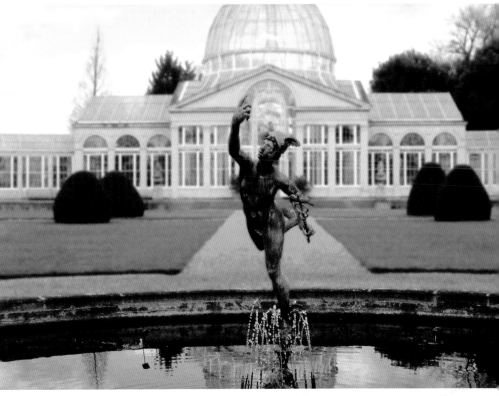

cluttered and distracting?

When taking a picture of a foreground subject, you may not be thinking of the background. But upon reflection you may decide that it is too cluttered or distracting. With the help of Photoshop you can increase the depth of field by adding Gaussian blur to the background. (For more on backgrounds, see page 26.)

Gaussian Blur

Improve your foreground focal point by increasing the amount of blur over the obtrusive background.

CHECKLIST

PHOTOSHOP ELEMENTS & CS
PAINT SHOP PRO
TOOLS & SKILLS
GAUSSIAN BLUR
LAYERS
ERASER
SOFT-EDGED BRUSH

SOFTENS PIXELS

It's not always that easy to take the time to set up a shot and take into account all the elements. It's not until you view your images on your PC that you may notice things that you wished you could change or reposition.

Backgrounds are no exception. They can be distracting and draw the eye away from your focal point. The Gaussian blur filter softens each pixel to look like a soft focus. It creates a false depth of field, bringing the foreground further out of the background.

Other Blur filters used in the range include the Average filter, which looks for the most common colour and smoothes all the colours out, the Blur and Blur More filters give a very subtle smoothing to hard edges, Motion Blur filter gives the illusion of movement in straight lines, and Radial Blur does the same thing but as a zoom or spin.

STEP ONE

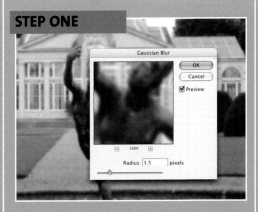

With your image open, drag the background layer in the Layers palette, down to the new layer icon to create the new layer. Click on the background layer and choose **Filter > Blur > Gaussian Blur**. Enter an amount in the dialogue box or use the slider to manually adjust. You view the amount as you go with the **Preview** checked.

STEP TWO

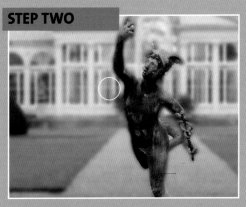

Select the **Eraser** tool and choose a suitable soft-edged brush size from the brush menu. Select the top layer with Sharp Image and start to gently erase the background so the blurred background shows through. Erase up to the edges of the foreground subject, taking the time to adjust the brush size as you go. Eventually you will be left with a sharp foreground and blurred background.

remove red-eye

little devils

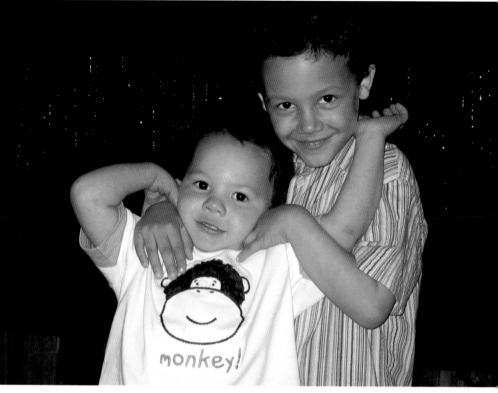

monkey!

Light from your camera's flash is reflected in the eye. This causes red-eye, which can easily ruin the best of shots. This tutorial uses special tools created to remove this problem. (For more on how red-eye is caused and how best to avoid it, see page 110.)

Remove Red-eye

Eyes like a zombie is not a good look! It's a very common fault from a built-in flash, but here's how to remove it.

CHECKLIST

PHOTOSHOP ELEMENTS & CS
PAINT SHOP PRO

TOOLS & SKILLS
RED -EYE REMOVAL BRUSH
BRUSH SIZES
COLOUR SWATCHES
TOLERANCE LEVELS

GETTING STARTED

It's a frequent problem with cameras with a built-in flash. If you get too close to your subject, the light can be reflected back from the pupils and cause a horrible red glow, which can easily ruin the best of shots.

Nearly all image-editing software gives you the option to remove red-eye in a couple of easy steps. Based on a Brush tool, this function replaces the red colour with a more natural hue.

In Photoshop Elements, the tool is found directly in the toolbar. In Photoshop 7 and CS you can find the tool nested in with the Healing and Patch tools.

Remember that when using any brush tools, you must select the size and softness from the Brush palette. Make sure that the size selected is smaller than the offending area in the eye.

STEP ONE

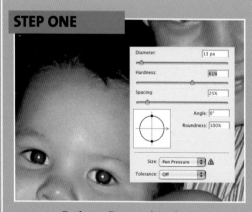

With the **Red-eye Removal tool** selected and the brush size and softness set, choose the colour you will replace the red with – usually this will be black. Make sure the colour black is in the foreground of the swatches.

STEP TWO

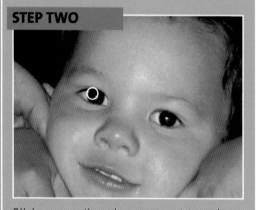

Click once on the colour you want to replace in the image, this being the red colour. Drag over the red with the brush to repair the image. You can increase the Tolerance level in the Options bar to help you get better coverage.

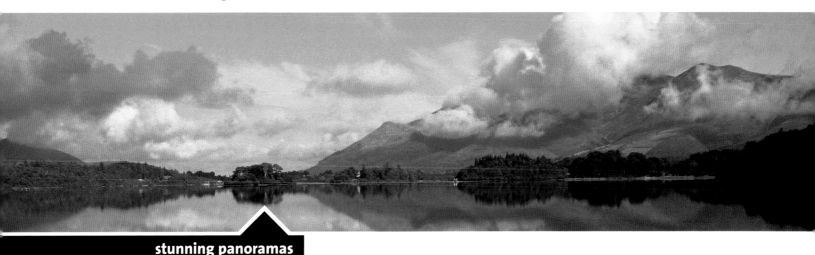

stunning panoramas

The only way to get stunning panoramas from your camera is to 'stitch' them together with your image-editing software. Take a sequence of pictures, while rotating the camera 360°, and then run them through Photomerge in Photoshop, an automated stitching command that will blend the images together seamlessly. (For more on panoramas, see page 94.)

 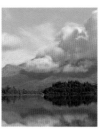

Image Stitching

Create beautiful panoramic vistas with your standard digital camera, using Photoshop's stitching function.

CHECKLIST

PHOTOSHOP ELEMENTS & CS
PAINT SHOP PRO

TOOLS & SKILLS
360° PHOTOGRAPHY
AUTOMATE
PHOTOMERGE
BLENDING

SEQUENTIAL SHOTS

If you don't own an expensive SLR camera with an ultra-wide-angle lens, you may find it almost impossible to get any real sense of width in your vistas. With the help of Photoshop's function called Photomerge, you can create stunning images that not even the most expensive of lenses could achieve.

To begin, shoot a sequence of images while gradually rotating the camera through 360°. Make sure that you allow enough overlap in each image to allow for improved joining. The exact amount of images needed depends on your camera's lens as well as the amount of overlap. Try to make sure that the exposure, focus and white balance are all locked and don't give any variation in the sequence.

When the images are loaded onto the PC, don't correct them until the stitching is complete. Then you can correct the composite as a complete image.

STEP ONE

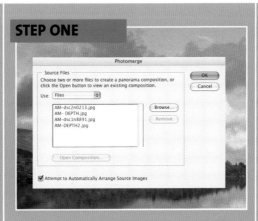

Put all your sequence images into a new folder. Make sure they are still named numerically, as this will help the automation.

Choose **File > Automate > Photomerge**. In the source dialogue box, navigate your way to the sequence folder. Make sure all the files appear in the source window. Click **OK**. This will set in action the automated stitching process. Sit back and watch!

STEP TWO

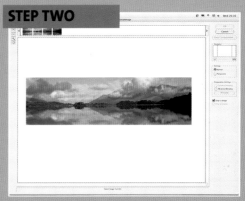

The new **Photomerge Preview window** will open and the images will appear inside, overlapping each other with blended edges. You have the option to choose **Advanced Blending,** which may help to smooth out any stray joins. You can also drag each image individually to reposition if necessary. Choose **OK** and let the stitching continue. When the panorama is complete, save the composite image.

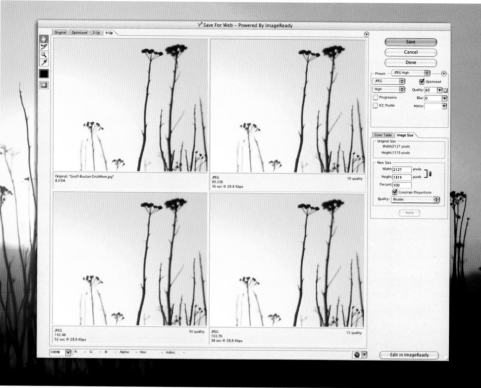

it's too big for me

When you download your images to your PC, you can resize them to fit on the screen with the Zoom tool. This is not the physical size of the image. Viewing at full size will clearly show you how it will appear on the Web...too big! (For more on resizing your images, see page 162.)

Web-ready Images

Getting your images up on the Web is one thing, but making sure they are ready for the Web is another.

CHECKLIST

Adobe
Photoshop Elements 2.0

Paint Shop Pro 8

PHOTOSHOP ELEMENTS & CS
PAINT SHOP PRO

TOOLS & SKILLS
SAVE FOR THE WEB
COLOUR DEPTH
FILE FORMAT
UPLOAD SPEEDS

SAVE FOR THE WEB

This tutorial shows you how to prepare your images for the Web.

Most people viewing online will be restricted by the speed of the modem. ADSL and cable are now ever more popular, but there are always going to be some who will be using the old-fashioned method. With this in mind, your images should be as optimised for the Web as possible to allow for a speedy download.

Photoshop has a 'Save for Web' command that can be very useful when deciding on how best to convert your images. With a range of options from colour depth to file type, there is everything here that you need to produce Web-ready photos.

The important thing to remember is to make sure the resolution is 72ppi. When viewed at 100%, this will show you the real size. If it does not fit in your monitor window, it won't fit in a Web browser window either.

STEP ONE

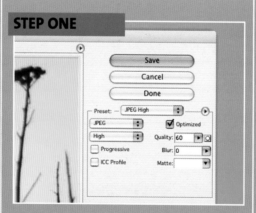

Make sure that your image is the correct size for a browser window, possibly 600 pixels wide. With your image set at 72ppi and in RGB mode, choose **File>Save for Web**. With the optimised window open, choose the **4 up** option found in the top left corner of the window. This will show you a range of image quality options. In the first section of the dialogue box make sure **JPEG** is selected for maximum quality.

STEP TWO

The second section gives you the option to resize the image further by entering the pixel value. Make sure that the **Constrain Dimensions** is checked; this will keep the image in proportion. You will be able to click on each window and view the download speed, file size and quality. When you have chosen the best for your image, make sure the window is active (blue line around it) and click **OK** to save for the Web.

115_1528.JPG 115_1546.JPG 115_1567.JPG 115_1573.JPG 1

116_1601.JPG 116_1603.JPG 116_1606.JPG 116_1608.JPG 1

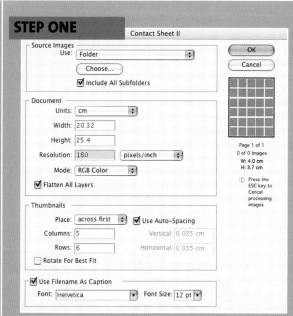

116_1655.JPG 116_1657.JPG 116_1658.JPG 116_1659.JPG 1

keep your images in order

Building up a substantial collection of images and keeping them all in order can be quite a daunting task. With the help of Photoshop you can make a traditional contact sheet in seconds. (For more on organising, see page 92.)

Contact Sheets

Keep your photos in order and easily accessible by making a visual contact sheet in Photoshop.

CHECKLIST

PHOTOSHOP ELEMENTS & CS
PAINT SHOP PRO

TOOLS & SKILLS
AUTOMATE
CONTACT SHEET
THUMBNAILS
FILE, NAME AS

WE HAVE CONTACT

Your collection of images may be named and stored correctly in a portfolio, but what about all the other shots? What do you do with all the ones that didn't quite make it?

In traditional photographic printing, a contact sheet was made by placing negatives straight onto a sheet of photo paper and exposing it to make a direct print. In this way, the image and the negative number were stored on the sheet.

Photoshop can do the same thing for you, but it can go one better, as it does this automatically! With the dialogue box correctly filled out, just one click will enable the software to carry out the filing process.

You create a composite file with all the images from the chosen folder placed in order, with the file names underneath.

STEP ONE

Contact Sheet II

Source Images
Use: Folder
Choose...
☑ Include All Subfolders

Document
Units: cm
Width: 20.32
Height: 25.4
Resolution: 180 pixels/inch
Mode: RGB Color
☑ Flatten All Layers

Thumbnails
Place: across first ☑ Use Auto-Spacing
Columns: 5 Vertical: 0.035 cm
Rows: 6 Horizontal: 0.035 cm
☐ Rotate For Best Fit

☑ Use Filename As Caption
Font: Helvetica Font Size: 12 pt

OK
Cancel

Page 1 of 1
0 of 0 Images
W: 4.0 cm
H: 3.7 cm

ⓘ Press the ESC key to Cancel processing images

Choose from the menu bar **File > Automate > Contact Sheet II.** The dialogue box is split into four sections, the first being the **Source** option. Click on the **Choose** button and navigate to your chosen folder. In the **Document** section, decide on how big you want the file to be. If you want to print your contact sheet, enter a resolution of at least 180ppi. Then choose in the **Thumbnails** if you want the images to run from left to right or top to bottom, how many rows and how many columns. Lastly, decide what type and size of font you want underneath each image from the **Use File Name As Caption** box.

When you are happy with the details, click **OK** and let the process begin. The file will automatically open, resize and place each image for you.

don't destroy the clarity

At some point while modifying your images you will need to adjust their size. Whether you decide to enlarge or reduce for the Web or for a printer, applying the correct method for resizing is very important. Information in the image can be ruined, destroying the clarity if the rules aren't followed. (For more on image quality, see page 63.)

Image Resizing

Learn to change the size of your images with the help of the Image Size command and the Transform tool.

CHECKLIST

PHOTOSHOP ELEMENTS & CS
PAINT SHOP PRO
TOOLS & SKILLS
TRANSFORM
SCALE
IMAGE SIZE
RESAMPLE

SIZE MATTERS

Whatever your final output, at some point you will need to resize your images to suit. It's important to follow the rules, because if you don't you can introduce rogue pixel information which can lead to blurring and loss of clarity.

There are different ways to increase or reduce images in editing software. It is, of course, easier to reduce an image, because pixels are thrown away to make way for a smaller size. To enlarge is more difficult, as extra pixel information is required and you cannot just 'create' new information in your image.

This tutorial covers two different methods of resizing, one manually with the Transform tool and the other through a numerical dialogue box. With this method, you have the option to decide if the image is to be resampled, which means adding more pixels to the image. This is where you need to be careful.

METHOD ONE

The easiest way to resize an image quickly is to use the Transform tool. Double click on the background in the Layers palette to convert it to a layer. Then choose **Edit > Transform > Scale**. This will run a box with handles around the edge of the image. As you move over the handles, the pointer will change to a **Transform arrow**. Grab the top corner handle and, with the **Shift key** held down, drag the handle down. The image will resize uniformly.

METHOD TWO

Choose **Image > Image Size**. You will notice that the dialogue box is split into three sections. The first tells you the current dimensions and is locked unless **Resample Image** is checked. The second is **Document Size**, where you can enter your new image size. **Constrain Proportions** will lock the dimension size uniformly. If you want to enlarge the image, choose a 10% increase and continue every 10%. Don't go too far, or blurring will occur.

resolution independent

The Text tool is an exciting and creative way of personalising your images. When you add type, they stay resolution independent, so you can resize as large or small as you like, until you rasterize them. That way they stay sharp and crisp. (To see how we made this montage image see page 154.)

Adding Text

Make your images more personal. Whether it's for a gift or just for fun, adding text to an image is easy.

CHECKLIST

	PHOTOSHOP ELEMENTS & CS
	PAINT SHOP PRO
	TOOLS & SKILLS
	LAYERS
	COPY AND PASTE
	ERASER
	OPACITY SLIDER

WHAT'S IN A WORD?

The Text tool places resolution-independent type on your image as a separate layer. It works like most basic text software, with options to adjust size, leading and tracking. Double click on the text to select it, and the text becomes highlighted. The text will remain editable until it is rasterized (turned into pixels). If the text is set too small or the resolution of the image too low, then the type can appear to have jagged edges and the words can possibly become unreadable.

When using the Text tool, you have the options of either horizontal or vertical type. You will, of course, also be able to choose the typeface, weight, size and colour. You can use the Transform, Rotate and Skew tools to adjust the shape of the text.

When the text is rasterized, you will be able to apply other filters to it if desired.

STEP ONE

Select the **Text tool** from the toolbar. Click onto the image and start to type. You will notice that a new text layer has appeared in the Layers palette. The layer will be named with the start of the text, so if you do have multiple layers it will be easy to navigate.

STEP TWO

Bring up the **Text palette** from the menu bar. In the Character section, enter the required type face, size etc. You can use the **Pointer tool** to move the text around the image. If you want to size manually, choose **Edit > Transform > Scale** and use the Transform tool to size up or down. When you are happy with the text, choose **Layer > Rasterize > Type**. This will turn the text into pixels.

perfect printing

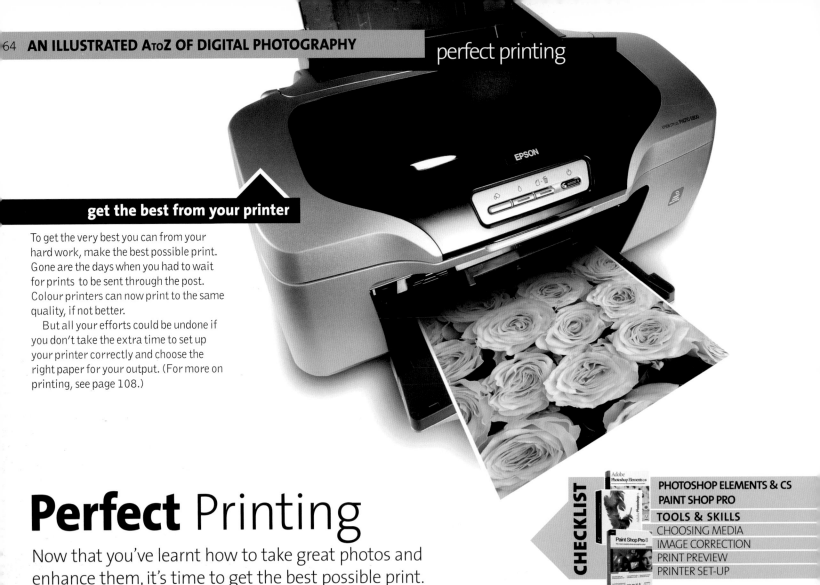

get the best from your printer

To get the very best you can from your hard work, make the best possible print. Gone are the days when you had to wait for prints to be sent through the post. Colour printers can now print to the same quality, if not better.

But all your efforts could be undone if you don't take the extra time to set up your printer correctly and choose the right paper for your output. (For more on printing, see page 108.)

Perfect Printing

Now that you've learnt how to take great photos and enhance them, it's time to get the best possible print.

CHECKLIST

PHOTOSHOP ELEMENTS & CS
PAINT SHOP PRO
TOOLS & SKILLS
CHOOSING MEDIA
IMAGE CORRECTION
PRINT PREVIEW
PRINTER SET-UP

MORE CONTROL

When printing your images, it is essential that you take extra time to make sure that you get the most from your printer and image.

It is important that you understand the differences between types of paper so you get the best output (see page 108).

Unless you have had your monitor calibrated (colours adjusted for your environment and printer output), you may not always get exactly the same colour and tone you see on your screen on your print. It's wise to produce test prints first, so you don't waste expensive paper.

Make sure that you have followed the instructions in the printer's dialogue box when sending to print, checking you have selected the correct paper size, media type (glossy, matt etc). You can choose the auto functions, but doing it manually will give you more control.

STEP ONE

CHOOSE THE RIGHT MEDIA

Both Epson and Canon print media are designed to give top-quality results when used with their own inks and printers and are ideal for a new user. Glossy Photo papers have a shiny surface which reproduces vivid colours and a wide tonal range. They print richer blacks than matt papers, and will allow you to use your printer's finest-quality settings.

STEP TWO

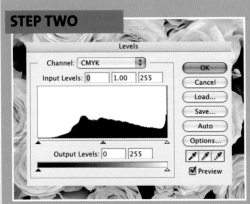

CORRECT IMAGE BRIGHTNESS

Open your image and bring up the Levels dialogue box. Inside here are all the tools you'll need to use for adjusting the brightness of your digital image. Inkjet printers are not good at reproducing darker tones and tend to increase the amount of black shadows already present. It's a good idea to make your image look slightly brighter onscreen by moving your Levels mid-tone slider to the left as shown.

STEP THREE

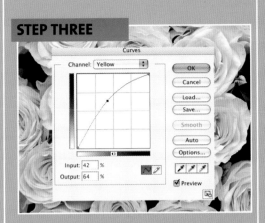

CORRECT COLOUR

Next, it's essential to correct any colour imbalance that may have been caused by your lighting. Photos shot with flash can look cold and devoid of atmosphere, but this can easily be put back using Curves . If you've been using the wrong white balance setting, this can also be corrected by applying a correction to both highlights and mid-tones in the Curves dialogue.

STEP FOUR

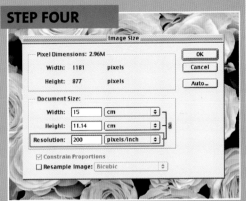

ADJUST RESOLUTION AND SIZE

Once you've made your image look good on screen, the next stage is to prepare it at the right size and resolution for printout. Open the Image Size dialogue and first uncheck the Resample option. Next, change the Resolution to 200 pixels per inch, which will set the maximum print size available as shown in the Document size readouts. It's not essential to prepare your images to match the 1440 or 2880ppi output resolution of your printer, as you won't see any increase in quality above 200.

STEP FIVE

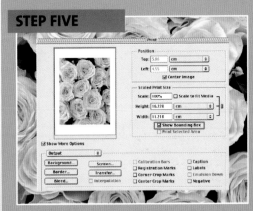

CHECK PRINT PREVIEW

Next, confirm your print size and orientation by using the Print with Preview function. At this stage, if your image is too big for your print paper, you can easily reduce its size by typing in a value less than 100% until it fits within your currently selected paper size. If your image is lying in the wrong orientation, you need to change this in your Page Setup dialogue, rather than rotate your original image file. Finally, select the Centre Image option for a perfect centrally positioned print.

STEP SIX

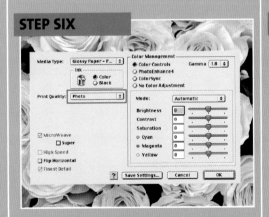

SET-UP PRINTER SOFTWARE

After choosing the Print command, pick the closest match to your print media from the Media drop-down menu. Next, set your print quality to its highest available option, sometimes referred to as High, Photo or 2880dpi. Turn off all auto Contrast, Colour and Sharpening controls, as these might undo your work in steps 1–3.

STEP SEVEN

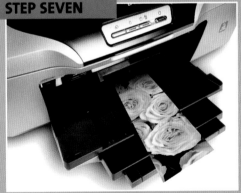

MAKE A TEST PRINT

Return to your image, pick the rectangular Marquee tool and make a selection around the area you want to test. This should contain highlight, mid-tone and shadow areas. Choose **File > Print** and select the Print Selected Area option. This will place your rectangular test selection exactly in the centre of your chosen paper size.

STEP EIGHT

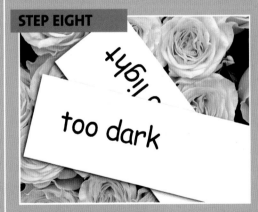

JUDGE YOUR RESULTS

Once printed out, write a comment on your test strip to help you remember your printer settings and paper type. If you need to make any changes, return to your image file, take off the selection and adjust in Levels or Colour Balance as before. Once ready, make another test print of your new settings before committing to a full-size sheet of paper.

JARGON BUSTER

Baffled by the technical terminology? Don't worry – this essential glossary is all you need to understand what it all means.

Aperture
Variable opening that controls the amount of light passing through the lens. Measured in f-stops. Wide apertures (such as f2.8) let lots of light in and give limited depth of field, whereas narrow apertures (such as f22) give greater depth of field but let much less light through.

Analogue/Analog
Continuously variable.

Anti-aliasing
Smoothing the jagged edges (aliasing) of selection or paint tools in digital-imaging applications.

Backlight control
An exposure compensation introduced when the subject of a picture is lit from behind (which can fool a camera's metering system, creating a silhouette effect).

Bit
A binary digit, basic digital quantity representing either 1 or 0. The smallest unit of computer information.

BMP
File format for bitmapped files used on Windows.

Buffer RAM
Fast memory chip in a digital camera. Buffer RAM is used for temporary storage while images are being written to the memory card.

Byte
Standard computer file size measurement: contains eight bits. Other common units include kilobyte (KB: 1024 bytes), megabyte (MB: 1024K) and gigabyte (GB: 1024 MB).

Calibration
The process of adjusting a device, for example a scanner, so it captures, displays or outputs colour in an accurate and consistent way. The same applies to monitors and printers.

CCD
A charged coupled device converts light into electrical current. The digital camera equivalent of film.

CD-R
Recordable CD, a useful archiving system. CD-Rs can only be written once and not erased. Also available are rewritable disks/drives (CD-RW,) which are more expensive but can be erased and reused.

CD-ROM
A non-rewritable digital storage compact disk used to provide software.

Cloning
A feature of many image-editing software programs where part of an image can be duplicated over another part. Used to seamlessly 'paint out' blemishes.

CMYK
Cyan, magenta, yellow is the colour printing model used by dye-sub and low-end inkjet printers. CMYK adds black (key) and is used for most professional printing.

Colour bit depth
The number of bits used to represent each pixel in an image; the higher the bit depth, the more colours appear in the image: 1-bit colour provides a black-and-white image with no greys or colours; 24-bit colour gives 16.7 million colours ('photo-realistic' colour).

Compact Flash
Type of removable memory card.

Compression
The 'squashing' of data to reduce file size for storage or to reduce transmission time. Compression can be 'lossy' (JPEG) or 'lossless' (TIFF, LZW). Greater reduction is possible with lossy compression than with lossless schemes.

Contrast
Range of tones in an image between the highlights and the shadows.

CPU
Central processing unit. Carries out all the instructions and calculations needed for a computer to work.

Data
The generic name for any information used by a computer.

Default
The standard setting for a software tool or command, used if the settings are not changed by the user.

Depth of field
The area in front of and behind the focused point that is sharp. A shallow depth of field is used in portraits to provide a soft backdrop, while a greater depth of field is useful for landscapes to ensure everything is in focus. Shorter (wide-angle) lenses and smaller apertures increase depth of field.

Dialogue/Dialog box
A window in a computer application where the user can enter options or change settings.

Digital zoom
Camera feature that enlarges the central part of an image to give a similar effect to a telephoto lens. Basically an in-camera crop, it usually results in a drop in image quality.

Download
The transfer of files or other information from one piece of computer equipment to another (such as when transferring pictures from camera to computer screen).

Dpi
Dots per inch. A measurement of the resolution of a printer or video monitor (see also ppi).

DPOF
Digital print order format. A system that lets digital camera users select images and quantities for printing in-camera.

Driver
A software utility that tells a computer how to operate an external device (ie a printer).

EVF
Electronic viewfinder. A recent addition to high-end digital cameras. A tiny colour LCD monitor placed inside a viewfinder, which does not suffer from the glare problems of standard LCD monitors.

Exposure
The amount of light falling onto a digital camera's CCD. Exposure is determined by the combination of shutter speed (duration) and aperture (intensity).

Exposure compensation
The ability to increase or decrease the exposure set automatically by the camera. Measured as + or - 'EV'.

f-stop/f-number
See Aperture.

Feathered edge
Found in image-editing software, this is a soft edge to a mask or selection. Allows seamless montage effects.

File
Used in computers to describe a single document (ie a digital photograph) stored on a disk.

File format
The way information in a file is stored. Common file formats include JPEG, TIFF, FlashPix and GIF.

Filter
Photo-editing software function that alters the appearance of the image being worked on, such as the filters for SLR camera lenses.

Fixed (non-zoom/prime) lens
A lens with a fixed focal length.

Focal length
Determines a lens' magnification and field of view.

Focus
Adjusting a lens so the subject is recorded as a sharp image on the CCD. There are three types of focus system used in digital cameras: fixed focus (focus-free), autofocus and manual focus.

Flash Memory
A type of fast memory chip that remembers all its data, even when the power is turned off. See Removable media.

Fringe
A (usually) unwanted border of extra pixels around a selection, caused by lack of a hard edge. Can also describe an unwanted artefact in digital images, caused by lens defects or CCD problems.

GIF
A graphic file format developed for exchange of image files (only supports 256 colours).

Greyscale
What photographers call a black-and-white image.

Guides and grids
Function in the camera LCD monitor that helps you achieve straight compositions. Also found in software for much the same thing.

Hard disk/Hard drive
A fast and cheap form of digital storage (usually refers to a computer's internal disk).

Hue/Saturation
An RGB image can also be defined by Hue, Saturation and Brightness, where Hue is the colour and Saturation the 'strength'. Hue/Saturation controls are useful for altering colours without affecting overall brightness or contrast.

Image manipulation
Once a digital image has been transferred into a computer, image-manipulation software allows the individual pixels to be altered in many ways. Colour corrections, sharpening, photomontage and distortions are all forms of manipulation.

Infinity
The farthest possible distance a lens can be focused on.

Internal storage
Some digital cameras have some built-in memory (although it has been replaced by Removable Media on most models).

Interpolation
Increasing the number of pixels in an image or filling in missing colour information by averaging the values of neighbouring pixels. This 'resampling' cannot add new detail.

Jaggies
The jagged, stepped effect often seen in images whose resolutions are so low that individual pixels are visible.

JPEG
A file format that stores digital images in a very space-efficient way. Used by virtually all digital cameras, JPEG uses a form of 'lossy' compression to reduce file sizes at the expense of fine image detail. The level of compression (and thus the loss of quality) is varied, and this forms the basis of digital camera settings.

Lasso
A selection tool used to draw a freehand selection around an area of an image.

LCD monitor
Liquid crystal display. A small colour screen found on many digital cameras that allows previewing/ reviewing of images as they are taken.

Lossy
A type of compression that involves some loss of data, and thus some degradation of the image. JPEG is a common lossy system.

>>

Lossless

File compression that involves no loss of data and therefore no loss in quality. LZW is a lossless compression system used in TIFF files. Lossless compression produces lower space savings than lossy.

Macro

Description used to indicate a lens that can focus closer than normal (usually nearer than about 30mm).

Manual override

The ability to alter the automatic setting on a camera (exposure or focus).

Marquee

Outline of dots created by an image-editing program to show an area selected for manipulation, masking or cropping. Most applications also call their basic selection tools (rectangles and squares) Marquee tools.

Mask

In digital imaging, an 8-bit overlay which isolates areas of an image prior to processing. The mask is used to define an area of an image to which an effect will not be applied by 'masking out' those areas and thus protecting them from change. The areas outside the mask (ie those not protected) are called the selection.

Megapixel

One million pixels – a measure of camera resolution.

Menu

Range of functions displayed on the LCD monitor of a camera.

Mode dial

This dial is found on the back of a digital camera and holds a selection of functions, including recording, playback and movie modes.

Moiré

Patterns that can appear in scans of printed materials.

Morphing

Effect where one image smoothly changes into another.

Network

Two or more computers and peripherals that are connected (by direct cable links or over phone lines using modems).

Noise

Unwanted electrical interference that degrades analogue electrical equipment. In digital cameras this most often occurs in very low lighting or shadow areas, in the form of pixels of the wrong colour appearing at random in dark areas.

Optical resolution

In scanners, the maximum resolution possible without resorting to interpolation. Also describes a digital camera's true CCD resolution.

Optical viewfinder

Viewfinder system showing a similar view to that seen by the lens. Uses no power, but can cause parallax and focus errors.

Parallax error

Misframed photographs (especially close-ups) caused by the different viewpoints of the lens and the optical viewfinder.

Peripheral

Any item that connects to a computer (such as a printer or scanner).

Photoshop plug-in

A small piece of software that adds extra features or functions to Adobe Photoshop or other compatible applications. Common uses are to add new special effects (such as filters).

Photosite

A single photosensitive element in a CCD which translates to one pixel in the resulting image.

Pixel

PICture ELement. Smallest element of a digitised image. One of the tiny points of light that make up an image on a computer screen.

Power-up time

Measure of a digital camera's speed of operation, showing how long it takes from turning the camera on until it is ready to take the first picture.

Ppi

Pixels/points per inch. A measure of the resolution of scanners, digital images and printers.

Quick Mask

A special Adobe Photoshop mode that allows a mask to be viewed as a colour overlay on top of the image. This mask can be edited using the standard Paint and Selection tools.

RAM

Random access memory. The computer memory where the CPU stores software and other data currently being used. A large amount of RAM usually offers faster manipulation of images.

Recovery time

The time delay during which a new picture cannot be taken on a digital camera, while waiting for the previous one to be saved.

Refresh rate

In digital camera terms, how many times per second the display on the LCD preview monitor is updated. A refresh rate of under about 15 fps (frames per second) will look 'jerky'.

Removable media

Small memory chips that store the captured images. The two main formats are Compact Flash and Smart Media – CompactFlash cards offer higher capacities, but Smart Media cards are smaller. Other types of removable media used include Multimedia/ Secure Digital (MM/SD) and Sony's Memory Stick.

Resample

To change the number of pixels in an image. Upsampling uses interpolation to increase the number of pixels, while downsampling throws away pixels.

Resizing

Changing the resolution or physical size of an image without changing the number of pixels, eg a 50 x 50mm (2 x 2in) image at 300dpi becomes a 100 x 100m (4 x 4in) image at 150dpi. Often confused with resampling.

Resolution
Measure of the amount of information in an image expressed in terms of the number of pixels per unit length (ie pixels per millimetre or pixels per inch). Camera resolution is usually defined as the actual number of pixels in an image, ie 640 x 480 (see dpi and ppi).

RGB
Red, green and blue. TV sets, monitors and digital cameras use a mix of RGB to represent all the colours in an image.

ROM
Read-only memory. ROM is fixed memory that can be read, but not written. Inside a computer or peripheral, it contains the basic code that allows the CPU to work.

Rubber Stamp tool
See Cloning.

Saturation
The amount of grey in a colour. The more grey there is, the lower the saturation.

Selection
In image-editing, an area of an image isolated before an effect is applied. Selections are the areas left uncovered by a mask.

Serial transfer
Connecting a digital camera to a computer via the serial ports in order to download images.

Shutter lag or delay
The delay between pressing the shutter and a picture being taken.

Shutter release
A button on a camera that, when pressed, activates the shutter, taking the photo. When pressed halfway, it refocuses the subject.

Shutter speed
The time for which the CCD or film is exposed during an exposure. High shutter speeds (hundredths or thousandths of a second) prevent camera shake and can freeze motion in photos. Slow (long) shutter speeds allow exposures in low light.

Subject modes/Scene modes
Special fully automatic exposure modes that use the optimum settings for specific subjects, such as sports or close-ups.

Telephoto lens
A lens that makes subjects seem closer than they are.

Thumbnail
A small, low-resolution version of a larger image file, used for quick identification or showing many images on a screen.

TIFF
Standard file format for high-resolution bitmapped graphics.

TWAIN
Protocol for exchanging information between applications and devices such as digital cameras.

Unsharp Mask
A software feature that selectively sharpens a digital image in areas of high contrast while having little effect on areas of solid colour. Increases the apparent detail and sharpness.

USB
Universal serial bus. Type of connector for attaching peripherals such as keyboards, scanners and printers. Offers faster data transfer and easier (plug 'n' play) connections than PC parallel ports or Mac serial ports. Works with Windows 98/Mac OS 8.5 or above.

Video output
Ability to display digital camera images on a standard TV or record images on videotape.

Viewfinder
The eyepiece on the back of the camera through which you view your subject. Can be rangefinder type (small separate lens found above the main lens), SLR type (through the main lens) or even an electronic viewfinder (small monitor)

VRAM
Video random access memory. The more megabytes of memory you have, the quicker you can perform operations on your PC.

White balance
In digital camera terms, an adjustment to ensure that colours are captured accurately (without colour cast), whatever the lighting used. Can be set automatically, using presets for different lighting types, or measured manually, depending on the camera.

Wide-angle lens
A lens of short focal length giving a wide angle of view, allowing more of a scene to be fitted into a photo.

Zoom lens
A variable focal length lens that allows the user to adjust their field of view (zoom in or out) without moving. Not to be confused with a digital zoom.

Picture Credits

Great thanks to all those who have contributed to the making of this book.
Please take some time to look at those who have generously donated their images.

Philip Andrews
Brisbane
www.adv-elements.com
pp.33, 51, 64

Nigel Atherton
Brighton
www.whatdigitalcamera.com
pp.16, 18, 20, 23, 24, 25, 26, 30, 33, 37, 42, 44, 45, 48, 50, 51, 52, 53, 54, 57, 59, 60, 61, 62, 65, 66, 67, 69, 74, 75, 81, 82, 83, 88, 96, 97, 98, 103, 110, 116, 117, 123, 124, 125, 126, 127, 132, 133, 149, 154, 160, 165

Stacey Bevan
Twickenham
www.lazyiguana.com
pp.49, 78, 159

Marian Brown
California
p.32

Geoff Buxton
Ilkeston
www.ewok30.freeserve.co.uk
pp.7, 17, 18, 20, 21, 22, 24, 36, 37, 68, 76, 77, 78, 96, 105, 149, 162, 164

Duncan Cox
Newbury
pp.24, 44, 50, 58, 64, 67, 120, 148

Barbara Crabb
Southampton
p.61

Steve Crabb
London
www.whatdigitalcamera.com
pp.45, 91, 95, 104, 137, 143, 146, 147, 150, 151, 158, 163

Tim Daly
Dorking
p.117

Damien Demolder
Braintree
p.98

Sheradon Dublin
Streatham Vale
www.musecube.com/alternativelondon
www.musecube.com/vividflorals
www.musecube.com/girlsonfilm
pp.37, 45, 88, 89, 103, 122

www.digitalvision.com
pp.39, 68, 70, 86, 134

Andrew Earp
Canada
p.129

Alex Fairfull
Stowmarket
p.84

Ali Graham
Hawick
p.76

John Grayston
Preston
pp.33, 51

Ben Hall
Stockport
benhall@wildlifephotography.fsworld.co.uk
p.19

Andrew Harris
Tamworth
www.andrewharrisphotography.co.uk
pp.30, 54, 55, 94, 95, 102, 161

Jamie Harrison
Basildon
wdctechblog.my-expressions.com/
pp.17, 75, 90, 102, 103

Steve Hillman
Barrow-in-Furness
pp.16, 83

Alex Holland
Hunmanby
www.alexfineart.co.uk
p.91

www.imagestate.com
p.121

David Inglis
Mauchline
p.84

Instant Picture Network
www.ipcmedia.com
pp.26, 50, 51, 56, 60, 98, 99, 115

www.istockphoto.com
pp.16, 17, 18, 30, 42, 51, 56, 69, 82, 84, 85, 102, 117, 119, 120, 123, 128, 131, 133, 136

Ashley Keates
Nottingham
p.95

Rod Lawton
Weston-Super-Mare
p.59

Alex Maddox
London
pp.20, 21, 34, 45, 36, 56, 61, 96, 152, 153, 156

Ken Marshall
Lincoln
p.115

Clare Masefield
Brighton
pp.40, 61, 69

Alan McFaden
Brighton
pp.43, 58, 63, 69, 83, 85, 88, 99, 120, 125

Ron McIlhenny
Glasgow
pp.36, 122

Charlotte Moore
Ypsilant, USA
p.135

Mike O'Carroll
South Devon
p.116

John Powell
Brierley Hill
p.32

Joel Bruno Santos
Portugal
p.99

Cliff Smith
Woking
http://bdpweblog.my-expressions.com/
p.120

Anthony Taylor
Whitworth
p.134

Melanie Wall
Newport, Isle Of Wight
p.32

Terry Wosely
Greater Manchester
p.129